PORTRAITS AND PROPAGANDA

FACES OF ROME

An Exhibition held at the David Winton Bell Gallery,
List Art Center, Brown University

January 21-March 5, 1989

Lay-out : cover by Julia W. Harisson, photograph by Brooke Hammerle, Brown University. book by Tony Hackens and Ghislaine Moucharte, Séminaire de Numismatique Marcel Hoc, Université Catholique de Louvain-la-Neuve.

The coin reproduced is catalogue no. 38.

Drawings : cover and book : Mary Winkes.

Photographic Credits : see p. 6.

Printing : Imprimerie É. Oleffe, 30, rue Sambrée, B 1490 Court-Saint-Étienne.

Deposited by law obligation at the Royal Library at Brussels n° 1989/1900/01.

Books in Print no. 0-933519-16-8.

PORTRAITS AND PROPAGANDA

FACES OF ROME

An Exhibition held at the David Winton Bell Gallery,
List Art Center, Brown University

This exhibition is part of the Program in the History of
Art and Architecture and organized by the graduate students
with Rolf Winkes as faculty advisor

It will be shown in altered form at :

THE MUSEU HISTORICO NACIONAL, RIO DE JANEIRO (JUNE 1989)

THE MUSEU PAULISTA, UNIVERSIDADE DE SÃO PAULO (JULY 1989)

THE MUSEU DE VALORES DO BANCO CENTRAL, BRASILIA (MAY 1989)

THE UNIVERSITY MUSEUM OF DEPAUL UNIVERSITY, CHICAGO (Fall 1989)

and under the auspices of the European Center for the Sensibilisation to Cultural Heritage,
Barcelona, in the following cities :

BARCELONA - BRUSSELS - NAPLES

Providence, Rhode Island
Brown University
1989

This exhibition at the Bell Gallery and the catalogue are supported by a grant from the National Endowment for the Arts (A-88-001925) and by Brown University.

Preliminary research was conducted by R. Winkes under a grant from the Getty Art History Information Program and the Institute for Research and Information and Scholarship at Brown University.

The European exhibitions and catalogues are under the tutelage of the European Center for the Sensibilisation to Cultural Heritage in Barcelona (Council of Europe and Commission of the European Communities) and coordinated by Prof. T. Hackens, Séminaire de numismatique Marcel Hoc, Louvain-la-Neuve (Université Catholique de Louvain).

The catalogue for the exhibition in Brazil is made possible by the Banco Central of Brazil and is translated by Dr. Maria Beatriz Borba-Florenzano, who also coordinated the Brasilian exhibits.

LENDERS TO THE EXHIBITION

The American Numismatic Society
Bowdoin College Museum of Art
The Brooklyn Museum of Art
Brown University, Bishop Collection
Brown University, Harkness Collection
Brown University, The John Hay Library
The Corning Museum of Glass
The Detroit Institute of Arts
Mr. Harry Dewit
The Harvard University Art Museums (Arthur M. Sackler Museum)
Mr. and Mrs. Artemis Joukowsky
The Metropolitan Museum of Art
Museu Historico Nacional, Rio de Janeiro
Museu Paulista, Universidade de São Paulo
Museu de Valores do Banco Central, Brasilia
Museum of Art, Rhode Island School of Design
Museum of Fine Arts, Boston
The University Museum, University of Pennsylvania
Worcester Art Museum.

PHOTOGRAPHIC CREDITS

All coins at Brown University were photographed by Brooke Hammerle. The coins in the Museu Paulista were done by Terezinha Blachessem and those in Rio de Janeiro by Calino-Rio. Prints of Brazilian coins were made by Maria Daniels. The coins of the Dewit collection were photographed by Jacques Piron, Louvain-la-Neuve.

FOREWORD

This exhibition was organized and this particular catalogue written by the graduate students in the Program of the History of Art and Architecture. It is the basic exercise for the Master's Degree in that program and is undertaken by every student during Semester II of their first year and Semester I of their second year at Brown. Academically, emotionally and physically demanding, this exercise is a difficult requirement and provides rigorous training.

The work that these students have done is the core of a project that was inspired by my friend Tony Hackens. He will see to it that other versions of the catalogue will be published in several different languages to accompagny the other exhibitions which will be shown in altered form at various locations throughout the Americas and Europe. It is thus the basic idea that is traveling and not necessarily the objects, which will be replaced by others of their kind in consideration of the holdings of other institutions.

My preparation for this project became part of *Object, Image, Inquiry, the Art Historian at Work, a Study by the Getty Art History Information Program and the Institute for Research in Information and Scholarship, Brown University, Santa Monica 1988.* I would like to thank M. Schmitt, W. Beeman, E. Bakewell and my assistants N. Duncan and K. Kamborian for the interesting discussions we had in 1986.

This is now the third time that the National Endowment for the Arts has supported me in undertaking such an exhibition. The collaborative efforts have increased considerably each time - as one should profit from previous experience. The Brown University Lectureship Committee again provided funds to host a colloquium of outside scholars. L. Beer's and G. Tobey's demonstrations on the striking of coins and their help with the creation of a slide show will be another exciting contribution to this exhibition, which we have very much designed to interest not just the scholar, but the public at large.

During the preparation, many individuals have helped. Their names are legion. All of them will have encountered Beth Googins without whom we would not have been able to finish the manuscript in time and who lived through the many days of confusion with her usual firm and humorous attitude.

Rolf WINKES
Director of the Center for Old World Archaeology and Art.

ACKNOWLEDGMENTS

The success of an exhibition rests upon the talent and cooperation of numerous individuals. Each one brings to the project his or her field of expertise and invaluable advise and assistance. Many of the strenghts of « Portraits and Propaganda : Faces of Rome » derive in one way or another from the individuals cited below. We pause here to extend our thanks to them.

First, we wish to thank Prof. Tony Hackens of the Université Catholique de Louvain-la-Neuve, Belgium and Prof. Maria Beatriz Borba Florenzano of the Museu de Arqueologia e Etnologia da Universidade de São Paulo, Brazil. We have appreciated their enthusiasm and interest in « Portraits and Propaganda : Faces of Rome, » and we are grateful to them for their cooperation regarding the transportation of the core of the exhibit to South America and Europe. Among those who have enriched this exhibit, we would like to acknowledge the gracious assistance of Leslie Beer and A. Guilford Tobey, who in their demonstration « Strike Your Own Denarius, » to be held in conjunction with the exhibition, will significantly complement its contents and illuminate the subject of Roman numismatics for the Brown community. Our sincerest appreciation goes to Nancy Versaci, Director, and Judith Tolnick, Curator, of the David Winton Bell Gallery, for their care and conscientiousness during the preparatory stages of the exhibition. Beth Googins of the Center for Old World Archaeology and Art has been a friend to us all and we are deeply indebted to her for her ceaseless help. Additionally, we express our gratitude to Dr. Carmen Arnold-Biucchi, Richard Ballou, Richard Benefield, Arabella Berkenbilt, Amy Brauer, David Brenneman, Dr. T.V. Buttrey, Norine Cashman, Madeleine Cody, Maria Daniels, Nina Duncan, Dr. Florence Friedman, Dr. Jean-Baptiste Giard, Brook Hammerle, Charles A. Hersh, Prof. R. Ross Holloway, Kelly Kamborian, Jennifer Lee, Martha Mitchell, Prof. David Gordon Mitten, Patricia Morrissey, David Ogawa, William H. Peck, Janice Prifty, Allen H. Renear, David Romano, Samuel Sachs II, Sherill Sanderson, Prof. Juergen Schulz, Samuel Streit, as well as to the staff of the Rockefeller Library, Brown University.

Our heartfelt thanks go to our respective families and friends who during the trials and tribulations of this exhibit have lent us an ear, guided us and nurtured us.

Finally, we would like to thank our advisor, Prof. Rolf Winkes. One year ago, we began to prepare for « Portraits and Propaganda : Faces of Rome » as novices in the field of Roman portraiture. Today, thanks to his patience and sharing of knowledge, we are able to produce this exhibition. Prof. Winkes's dedication to the exhibit and to his students has been inestimable ; he has been a never ending source of encouragement. It has been a great privilege to study with him.

Laura L. AARON
Karen Lee BOWEN
Elizabeth GEORGIOPOULOS
Elaine D. GUSTAFSON

Julia W. HARISSON
Hannelore B. RODRIGUEZ
Diana C. SILVERMAN
Jessica STALEY

John TURNER
Gregory WALLACE
Allison C. WHITING
Mark R. WILSON

TABLE OF CONTENTS

LIST OF ABBREVIATIONS

AJA	*American Journal of Archaeology.*
ANRW	*Aufstieg und Niedergang der Römischen Welt* (ed. H. Temporini).
ANS	*American Numismatic Society.*
Bab.	E. BABELON, *Description historique et chronologique des monnaies de la République romaine vulgairement appelées monnaies consulaires*, Vol. I & II, Paris, 1885-86.
BMC	H. MATTINGLY, *Coins of the Roman Empire in the British Museum*, London, 1923-1930.
BMCRep.	H.A. GRUEBER, *Coins of the Roman Republic in the British Museum*, London, 1910.
BullRISD	*Bulletin of the Museum of Art, Rhode Island School of Design.*
C	H. COHEN, *Description historique des monnaies frappées sous l'Empire romain communément appelées médailles impériales*, Paris, 1880-92.
CorNumRom	*Corpus Numorum Romanorum.*
Crawford	M.H. CRAWFORD, *Roman Republican Coinage*, Cambridge, 1974.
Curtis	J.W. CURTIS, *The Tetradrachms of Roman Egypt*, Chicago, 1969.
Dattari	G. DATTARI, *Monete Imperiali Greche, Numi augustorum alexandrini. Catalogo delle Collezione G. Dattari*, 2 vols, Cairo, 1901.
DRC	S.W.S. STEVENSON, *Dictionary of Roman Coins*, London, 1889.
ERC	*Essays in Roman Coinage Presented to Harold Mattingly*, Oxford University Press, 1956.
Giard	J.-B. GIARD, *Catalogue des monnaies de l'Empire romain*, I, *Auguste*, Paris, 1976.
Grant, FITA	M. GRANT, *From Imperium to Auctoritas : an Historical Study of Aes Coinage in the Roman Empire*, Cambridge, 1946.
» , RAI	M. GRANT, *Roman Anniversary Issues*, Cambridge, 1950.
» , RIM	M. GRANT, *Roman Imperial Money*, London, 1954.
» , SMACA	M. GRANT, *The Six Main Aes Coinage of Augustus*, Edinburgh, 1953.
HCC	A.S. ROBERTSON, *Roman Imperial Coins in the Hunter Coin Cabinet*, Oxford, 1982.
JRS	*Journal of Roman Studies.*
Kent	J.P.C. KENT, *Roman Coins*, London, 1978.
LRBC	R.A.G. CARSON, P.H. HILL and J.P.C. KENT, *Late Roman Bronze Coinage, A.D. 324-398*, London, 1960.
Milne	J.G. MILNE, *Catalogue of Alexandrian Coins in the Ashmolean Museum*, London, 1933.

NC *Numismatic Chronicle*

NNM *Numismatic Notes and Monographs*

Poole R.S. POOLE, *Catalogue of Greek Coins*, London, 1889.

RIC *Roman Imperial Coinage*. Ed. by H. MATTINGLY, E.A. SYDENHAM, C.H. SUTHERLAND and R.A.G. CARSON, London, 9 vols, 1923-1987. For vol. I, the second edition has been used.

RN *Revue Numismatique*

RömMitt *Mitteilungen des Deutschen Archäologischen Instituts, Römische Abteilung*

Syd. E.A. SYDENHAM, *The Coinage of the Roman Republic*, London, 1952

GLOSSARY

aquila : eagle - standard of the Roman legion

aspergilium : holy water sprinkler

biga : two-horse chariot

capis : bowl with one handle

chlamys : Greek mantle

cippus : funerary monument, grave stone

cista : basket or wooden box

corona civica : crown of oak leaves

fasces : bundles of rods carried by lictors before a high-ranking Roman citizen

imagines maiorum : ancestor portraits

lectisternium : meal and festival of supplication to the gods

lituus : augural staff

modius : measure of grain, referring to amount or container

paludamentum : mantle worn by commanders and later by emperors

parazonium : a short sword

patera : a broad, flat dish used in offerings

pskhent : type of Egyptian crown

quadriga : chariot drawn by four horses

simpulum : ceremonial ladle

sistrum : metal rattle

situla : bucket

Previous Graduate Student Exhibitions :

Early Lithography, 1800-1840
26 March - 19 April 1968

The Portrait Bust : Renaissance to Enlightenment
5-30 March 1969

Jacques Callot, 1592-1635
5 March - 11 April 1970

Caricature and Its Role in Graphic Satire
7 April - 9 May 1971.

To Look on Nature : European and American Landscape, 1800-1974
3 February - 5 March 1972

Drawings and Prints of the First Maniera, 1515-1535
23 February - 25 March 1973

Europe in Torment : 1450-1550
6 March - 7 April 1974

Rubenism
30 January - 23 February 1975

The Classical Spirit in American Portraiture
6-29 February 1976

Transformations of the Court Style : Gothic Art in Europe, 1270-1330
2-27 February 1977

The Origins of the Italian Veduta
3-26 March 1978

Festivities : Ceremonies and Celebrations in Western Europe, 1500-1700
2-25 March 1979

Ornament and Architecture : Renaissance Drawings, Prints and Books
8 March - 6 April 1980

Edouard Manet and the Execution of Maximilian
21 February - 22 March 1981

All the Banners Wave : Art and War in the Romantic Era, 1792-1851
26 February - 28 March 1982

Gold Jewelry : Craft, Style and Meaning from Mycenae to Constantinopolis
25 February - 3 April 1983

Children of Mercury : Education of Artists in the Sixteenth and Seventeenth Centuries
2-30 March 1984

Ladies of Shalott : A Victorian Masterpiece and its Contexts
23 February - 23 March 1985

Definitive Statements : American Art : 1964-66
1-30 March 1986

Survival of the Gods : Classical Mythology in Medieval Art
28 February - 29 March 1987

Thomas A. Tefft : American Architecture in Transition, 1845-1860
23 January - 6 March 1988

INTRODUCTION

Portraits and propaganda were intimately linked in Rome. Closely associated with both are coins. There are not only a favored tool to date works that have come down to us without their original context, but they also help us to understand the meaning of those portraits. Often a coin's reverse depicts certain statues. Even though the leaning imposed by the legend and the obverse image of such a coin may represent an interpretation that was new and different from the original creation in sculpture, it was obviously considered to be compatible. Therefore, both sides of a coin must be looked at, and this is done here by grouping them under various categories to illuminate the complexity of the subject.

Virtues

Single figures on the reverse may represent divinities like Juno, Venus, Minerva, Jupiter, Mars, or other Olympians, and thus they evoke a particular association with the portrait on the obverse ; or they may show personifications like Fortuna, Fecunditas and Pudicitia. Both the divinities and the personifications are often used to express a virtue, a good quality of the person portrayed on the coin. Figures of virtues themselves are the deification of abstract ideas and values[1]. The anthropomorphic pantheon so familiar to us from Greece was alien to Roman thought, even at a time when images of Greek divinities in human shape were chosen to express particular ideas about the divine and spiritual realm. Cults of Concordia, Salus and Victoria, among others, are a natural development of the Roman conception of divinity, inasmuch as religion embraced every aspect of the life of the Roman state and these cults thus mirrored the change of the political structure. R. Fear points out that in the Republic the virtues originated mostly in the

vota made during a war[2]. They are thus not distant ideas, but expressions of piety and are consequently profoundly religious. Based on vows originally made at moments of duress the virtues reflect the faith in divine salvation ; they are also agents that can produce the same state in a person. Because of the influence of Greek and Etruscan mythology, these forces are represented in human shape. Hence an opportunity presented itself for the leaders to use this as a tool in self promoting propaganda. The emperor as a charismatic leader was believed to embody those qualities, and by his virtues he assured the continuation of a prosperous and well-ordered state. Their presence was considered to be essential for society, and they were a creative and forceful response to the need for unity.

The cults of Roman virtues are traceable in literature, in inscriptions and on coins. As an instrument of imperial propangada, they help us to define the character of a particular reign and understand the ideology of its emperor. Every successful society imposes its conception of order upon its world : for the emperor, the imperial bureaucrat and the ordinary Roman citizen, central to his conception of an ordered universe was the image of the emperor as a charismatic being. The selection of particular virtues from the range available made it possible for the emperor to define his reign in specific terms, to set it apart from or compare it to those of his predecessors, and to project his political ambitions on the public. For example, under Augustus, the age that had followed civil wars and that saw the establishment of the new principate, such virtues as Pax, Victoria, Fortuna Redux, Virtus, Clementia, Justitia and Pietas were stressed[3]. When Claudius comes to power his coins promise Libertas Augusta, Constantia Augusti and Pax Augusta, thus linking

1. FEARS, R.F., *The Cult of Virtues and Roman Imperial Ideology*, in *ANRW*, 17.2, 1981, p. 828.

2. *Ibid.*, p. 834.
3. *Ibid.*, p. 889-890.

these virtues with the wording of the legend to the Emperor himself[4]. Nero's response to the conspiracy by Piso is Securitas Augusti and Annona Augusti; thus he not only stresses stability, but he also uses this occasion as an opportunity to bring to the peoples' attention his role as general benefactor and provider. During the first and second centuries AD the number of virtues used in the medium of imperial propangada increases and becomes rather complex. The four cardinal virtues — Virtues, Pietas, Clementia and Concordia — can almost always be found, while others are chosen because of their old Roman values or created in response to particular needs. Virtue herself originally meant military virtue and is constantly referred to in literature, whenever the images of ancestors and their qualities are mentioned. Pietas constituted an attitude that was not only directed toward the gods, but also toward the ancestors and the state. Clementia appears to become, in Roman propaganda, an almost automatic response to victory, while Concordia, whose temple stood on the Forum from the early Republic on, was an ever present theme in all forms of Republican and Imperial propaganda. Holding the horn of plenty, she points toward the fruit that her forces bring to the empire. The good relationship between members of a family or co-regents produces such a force. During the third century a decrease in the representation of virtues is evident, while an increased belief that the emperor was to be associated with such divinities as Jupiter or Sol can be seen. At this time he was considered to be their representative on earth. However, representations of virtues still played a significant role as tools of propaganda. They now become more stereotyped and formulaic, and some become shared values between traditional religious beliefs and emerging Christianity.

Commemorative Coins

Coins celebrating special events were first struck during the Republic. They aggrandized the moneyer issuing them, mostly through the depiction of his forebearer's achievements such as heroism in battle or civilian largess[5]. These early coins are centered on the city of Rome and its life, and portray events from the distant past. When emperors began to strike commemorative coins, they did not deviate much from the goals of the moneyers, the difference being the greater impact of the propaganda.

The representations are usually allegorical or symbolic, and often give other information besides these depictions. Frequently on finds names of cities, countries, festivals, famous monuments, deities, and family members on the coins, which help in discerning their meaning and significance.

Some emperors chose to give prominence to themselves and their relatives by an ancestor's achievements.

Civic festivals, athletic competition, buildings, and natural phenomena were also commemorated on Roman coins. Coins with these types of representations were issued to illustrate the wealth of the state and to exalt the emperor's generosity and achievements. Moreover, coins that depict monuments and buildings of ancient Rome sometimes provide the sole evidence for the existence of the originals, other times they permit us to compare the depiction with the extant building like the Colosseum.

However, the most frequent subject for commemorative themes is military sucess and pride in Rome. For instance, Augustus relayed the importance of his victory over the Parthians in 20 BC on a denarius that shows the Roman standards that were recaptured form the Parthians in the temple of Mars Ultor[6]. The closing of the doors of Janus, a race act symbolic of universal peace, is always celebrated and appears her on the reverse of a sestertius from the reign of Nero. Roman historical relief, which decorated public buildings like arches, alludes to the same military successes. Like other buildings that were used for commemoration, these arches became a favorite motif on coins to illustrate a particular victory or the images of a defeated or captured enemy.

There is a frequent reference to the Roman Republic and a claim that the Republic is restored under a given reign; and great emphasis is placed on the commemoration of traditional values in the long history of Rome. Naturally, important events of the actual history of the City and the Republic that it stood for receive special attention such as the millennium of the foundation of Rome under Philip I. Part of the celebration, like so many other festivals in Rome, were the millenary games alluded to on the coinage.

4. *Ibid.*, p. 893.
5. HANNESTAD, N., *Roman Art and Imperial Policy*, Moesgard, 1986, p. 21.

6. GROSS, W. H., *Ways and Roundabout Ways in the Propaganda of an Unpopular Ideology*, in *The Age of Augustus*, ed. by R. WINKES, Providence, 1985, p. 40.

Provinces

The conquered territories that became the provinces of the Roman Empire were an important and constant part of early imperial propaganda, as can be seen from the many coins with the legends CAPTA and RECEPTA. Generally speaking, local traditions and customs were respected as long as they did not conflict with Roman governmental policy. Furthermore, the Eastern provinces were a major resource from which the imperial government drew its artists. These exercised considerable influence on the creation of Roman official portraits. For example, Augustus's portraits were partly inspired by the Hellenistic ruler-type with his hair arranged in heroic-looking locks, and thereby his earlier portraiture is in direct imitation of Alexander the Great.

Traditionally, provinces were under the jurisdiction of the Senate. Augustus, however, declared himself in charge of Egypt, Syria, Gaul and Spain, and thus created the imperial provinces. In addition, he exercised general control over the senatorial provinces by influencing the character of their administration. This direct control over the provinces provided an economic and political power-base. In AD 69, the year of the Four Emperors, Galba's Hispania series of coins testifies to the strength of the Spanish legions that enabled him to march into Rome. The provinces were now assuming an increasingly dynamic role. The emperors appeared to offer them more benefactions, which sometimes meant simply the removal of previous abuses. When, for example, after the suppression of the Jewish revolt during the Flavian dynasty (AD 69-70), Jews had been ordered to pay Jupiter the silver piece previously paid to the Temple of Jerusalem, lists of those liable had been drawn with the distasteful aid of informers[7]. Nerva claimed to have removed the false accusations employed for the Jewish tax, though the tax itself remained.

In the second century AD imperial policy toward the provinces became more human and cooperative. This is already evident in the reign of Trajan, the first Roman Emperor from the provinces, and in his coinage. On coins minted after the Dacian Wars (AD 101-106), Dacia (modern Rumania) at first is depicted in the traditional dejection of

defeat, but later she is shown in a more hopeful and peaceful guise as Rome's friend[8].

By Hadrian's time (AD 117-138), the links between Rome and the provinces had grown steadily closer, and the master-subject gave may to one between members of a commonwealth. The theme of unity is now stressed throughout the Empire and the cultural and religious ties between Rome and the provinces were strengthened, which he ensured by undertaking two long journeys throughout the provinces (AD 121-125 and 128-133). The coinage reflects these in the great province series. The provinces are represented mainly as female allegorical figures in appropriate attire and with distinguishing attributes. On the part of the provinces, this series is supposed to reveal their pride in their membership in the Empire.

During the Antonine period (AD 138-193), the provinces enjoyed unprecedented economic stability and had become very active culturally. They produced a steady stream of artists, writers and philosophers. All this culminated in the *Constitutio Antoniniana* of Caracalla in AD 212, by which the privilege of Roman citizenship was legally extended to every province.

The city of Rome, the *caput mundi*, became more and more subsumed by the vast empire and many emperors from the second to the fourth centuries AD came from provinces and conducted a considerable amount of their administration while travelling through the provinces. Septimius Severus, for example, was born in Leptis Magna, present-day Libya, and died in York, England.

When Diocletian divided the Empire into four sections, he set his capital in Nicomedia, in Asia Minor and his co-Augustus, Maximian, held court in Milan. Rome had become merely a meeting-place for the Senate. Rome's relation to the provinces was drastically altered ; no longer was she the undisputed center of the Empire. After Constantine the Great founded a new capital city, Constantinople, on the Black Sea in AD 330, Rome's decline was irrevocable[9].

The stylistic traits, which in general terms characterize much of provincial art, are seen as manifestations of an attitude toward artistic representation,

7. GRANT, M., *Roman History from Coins*, Cambridge, 1958, p. 50-53.

8. *Ibid.*, p. 53.
9. For portrait sculpture in the provinces, see ZANKER, P., *Provinzielle Kaiserportraits*, (*Bayerische Akademie der Wissenschaften, phil.-hist. Kl., N.F., Heft 90*).

which is different from the Greco-Roman tradition, and is representative of the vastness of the Empire. The interaction of styles and cultures, a hallmark of the heterogeneity of the Roman Empire, tended to produce new art forms like the mummy portraits from the Fayum or the grave stelai of Roman Gaul.

The Imperial Family

Roman society traditionally placed emphasis on the family, and this was a means to assure stability for the imperial propaganda. Coins thus become an appropriate medium to express sharing of power and to demonstrate the close association among individuals. Hence, not only do the natural children tend to look like the emperor, but also to his spouse and adopted heirs. The legitimacy of a reign is further underlined in the legends, a constant reference to filial relationships. Likeness, and especially a similar hairstyle, claim an association with the qualities of a reigning or a past emperor. Augustus and his legendary Golden Age are a favorite citation in this respect. His name CAESAR AVGVSTVS becomes the title for emperors. During his reign it becomes customary that the declared heirs to the hold high offices, even though they may be legally under age for such an office. At the point when emperors share their rule, Caesar becomes the title for the junior and Augustus the title for the senior emperor. The relationship between father and son is also expressed through the association with particular gods in that the senior emperor is like Jupiter, the father of all gods, and the junior is like his son Hercules. The likeness with these particular gods affects the portraits of the emperor and his sons. Yet, likeness is not only attempted by copying iconographic traits from earlier images, but also by using features that one believed to be typical of the character of famous rulers or ancestors [10]. For this, one relied on general books on physiognomy and biographies. For women, these biographical sources were scarce. Also, women had no role within the Roman governmental structure, even though some of them appeared to have exercised great political power and influence as was the case of Livia, wife of Augustus [11].

10. For Augustus, see GROSS, W. H., *Augustus als Vorbild*, in *ANRW* ii 12.2, p. 599-611 ; for Trajan and in general, see ZANKER, P., *Herrscherbild und Zeitgesicht*, in *Wissenschaftliche Zeitschrift* 31, 1982, 2/3, p. 307-312.
11. WINKES, R., *Leben und Ehrungen der Livia*, in *Archeologia*, XXXVI, 1985, p. 55-68.

By the end of the Republic, women had acquired a fair measure of independence. Although dominated by either a father or a husband, patrician women could easily return to their own family after a divorce. The woman was mistress of her home and therefore she directed all domestic and social activities, and officiated the family cult. As empress and wife of the Pontifex Maximus, she was involved in public ceremonies and often received the honors of the Vestal Virgins. Moreover, the title Augusta, which she could also attain, while not denoting constitutional power, referred to her public role as priestess of the cult to the Divine Augustus. This title was not conferred automatically to every empress. Faustina I received this honor at the time of her husband's, Autoninus Pius, elevation to Emperor. Her daughter Faustina II was not named Augusta until the birth of her first child.

Under the reign of Augustus, a falling birthrate prompted the Emperor to institute a series of laws governing marriage. The *Lex de Maritandis Ordinibus* encouraged marriage and offspring by penalizing the unwed and childless ; a mother of three or more children received independence in the management of her property, while childless couples were unable to receive inheritances. Also in order to restrain adultery, he supported the *Lex de Adulteris Coercendis*.

Coin portraits tell us a great deal about the women of the imperial family. The first instance of a living woman's portrait on coins occurred under Marc Anthony, who issued coins bearing the portrait of his wife, Octavia, the sister of Augustus. Portraits of Augustus's wife Livia also appear on coins. In his testament, Augustus adopted her and she became a member of his family. Under the reign of her son Tiberius, coins were issued in Rome that connected her image with Salus, which conveyed a concern about her health. Posthumous and commemorative coins portraying the Imperial women are first found under Caligula, who also promoted the defication of his sister, Drusilla, in AD 38. Claudius followed with the deification of his grandmother Livia, and his mother Antonia.

The most common form of propaganda was to choose an imagery for women of the imperial house at seemed compatible with the role in which the women were placed as *mater familias* in society generally. Many coins of the empresses include symbols of Juno, wife of Jupiter and protectoress of marriage. Venus is also a popular

reverse image, often in one of her other guises : Venus Felix, associated with wedded bliss ; Venus Victrix, or Victor ; and Venus Genetrix. Also prominent are Ceres, who is associated with fertility, and Vesta. Personifications of virtues are similary employed : primarily applicable to women was Pudicitia, referring to religious sanctity and personal chastisty.

The coins, as well as sculpted portraits, reflect the change in women's hairstyles. Although clothning fashions changed little, hairstyles changed rapidly, often demonstrating the taste of the Empress, and testifying to the extensive use of wigs.

From the beginning of the Empire an attempt to incorporate women of the imperial family into state cult is evident, and at times they played a significant role. For example, Julia Maesa, Julia Soemias, and Julia Mamaea were devotees of the cult of the sun-god, Elagabalus. They managed to secure the emperorship for Julia Soemias's son under the name of this god. With the dawn of Christianity, several empresses were either memebers of, or sympathetic to, that religion. Salonina, Otacilia, Valeria and her daughter Galeria were all thought to be Christians. Helena, mother of Constantine the Great, was later given sainthood, thus elevating her to a sphere that is close to God.

Citizens

During the Republic there were numerous references to honorary statues of citizens that were placed on the Forum, in basilicas and before temples[12]. However, most of them were never found, and information about them comes almost exclusively from brief literary sources. These sources suggest that basic types like togate and equestrian statues became part of the vocabulary of later Roman portraiture. Most likely they were influenced by Greek art ; yet it can be assumed that there was something distinctly Roman in their appearance as can be seen in funerary portraits of the late Republic. They were called *imagines* and some scholars link them with waxmasks, which were taken from the faces of the deceased and were displayed in the *atrium* of the patrician family. These masks were most likely precursors for the Italic-Roman portrait tradition, which culminates in the characteristically Roman veristic portrait style

that exemplifies the *gravitas* so important to the patrician[13].

Significant changes occurred in the period of Augustus. Varying degrees of dependence on and influence of official models are found in private portraiture. A number of such works exhibit the influence of the *Ara Pacis* in formal aspects.

Generally speaking, hairstyles such as the *nodus* on women provide a date for private portraits. Although older men and women still wear the Republican hairstyle, children might be portrayed in a manner commensurate with the prevailing hairstyles and features of Augustan classicism. Portraits of citizens, however, follow the emperor's features in a reflection of the imperial image. This does not necessarily express loyalty to the emperor, but a preferred image of the time. Even though the portrait of the emperor usually sets the trend in fashion, there are cases when private portraits set the precedent. That Hadrian introduced the wearing of a beard to the Empire is contested by examples of citizens wearing beards during the Flavian period[14]. Children's hairstyles were the prototype for a style that Trajan adopted later[15]. Particular conventions are also followed within certain groups. Portraits of Flavian women seem far more elaborate than male portraits, and they pursue their own independant course of development. Another convention is found on Antonine *sarcophagi*. Men are depicted in traditional roles such as moral philosophers, while women are depicted in roles associated with the values of the Republican *matrona*.

Finally, a citizen could receive deification[16]. In the case of Hadrian's lover, Antinous, this was based on the belief that those who drowned in the river Nile would become gods. Deification of citizens was a rather wide-spread phenomenon, and it flourished especially from the Flavian through the Hadrianic period on funerary monuments. The citizen may be portrayed in the guise of a god or may carry his attributes, and inscriptions on tomb-

12. HÖLSCHER, T., *Die Anfänge Römischer Repräsentationskunst*, in *RömMitt*, 85, 1978, p. 315-357.

13. For the function and influence of these *imagines* see LAHUSEN, G., *Zur Funktion und Rezeption des Römischen Ahnenbildes*, in *RömMitt*, 92, 1985, p. 261-289.

14. BONANNO, A., *Imperial and Private Portraiture : a Case of Non-Dependance*, in *Ritratto Ufficiale e Ritratto Privato, Atti della II Conferenza Internazionale sul Ritratto Romano*, Rome, 1984, p. 157.

15. ZANKER, P., *loc. cit.*, p. 304.

16. WREDE, H., *Consecratio in Formam Deorum*, Mainz, 1981.

stones make references to deification. Especially favored are divinizations of children. For boys popular divinities are Amor, Herakliskos and Mercurius, and for girls they are Diana, Luna, Psyche or the Muses. Even during his life a citizen may be divinized as statues in baths, in theaters, and in temples attest. Because of his association with a god or virtue, the emperor was considered to be charismatic, while the citizen's deification revealed something about his character but did not claim to be in possession of intrinsic powers of the particular god.

Techniques

Roman portraits are found in almost all the available materials of the time and involved the use of numerous techniques. Among the media that were especially favored are two of which a relativery small number of examples survived. Painted portraits were believed to render likenesses better than any medium, and were painted mostly on wooden panels, which disintegrated except for those found in the desert of Egypt. Bronze portraits, the gilded appearance of which made them a favorite for public and honorific statuary, were mostly melted down. In this exhibition, coins, semiprecious stones and sculpture are predominant and their basic techniques are discussed here.

Coins and Cameos

Coins and cameos share some important characteristics, most notably the high degree of engraving skills required and the tools and methods used[17]. Written documentation for these techniques is scarce, and in the absence of such texts, analysis rests upon visual examination of the objects themselves. From a coin a great deal can be learned about the materials, tools and techniques employed ; cameos often clearly show marks of the polishing burrs and incisive scalpers that the artist used. Contemporary images can also provide a valuable source of information. For example the famous *stele* in the British Museum shows a relief with tools used in minting coins. Another instance is the Republican denarius of c.45 BC with tools such as tongs on the reverse. The roots of engraving cameos and coins lie in Greece, and before that in Mesopotamia and Babylon. However, to this art the Romans bring innovations in efficient production, technique and eventually a character and function that is individual to them[18].

The first stage in the production of coins involves creating a flan, or blank metal disc, either stamped from a sheet or cast in an open mold. This flan is then placed between the two differently engraved dies, the lower fixed into an anvil, the upper held by hand or tongs. With the flan in place, the pressure of an anvil brought down upon the upper die is sufficient to make a doublesided impression simultaneously. The physical production of coins employed slave labor. It has been suggested that four men were required : one to placed the flan, another to hold the upper die, a third to wield the anvil and the last to remove the finished product. Incorrect obverse-reverse alignment, a common feature, is probably accounted for by the speed of production and would suggest that the dies were positioned by visual judgement. Hinged upper and lower dies would result in greater accuracy. Flans were predominantly made of gold, silver or copper, in varying degrees of purity.

Gold is generally the most consistently pure metal employed in coinage-sometimes with purity levels as high as 98 % from the Republic through Constantine ; although this figure drops to 50 % in a number of Septimius Severus's issues, and as low as 2 % under Gallienus. The debasement of costlier metals with lesser ones is a recurrent theme throughout Roman numismatic history. Such action is not necessarily the result of economic motives but can also reflect aspects such as casting and cost efficiency in production. Less valuable metals that were more abundant and had a greater circulation are more often debased. In the case of copper, increasing the proportion of zinc in the *orichalcum* mixture was likely to increase durability. A side effect of these admixtures was the gradual acceptance of a coin's face value rather than inherent metallic worth. The prevalence of *serrati* indicative of a possible provincial concern for purity and authenticity.

The most time-consuming and skilled process in the production of a coin was the engraving of the dies. The majority seem to have been made of a high tin bronze, their rarity attributable to either decomposition over time or having been melted

17. On minting, see SELLWOOD, D., in D. STRONG and D. BROWN (eds.), *Roman Crafts*, London, 1976, p. 63-73.

18. RICHTER, G. M. A., *Catalogue of Engraved Gems, Greek, Etruscan and Romans in the Metropolitan Museum of Art*, New York, 1956.

down at the end of an issue and subsequently re-used. The dies had to be massive enough to withstand considerable pressure and there is some evidence that iron caps were placed over the upper die to prevent cracking. The die itself was cast in a rod with one end rounded and the other blunt. Into the latter the design would be incised with an increasingly fine range of steel or diamond-tipped scorpers as the design required more detail. It is debated whether or not a magnifying glass was used in this process. The broad areas were probably gouged out with a bow-powered drill and the fine details, such as lettering and facial features, cut by hand.

Die engraving techniques have in part been deduced from cameos and gems. The materials involved range from precious stones to glass. Once again the bow-drill was employed with a variety of attachements including a polishing burr. To facilitate the tools' cutting action the engravers may have applied abrasive paste to heighten the action of the bit. Close similarities in the technical production of coin dies and cameos have led scholars to suggest that the same artist could be responsible for work in both media although there is no documentary evidence to either support or refute this.

Sculpture

As in the case of coins, no written accounts of the Romans' sculpting techniques remain. The processes involved have been deduced through studies of the objects themselves and excavations of ancient quarries and workshops[19].

The *marmorarius*, the stone craftsman, worked with a variety of materials that were quarried throughout the Empire, although marble was not as readily available in the western colonies. Due to the high costs of transportation, workshops were often set up near the quarries. Marble for export was first shaped as much as possible to help reduce transport costs.

The sculptor's principal tools, typically made from iron or low-grade steel, were the punch, points, the drill, and flat and claw chisels (Fig. 1)[20].

19. On marble sculpture, see STRONG, D., and CLARIDGE, A., in D. STRONG and D. BROWN (eds), *Roman Crafts*, London, 1976, p. 195-207.
20. *Sculpting tools* and *Pointing Machine (fig. 2)* were adapted after illustrations in D. STRONG and D. BROWN, ed., *op. cit.*, and in R. WITTKOWER, *Sculpture : Processes and Principles*, New York, 1977.

The sculptor would rough out the forms using punches and heavy points. The initial modelling and smoothing of the surface was done with the claw chisel, saving the flat chisel for more precise modelling. Details of the hair and the eyes, and textural effects were created with fine points and the corners of flat chisels. Rasps and abrasives were then used to finish the surface and enhance the qualities of the marble. How harder stones like granite and porphyries were finished is still debated. The drill was employed throughout this process. It was favored for such diverse tasks as facilitating the initial definition of the form, and creating dramatic decorative effects. The drill was also valued for its effectiveness in undercutting statuary drapery and for parts of relief sculpture.

When a figure was too large or too complex, its projecting elements would be carved separately and then attached. Typically, the head and neck were set into a rounded socket in the body while other protruding elements were joined with clamps, or were fitted onto short rods of stone or metal sunk into the principal form with lead or mortar. The union of distinct materials within a single figure was also done for cosmetic reasons stemming, from an interest in polychrome effects. Occasionally a complete form would be carved from a colored stone ; more likely,

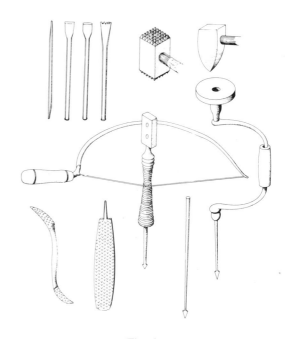

Fig. 1.

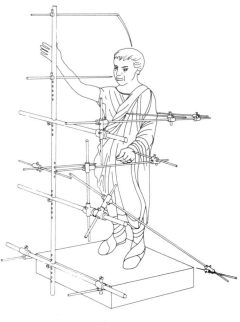

Fig. 2a.

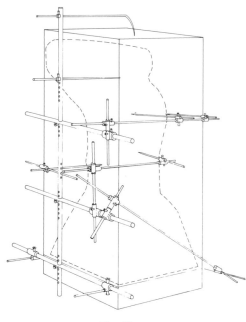

Fig. 2b.

however, specific components of a statue or relief sculpture — particularly facial elements and ornamental details would be painted, gilded or made from inlaid colored stone, gems or glass.

By the end of the first century BC, stone cutters are assumed to have begun to work from plaster or clay models. Evidence from unfinished sculptures indicate that the Romans used some form of a pointing machine (Fig. 2) with which they could transfer key points of projection or degrees of relief from the model onto their block of stone. A drill was then used on the marked marble to cut down to the desired depth. For bronze two casting methods were employed : lostwax casting which was used for small-scale objects that were less than six to nine feet tall, and hollow casting which was favored for bulkier objects that needed to be copied or mass-produced.

In lost-wax casting, a wax model of the finished object would be made and then thinly coated with a clay and sans mixture. Leaving some holes in the outer shell, the wax could then be melted out and molten metal poured in. Once the metal had cooled, the mold would be broken and the object removed. Its surface could then be smoothed with a chisel, fils or burin and polished. Detailing of the hair and eyes might be carved in and, as with marble sculpture, polychrome effects might be created through the application of paint or varnisch and the inlaying of other metals, glass or enamel.

In hollow casting, a fine-grad clay model of the general form of the object was made to within an eighth of the intended size. A layer of wax was formed on top of this, incorporating all of the desired details, and this in turn would be coated with a clay and sand mixture. In order to maintain the spacing between the inner and outer clay forms, supports be pushed through the outer layers to the inner core during the next stages of melting out the wax and pouring in the molten metal. When the molten metal was added, these supports would be incorporated into the form. Figures up to three feet tall could be cast whole ; larger figures needed to be cast in parts that would then be riveted or, more commonly, welded together. The procedure for the multi-part casting involved a composite mold that would be created over the original model so that it couls be removed in tact. Once formed and reassembled, the new outer mold would be lined with wax and then filled with a clay and sand mixture to form an inner core. The pieced outer mold could then be removed and a new solid outer shell created over the wax-covered core, enabling casting to be completed as above. The original form could then be reused for future castings.

CHRONOLOGY AND STYLE

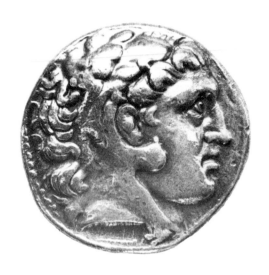
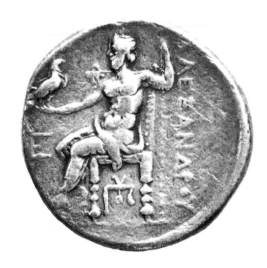

1. Portrait of Alexander the Great

AR Tetradrachm - Posthumous

Obv. Head of Alexander, wearing lion's skin, r.

Rev. [ΒΑΣΙΛΕΩΣ]/ΑΛΕΞΑΝΔΡΟΥ Monograms in the field and under the throne Zeus seated l., holding an eagle in l. hand and a spectre in r.

Cm. 2.7 - Gr. 17.5

Courtesy of The Museu Paulista, Universidade de São Paulo

Bibliography : Compare with A. BRETT, *Catalogue of Greek Coins*, Boston, 1955, p. 88, n° 664.

The tetradrachm, minted after Alexander's death sheds light on the ruler's legendary nature. Alexander here is represented in the guise of Heracles for he wears the trophy of the Nemean lion over his head. The appearance of Heracles on Macedonian coins had been common before Alexander's time because the kings of the region claimed descent from him[1]. Unlike these earlier examples, however, the coin in question does not merely show an image of the mythological hero, but shows him with the features of Alexander[2].

Alexander's Heraclean portraits show a deliberate conflation of the identities of the Macedonian King and the demi-god. The purpose of this fusion was to emphasize Alexander's divine attributes and his relation to his mythical ancestor, Heracles[3].

Not surprisingly, many of the emperors of Rome in accordance with their own selfaggrandizing programs had themselves represented as Heracles. The bust of Commodus in the Palazzo dei Conservatori, which shows the Emperor cloaked in a lion's skin and brandishing a club, is the best known of these images[4].

GW

1. BIEBER, M., *Alexander the Great in Greek and Roman Art*, Chicago, 1964, p. 47.
2. National Gallery of Art, *The Search for Alexander*, New York, 1981, p. 112, n° 27 ; for a consideration of the Alexander-Heracles fusion in sculpture, see SJÖQVIST, E., *Alexander-Heracles : A Preliminary Note*, in *Bulletin of the Museum of Fine Arts*, 5, June 1953, p. 30-33.
3. HÖLSCHER, T., *Ideal und Wirklichkeit in den Bildnissen Alexanders des Grossen*, in *Abhandlungen der Heidelberger Akademie der Wissenschaften, Philosophisch-historische Klasse*, 1971, 2, has demonstrated that the physiognomies of Alexander and Heracles in sculpture and coins were consciously manipulated to resemble one another (p. 47). Alexander, in addition to having blood ties with Heracles, was thought to be related to Helios, the Dioscuri and Achilles.
4. For a discussion of the identification of Commodus with Heracles, see GROSS, W., *Herakliskos Commodus*, in *Nachrichten der Akademie der Wissenschaften in Göttingen, I. Philologisch-historische Klasse*, 1973, n° 4.

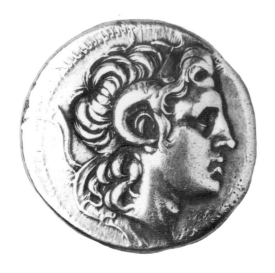

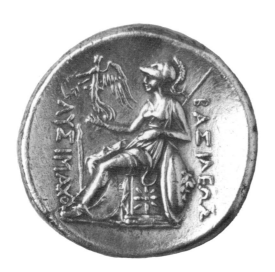

2. Portrait of Alexander the Great

AR Tetradrachm - 297/6-282/1 BC
Obv. Head of Alexander with the ram's horn of Zeus Ammon, r.
Rev. ΛΥΣΙΜΑΧΟΥ - ΒΑΣΙΛΕΩΣ Athena seated on throne, l. arm placed on shield, r. hand holding a Nike. Cm. 2.8 - Gr. 16.8
Courtesy of The Museu Historico Nacional, Rio de Janeiro
Bibliography : Margareth THOMPSON, *The Mints of Lysimachus*, in *Essays Presented to Stanley Robinson*, Oxford, 1968, p. 171, no. 43, pl. 17.

After Alexander's death in 323 BC, his successors, the diadochi, minted coins which depict the late monarch as deified ruler[1]. This tetradrachm, struck c. 297/6-282/1 BC at the mint of Lampsacus under Lysimachus, King of Thrace, is an example of this phenomenon.

In this portrait, Alexander's likeness approximates that of Zeus Ammon for it combines the tousled locks of Zeus and the zoomorphic attribute of the ram's horn of his Egyptian counterpart, Ammon[2]. The portrait's similarity to images of the composite deity is meant to convey Alexander's divine role as the off-spring of the graeco-Egyptian god. The Macedonian conqueror's association with the god dates to 332 BC, when he visited the deity's oracle at the Temple of Siwa, whereupon the priests proclaimed him the Son of Ammon on the site[3].

Significantly, the representation of Alexander as divinely-inspired leader would in time become a prototype for later Hellenistic and Roman rulers who wished to associate themselves with Alexander and to claim divine status[4].

GW

1. BIEBER, M., *Alexander the Great in Greek and Roman Art*, Chicago, 1964, p. 52-53.
2. National Gallery of Art, *The Search for Alexander*, New York, 1981, p. 107, n° 17.
3. *The Oxford Classical Dictionary*, Oxford, 1970², p. 43 ; BALDSON, J., *Die Göttlichkeit Alexanders*, in *Römischer Kaiserkult*, WLOSOK, A., ed., Darmstadt, 1978, p. 266-267.
4. See on this topic, MICHEL, D., *Alexander als Vorbild für Pompeius, Caesar und Marcus Antonius*, Brussels, 1967 ; L'ORANGE, H.P., *Apotheosis in Ancient Portraiture*, Oslo, 1947.

3. Portrait of Ptolemy I Soter

AR Tetradrachm - 144/3 BC Paphos Mint under Ptolemy VIII.

Obv. Head of Ptolemy I Soter, r.

Rev. ΠΤΟΛΕΜΑΙΟΥ - ΒΑΣΙΛΕΩΣ / ΠΑ-LKI Eagle standing on a thunderbolt.

Cm. 2.6 - Gr. 14.4

Courtesy of The Museu Paulista, Universidade de Sâo Paulo

Bibliography : J.N. SVORONOS, Τά νομίσματα τοῦ κράτους τῶν Πτολεμαίων, Athens, 1904, pl. 52, no. 2 ; O. MØRKHOLM and I. NICOLAOU, *A Ptolemaic Coin Hoard* (*Paphos*, I), Nicosia, 1976, p. 104 and pl. XIV.

The coin bears the portrait of Ptolemy I, who had been one of Alexander's generals, before becoming the King of Egypt in 304 and conqueror of Cyprus, Palestine and much of the Aegean World. Although there is a degree of realism apparent in the portrait — most notably in the King's jutting chin, deep-sunken eyes and bulging forehead — there is also a continuation of the idealizing tendencies that characterize the portraiture of Ptolemy's predecessor, Alexander the Great.

For example, the flowing locks which spill down to the nape of the neck, the *anastole*, or upwardly turned tuft of hair and the ruler's subtly rendered heavenward gaze carry on some of the traits of the deified Alexander portrait and are meant to endow the King of Egypt with celestial inspiration[1]. The importance of the portrait at hand is its application of Alexander's iconography of rulership to another individual. This Hellenistic portrait type, which stresses the ruler's divinity, would to a large extent be adopted by Rome for the representation of her Emperors.

GW

1. See L'ORANGE, H.P., *Apotheosis in Ancient Portraiture*, Oslo, 1947, especially p. 39-47 for a discussion of the divine attributes seen in the portraiture of Hellenistic kings derived from Alexander's images.

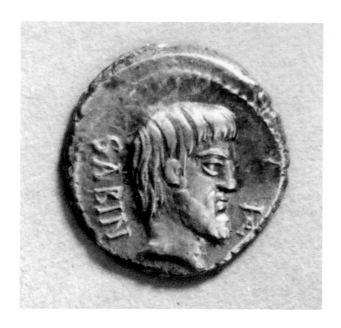 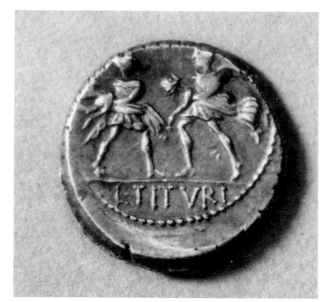

4. Tatius

AR Denarius - 88 BC

Obv. SABIN on l., Ā (Tatius) on r., Tatius facing r., bearded.

Rev. L. TITVRI in exergue. Two soldiers facing each other, each carrying a Sabine woman.

Cm. 1.88 - Gr. 4.0

Brown University, Harkness Collection

Bibliography : BMCRep. I, n° 2322 ; Syd., n° 698 ; Crawford 344.1a.

In Republican times, the right to produce and control coinage belonged to the Senate. Generally, coinage was controlled by a magistracy of three moneyers-Triumviri Monetales appointed annually, and usually young men just entering into public careers[1].

L. Titurius Sabinus, the moneyer of this coin, issued coinage under Sulla, in the period during the Social and Civil Wars, c. 91-71 BC[2]. During this period, the popular obverse type of Roma is issued less frequently, and various obverse and reverse types are now struck[3]. Like many first century BC coins, Titurius's bear his name, but these are usually not dated and rarely refer to contemporary events. In keeping with other contemporary moneyers, Titurius strikes denarii with several personal reverse types. Some have mintmarks, symbols, numbers or letters, and most refer to the surname of his family, the rape of the Sabines, and the death of Tarpeia[4]. It

seems Titurius traced his descent from the Sabines, and perhaps, from King Tatius himself, whose portrait is on the observe. The monogram Ā, besides referring to Tatius, may also symbolize *tribunus aerarius*, or Titurius as paymaster of the soldiers[5].

Mommsen identified this moneyer as the Titurius who fought under Q. Caecilius Metellus Pius in Spain against Sertorius, and as the father of Q. Titurius Sabinus, who fought under Julius Caesar in the war against the Gauls (57-54 BC)[6].

EDG

1. Syd., p. xlviii.
2. *Ibid.*, p. 95.
3. MATTINGLY, H., *A Guide to Republican and Imperial Roman Coins in the British Museum*, Chicago, 1927, p. 20.
4. BMCRep. I, p. 297.
5. Syd., p. 108.
6. BMCRep. I, p. 297.

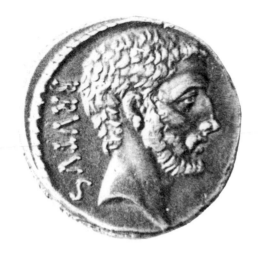 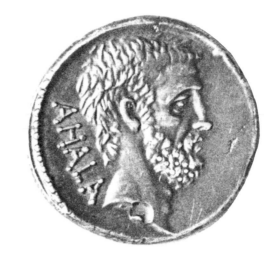

5. Brutus

AR Denarius - c. 55 BC
Obv. BRVTVS Head of Lucius Junius Brutus to r.
Rev. AHALA Head of Servilius Ahala to r.
Cm. 1.8 - Gr. 3.9
Courtesy of The Museu Paulista, Universidade de São Paulo
Bibliography : BMCRep. 1, n° 3864 ; Crawford 433/2.

The customary Republican device of employing ancestor's images to display family achievements appears in both obverse and reverse portraits. M. Junius Brutus, the moneyer, is foremost remembered for his part in the assassination of Julius Caesar. Brutus later conspired with Cassius : in 42 BC, Octavian and Antony defeated them at the battle of Philippi, and Brutus committed suicide a year later. The obverse illustrates L. Junius Brutus, appointed first Consul of the Republic after expelling the Tarquins from Rome in 509 BC. The reverse depicts Servilius Ahala, who protected Rome from a traitor in 439 BC[1]. The busts are rendered with attention to individual features ; nonetheless, traces of Greek prototypes appear in the outlines of the noses, and in the beards. The iconography, then, promotes Brutus's Republican views at the same time that it reflects contemporary portrait-styles.

JS

1. BMCRep I, p. 480.

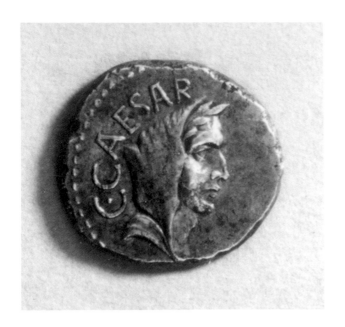
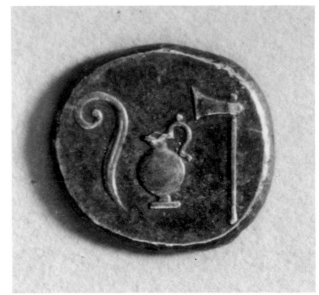

6. Caesar

AR Denarius - 17th-18th Centuries
Obv. C. CAESAR Female veiled and laureate head, to r.
Rev. Sacrificial implements : lituus, jug with handle, axe.
Cm. 1.7 - Gr. 4.1
Brown University, Thompson Collection
Bibliography : M.V. BAHRFELDT, *Die Römische Gold-münzenprägung*, Halle, 1923, p. 37 ; Crawford, 466/1.

Experts believe that this coin is a modern forgery[1] probably fabricated during the 17th or 18th centuries[2]. The problematic nature of the coin became apparent, when it was not found in any of the known numismatic catalogues. The closest corresponding coins were the gold aurei in the British Museum[3], which have the exact same observe and reverse types and which are known forgeries by now[4].

Most likely this issue of modern forgery including gold and silver coins, was done imitating the aureus of Aulus Hirtius struck in 46 BC in honor of J. Caesar. The aureus's obverse shows a veiled female head to the left, while the legend reads, C. CAESAR COS TER. The reverse depicts sacrificial implements and the legend A HIRTIVS PR.[5]. The Hirtius's aurei were struck before 44 BC, when the first portraits of Caesar began to appear, and the series exhibits a variety of qualities. The variety omitting the COS TER has been proven false and of modern origin[6].

It is interesting to note how a forged piece of art can manipulate te public's perception and understanding of history. If this denarius of the Thompson Collection were genuine, it could change the whole dating of Caesar's coinage. However, it is not even close to 45-44 BC, but rather come from a period of almost two thousand years later.

EG

1. Information in letters to the author, from ARNOLD-BIUCCHI, HERSH, C.A. and BUTTREY, T.V.
2. HERSH, C.A., in a letter to the author, October 10, 1988.
3. GRUEBER, H.A., *Coins of the Roman Republic in the British Museum*, London, 1910, p. 527.
4. BAHRFELDT, M.V., *Die Römische Goldmünzenprägung*, Halle, 1923, p. 37.
5. CRAWFORD, n° 466/1.
6. BUTTREY, T.V., in a letter to the author, October 10, 1988. See also GRUEBER, the aurei discussed in p. 527 lack the COS TER in their obverse legend.

7. Julius Caesar

AR Denarius - c. 44 BC
Obv. CAESAR. IMP Head of Caesar, r., laureate, star
with eight rays on l. field.
Rev. P. SEPVLLIVS - MACER Venus Victrix standing l.,
victory in r. hand, leaning on sceptre in l. hand.
Cm. 1.9 - Gr. 3.9
Courtesy of The Museu Paulista, Universidade de São
Paulo
Bibliography : BMCRep. I, n° 4167 ; Syd., n° 1071 ;
Crawford 480/5a.

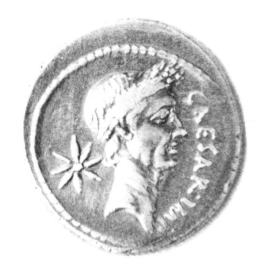

The observe portrays Julius Caesar, an image
many scholars believe to be a portrait of a living
man. In 44 BC, the Senate voted to allow portrait
coins of Caesar to be struck, and there is general
agreement that this was decided while Caesar was still
alive[1]. Sydenham, however, believes that the coins
were in fact not issued until after Caesar's death in
March of 44 BC, although he would have personally
sanctioned the idea before his assassination[2].

The reverse image is also an important innovation
in the development of coin types. The legend
records the name of the moneyer as was customary,
but instead of a traditional image of a god or
hero worshipped by the Roman people, the figure
depicted is Venus Victrix, Caesar's protectoress[3].
This figure alludes to his victories in Spain and
Gaul, as well as his descent from Venus, through
Aeneas and his son Iulus[4].

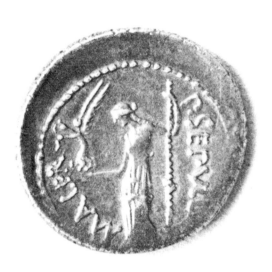

LLA

1. BIEBER, M., *The Development of Portraiture on Roman
 Republican Coins*, in *ANRW*, I, p. 881 ; HANNESTAD, N.,
 Roman Art and Imperial Policy, p. 28 ; SUTHERLAND,
 C.H.V., *The Emperor and the Coinage*, p. 10.
2. Syd. I, p. xxviii.
3. BIEBER, p. 881.
4. *Ibid.*, p. 881.

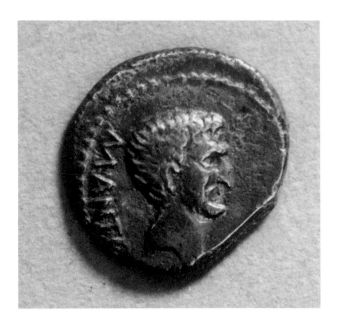 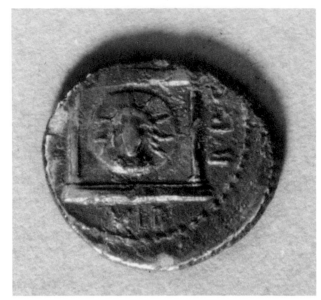

8. Marcus Antonius

AR Denarius - 40 BC
Obv. M. ANTONI IMP Head of M. Antonius r.
Rev. III - VIR - R P C Sol within a temple.
Cm. 1.5 - Gr. 3.2
Brown University, Harkness Collection
Bibliography : BMCRep. II, n° 398 ; Syd., n° 1168 ; Crawford 496/1.

Although the portrait-bearing coins of Julius Caesar were probably not issued until just before or after his death, it is likely that he sanctioned such practices, although this is a matter of the greatest debate in numismatic scholarship. Early Caesar coins, minted during his lifetime, although avoiding direct portraiture, do however, make overt reference to Caesar, for example the unusual elephant issue which alludes to the family name. In coins of this date the strictly Republican type of portraiture — for example the veristic busts of private citizens — gradually began to be replaced by an emphasis on imperialistic or personal qualities, of which this coin is an example. The IMP on the observe legend makes reference to the second triumvirate between M. Anthony, Octavian and Lepidus of 40 BC in which the Empire was divided, with the Eastern provinces falling under M. Anthony's command. The presence of Sol[1], one of the most important Egyptian deities, on the reverse, may be accounted for by M. Antony's infatuation with Cleopatra, whom he had married, thus committing bigamy, several years before. The notch on the edge of the coin was taken as a proof a purity, and the coin itself was inaccurately struck : the image was incorrectly positioned between the dies.

JWH

1. A symbol of eternity derived from the powerful Osiris.

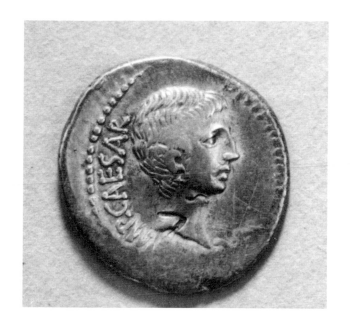
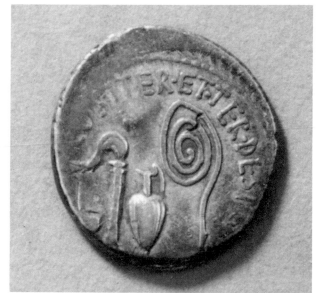

9. Octavian

AR Denarius - c. 37 BC
Obv. IMP. CAESAR. DIVI. F. III. VIR. ITER. R. P. C.
Head of Octavian r., bare-headed with beard, border of dots.
Rev. COS. ITER. ET. TER. DESIG. Religious ceremonial tools : simpulum, aspergillum, capis and lituus, border of dots.
Cm. 1.8 - Gr. 3.9
Brown University, Harkness Collection
Bibliography : Syd., n° 1334 ; Crawford 538.

Numismatic portraits of Octavian from c. 42-36 BC, while showing some regional variations, are characterized by a youthful visage, sharp, thin features and full hair cut straight across his forehead[1]. Stylistically, this portrait is closer to the Republican characterizations than perfected, classicizing images ; however, Octavian's obvious youth would have forcibly distinguished his image from those of the older men typically portrayed in the Republican fashion.

A consideration of the legends and reverse types reveals Octavian's ambivalence toward strictly adhering to Republican traditions[2]. Octavian's participation in the established Republican mode of governing is indicated by the reverse's allusions to his terms as consul and to his election as an augur and pontif. Nevertheless, Octavian's monarchical aspirations may be discerned. While the observe legend refers to the continuation of his triumvirate with Marcus Antonius and Marcus Lepidus, Octavian also calls himself the son of the deified Julius Caesar and has positioned the imperator title as a regal praenomen. Thus, Octavian was going beyond Republican traditions in seeking to justify his right to claim the powers necessary to establish the Roman Empire.

KLB

1. This has been classified by Otto Brendel as Augustus's « Type B » portrait style. See V. Poulsen's discussion of these portrait types in *Les Portraits Romains*, I, Copenhagen, 1962, p. 21-30.
2. See GROSS, W.H., *Ways and Roundabout Ways in the Propaganda of an Unpopular Ideology*, in *The Age of Augustus*, ed. by R. WINKES, Providence, 1985, p. 29-35, for Gross's argument that Octavian was, at this time, trying to associate himself with Republican practices.

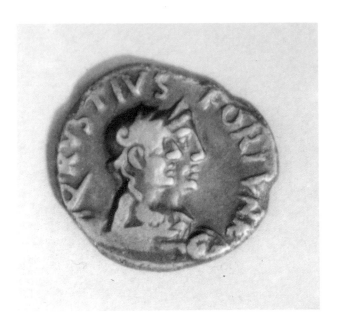

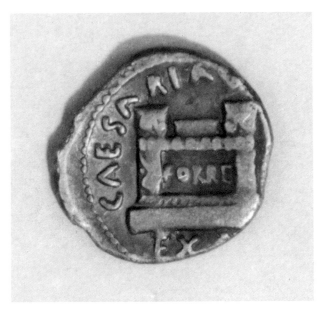

10. Q. Rustius

AR Denarius - c. 19 BC

Obv. FORTVNAE ANTIAT Q. RVSTIVS. Fortuna Victrix, helmeted, and Fortuna Felix, with diadem, a patera between them, busts set on a base terminating in ram's heads.

Rev. CAESARI AVGVSTO. FOR RE in ornate altar, below, EX. SC.

Cm. 1.8 - Gr. 3.2

Brown University, Bishop Collection

Bibliography : BMCRep II, n° 4580.

While the obverse of this denarius contains no portrait, it relates directly to Republican coin portraits ; for example, the position of the two busts of Fortuna is the same as that of the jugate portraits of Antony and Octavia on a silver cistophorus of 39 BC[1]. In late Republican coinage, virtues were sometimes precursors to portraits. Sometimes the features of an individual such as Caesar would appear in the face of a personification[2]. Although the faces of the Fortunae on this coin have not been identified with any specific person, the smooth idealized features are similar to those of female portraits on coins during the period.

Often the choice of images would reflect in interests or personal history of a particular person[3]. Neither Augustus, whose name is on the reverse, nor Q. Rustius, the moneyer whose name is on the observe, appear on the denarius ; yet, in symbolic form, the coin would have relayed a specific message about each man. Rustius incorporates into the design a ram's head, which refers to the coins minted by his grandfather, also a moneyer[4]. The images on this coin mainly allude to Augustus. Fortuna was intimately associated with the Emperor in literature and history. In a famous ode, Horace entrusts Augustus to Fortuna[5]. The temple of Fortuna at Antium, mentioned in the observe legend, was often visited by the Emperor. The altar on the reverse represents that erected to Augustus on his return from the East in 19 BC. The inscription Ex SC on the reverse conveyed that the altar had been set up by the Senate.

DCS

1. Kent, n° 110.
2. Alföldi, A., *The Main Aspects of Political Propaganda on the Coinage of the Roman Republic*, in *ERC*, p. 78-90.
3. *Ibid.*, p. 78.
4. BMCRep II, p. 77.
5. I.35.

11. Augustus

AE As - 7 BC
Obv. CAESAR. AVGVST. PONT. MAX. TRIBVNIC.
POT. Bare head of Augustus, l.
Rev. M. SALVIVS OTHO III VIR AAA FF S.C center.
Cm. 2.4 - Gr. 11.6
Brown University, Harkness Collection
Bibliography : RIC I, p. 75, n° 432 ; Giard, n° 704.

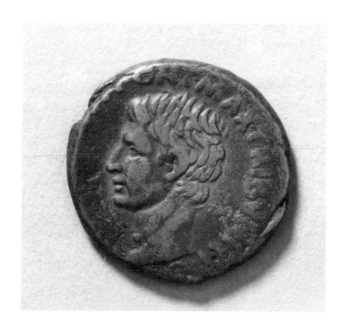

One example which indicates the immediate impact throughout the empire of Augustus's power, consolidated after the Battle of Actium in 31 BC, was an oath, sworn by lamplighters from Oxyrhynchus in Egypt, which identified 30-29 BC as the first year of Caesar. The pledge taken by four temple lamp-lighters, two of whom were illiterate, in a small, provincial town, within a year of conquest, recognized Augustus as supreme leader[1]. Public displays of homage to Augustus represent not necessarily sincere expressions, but certainly « words felt to be publicly appropriate »[2], and, as such, ideas about the location of power during his reign.

In 27 BC, Augustus offered to lay down his powers, officially only those of the *imperium proconsolare* and the *tribunicia potestas*[3]. In response, the Senate awarded him highest honors : granting him the name of Augustus, displaying celebratory laurel trees and bestowing the *corona civica*[4]. Despite this vote of confidence, in monuments and in his autobiography, the *Res Gestae*, Augustus constantly employed imagery to defend his own *virtus, iustitia, clementia* and *pietas*[5].

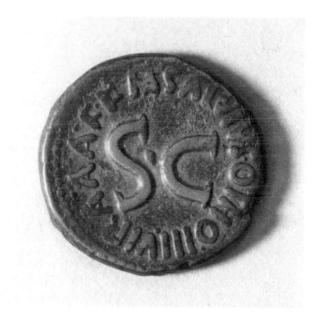

If Augustus was lauded as Victor and Restorer of Peace, then why was projecting a positive self-image important ? Augustan imagery, in part, was a reaction to the « inherently ambiguous »[6] role of establishing a monarchy while appeasing continuing, strong, Republican values[7]. Augustus had to be an astute creator of « acceptable myths »[8] for a not

always friendly populace. As is evident on the obverse of this coin, he officially retained only Republican titles, investing himself with power without the objectionable title « king »[9].

In 19 BC, Augustus established these *tresviri monetales*. The name and titles of M. Salvius Otho, moneyer in 7 BC, appears on the reverse of this as[10].

1. MILLAR, F., *State and Subject : The Impact of Monarchy*, in *Caesar Augustus*, MILLAR, F. and SEGAL, E., eds., Oxford, 1984, p. 38-39.
2. *Ibid.*.
3. REINHOLD, M., *The Golden Age of Augustus*, Toronto, 1978, p. 14-15.
4. MILLAR, p. 45-46 ; SUTHERLAND, C.H.V., *Roman History and Coinage 44 BC - AD 69*, Oxford, 1987, p. 3-38.
5. YAVETZ, Z., *The Res Gestae and Augustus's Public Image*, in *Caesar Augustus*, MILLAR, F., and SEGAL, E., eds., Oxford, 1984, p. 2-7.
6. MILLAR, p. 40.
7. YAVETZ, p. 2-7.
8. REINHOLD, p. x.

9. DIO CASSIUS, *History of Rome* LIII, 17-18.
10. SUTHERLAND, p. 3-38 ; RIC I (new edition), p. 20-24 ; GRANT, SMACA, p. xiv and 3-63 ; RIC I, p. 79.

Augustus granted nominal control of the Aes coinages to the Senate (hence the SC on this coin's reverse), while in actuality he oversaw the appointment of moneyers and gained enormous power over finances[11].

While Augustus sought to suggest Republican sentiment, he also used the coinage to strengthen his

11. SUTHERLAND, p. 3-38 ; RIC I (new edition), p. 20-24 ; GRANT, SMACA, p. xiv and 3-63 ; RIC I, p. 79.

claims to absolute rule. His portrait, of itself, proposes an ideal of rulership. The incised locks of hair, smooth flesh and upward gaze of the portrait on this as are reminiscent of those of Alexander[12].

DCS

12. GROSS, W.H., *Ways and Roundabout Ways in the Propaganda of an Unpopular Ideology*, in *The Age of Augustus*, ed. by R. WINKES, Providence, 1985, p. 36-37.

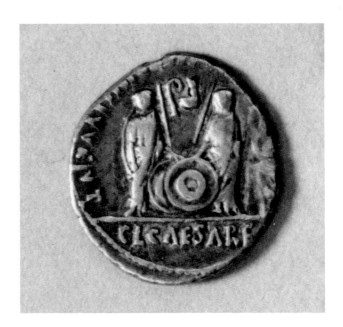

12. Augustus

AR Denarius - 2 BC
Obv. CAESAR AVGVSTVS - DIVI F PATER PATRIAE Head of Augustus, r., laureate.
Rev. C L CAESARES in exergue AVGVSTI F COS DESIG PRINC IVVENT Gaius and Lucius Caesar, togate and veiled, standing frontally with overlapping shields and crossed spears at center. In the field above, a simpulum and lituus.
Cm. 1.9 - Gr. 3.8
Brown University, Harkness Collection
Bibliography : RIC I, n° 207 ; Giard, n° 1651.
See also no. **48**.

One finds Augustus wearing the laurel wreath in his Roman coin portraits only in the last decade of the first century BC, although he had been in full command of the Empire since 27 BC. He was responsible for vast political reforms, imperial expansion, and long-lasting peace. However, Augustus cautiously waited for twenty-five years before he used the laurel wreath as an attribute, due to its

negative connotation for Romans[1]. Already designated as *princeps senatus* and Augustus, he was hailed as *pater patriae* by the senate in 2 BC[2]. His image appears here in the manner of the fully developed Augustan classical style. The delicately modelled features, with straight, flawless nose, are reminiscent of contemporary cameos of Apollo, his tutelary god for many years[3]. Not only is laurel sacred to Apollo, but also the elegance and restraint that characterize Augustan classicism are commensurate with the character of the god himself.

JT

1. GROSS, W.H., *Ways and Roundabout Ways in the Propaganda of an Unpopular Ideology*, in *The Age of Augustus*, ed. Rolf Winkes, Providence, 1985, p. 29, « the wreath...elevated the portrayed person above normal mortals ». In 27 BC the senate had decreed that laurel, coveted symbol of victors, should be planted at the entrance of Augustus's house.
2. *Ibid.*, p. 37.
3. REINHOLD, M., *The Golden Age of Augustus*, Toronto, 1978, p. 14-15.

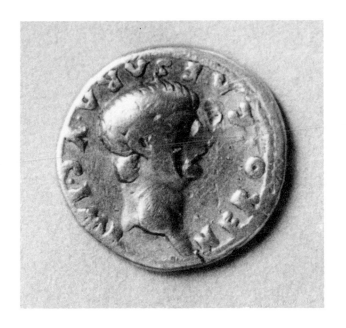

13. Nero

AV Aureus - AD 56-57
Obv. NERO. CAESAR AVG IMP Bare head of Nero r.
Rev. PONTIF MAX TR P III PP Oak wreath in center
enclosing EX SC
Cm. 1.9 - Gr. 7.4
Courtesy of The Museu Paulista, Universidade de São
Paulo
Bibliography : RIC I, n° 11 ; BMC I, n° 12.

From AD 55 to 60 with the influence of Agrippina replaced by that of Seneca and Burrus, only a single type was used on the gold and silver coins of Nero[1]. In general, Nero appears bareheaded with a simple legend and the *Corona Civica* on the reverse together with the formula EX S C. This legend appears consistently in Nero's aurei from 54 to 63, and probably denotes that the coins were issued in respect of a Senatorial grant of gold and silver[2]. It may also be argued that EX S C alludes to the voting of the *Corona* to Nero as a result of a Senatorial decision (EX)[3].

Nero appears in his new portrait style introduced in AD 55 and designed to give him greater prominence. This portrait type bears the unmistakable facial traits of his adult life. Fleshy cheeks, neck and underchin are prominent features, as is the distinctive formation of the mouth, which recedes between the slight overhang of nose and rounded chin[4]. This style continues up to AD 59 and it is often rendered with exceptional detail and clarity[5].

EG

1. RIC I, 1984, p. 135.
2. RIC I, 1984, p. 10.
3. RIC I, 1984, p. 135.
4. HIESINGER, U.W., *The Portraits of Nero*, in *AJA*, 79, 1975, p. 114.
5. *Ibid.*, p. 114.

14. Vespasian

AR Denarius - AD 73
Obv. IMP. CAES VESP - AVG CENS Head of Vespasian, r., laureate.
Rev. PONTIF - MAXIM Vespasian seated r., togate, holding branch in extended l. hand and sceptre in r.
Cm. 1.9 - Gr. 3.0
Brown University, Harkness Collection
Bibliography : RIC II, n° 65.

Vespasian (AD 9-79) was proclaimed Emperor following the Civil Wars that had erupted after the death of Nero ; the armies first supported him in Alexandria, in 69, and finally in Rome, in 70, at the death of Vitellius. He died in AD 79, following a reasonably calm rule.

Vespasian assumed the role of Censor in AD 73, which dates this coin to that year. Added in the legend are the titles AVGVSTVS and CAESAR.

The office of Pontifex Maximus, represented on the reverse, was that of high priest in Rome. Julius Caesar was the first to attach this title to his other offices, and many of the emperors who followed him did the same. Vespasian is depicted seated in the traditional curule, with his feet on a low stool. The extended branch is a symbol of peace.

LLA

15. Domitian

AR Denarius - AD 77-78
Obv. CAESAR AVG F - DOMITIANVS Head of Domitian, laureate, bearded, r.
Rev. COS V The she-wolf feeding the twins, Romulus and Remus. Below, a boat in exergue.
Cm. 1.8 - Gr. 3.6
Brown University, Harkness Collection
Bibliography : BMC II, n° 241.

This coin of Domitian was struck while he was still a Caesar, under the reign of his father Vespasian. Between the years AD 77-78, Domitian begun to take a fuller share in the general types of coin series[1]. He is portrayed as a true Flavian, with a heavy brow, a Roman nose and jutting chin ; all typical features in the representations of this Dynasty[2]. His features exhibit a heaviness and a thickness, but not to the extreme degree that these

1. RIC II, p. 1-3.
2. *Ibid.*, p. 1-10.

will reach later on in his future depictions. The she-wolf with the twins on the reverse, echoes the *Roma-Renascens* type of Titus[3].

EG

3. BMC II, p. xli.

16. Trajan

AR Denarius - c. AD 104-107
Obv. IMP TRAIANO AVG GER DAC PM TR P COS V PP Trajan facing r., laureate.
Rev. SPQR OPTIMO PRINCIPI Dacian in costume, seated r. on ground, before trophy. L. knee bent, head propped on l. hand, l. elbow on l. knee, r. hand across breast.
Cm. 1.7 - Gr. 2.9
Brown University, Harkness Collection
Bibliography : BMC III, n° 191 ; RIC II, n° 223.

Trajan's natural father was M. Ulpius Traianus, a Spaniard who was the first in the family to enter the Roman aristocracy[1]. Trajan, however, became Emperor because he was adopted by Nerva. Nerva chose Trajan to succeed him for many reasons. For example, he was well loved among the army and was strong, modest, generous and intelligent. Furthermore, Nerva chose Trajan as his heir to ensure the quality and attitude of the next *princeps*. This also held out hope to members of the aristocracy that they too could be adopted as *princeps*[2].

Trajan's coinage deviates from Nerva's in order to illustrate a new and better reign. Types that Nerva coined are replaced by more active and positive types, which correspond to events in Trajan's own reign. For example, his standardized SPQR OPTIMO PRINCIPI issue, which was struck to his glory and honor, illustrates his victory over the Dacians, a conquest which occurred between AD 101-102 and 105-106[3]. The Dacian depicted on the reverse of this coin is shown in mourning and sits beside the trophy that symbolizes Trajan's victory. The word *Optimus* in the reverse legend is not a legal title of Trajan's, but a descriptive one[4].

EDG

1. GARZETTI, A., *From Tiberius to the Antonines*, trans. J.R. Foster, London, 1960, p. 311.
2. *Ibid.*, p. 310.
3. RIC II, p. 238.
4. BMC III, p. lxxi.

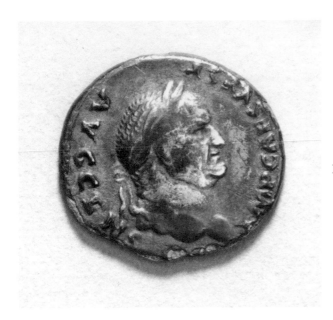

14

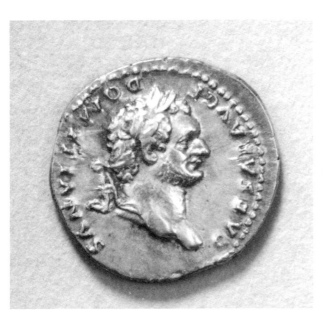 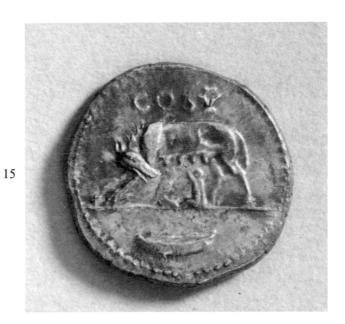

15

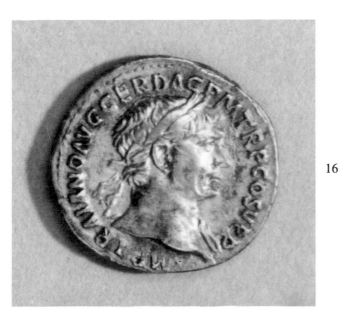 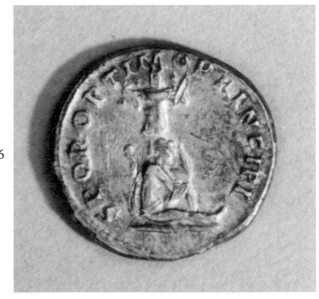

16

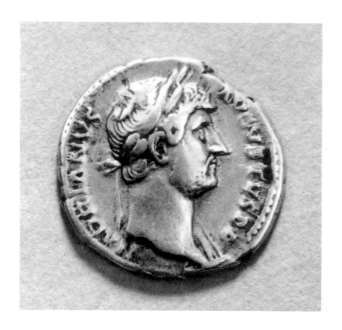
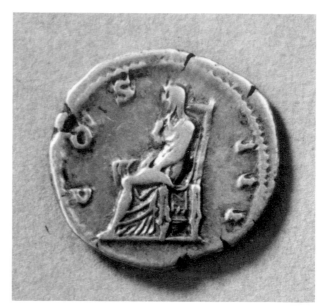

17. Hadrian

AR Denarius - AD 128-132
Obv. HADRIANVS - AVGVSTVS P.P Laureate head of Hadrian, r.
Rev. COS - III Pudicitia veiled seated l.
Cm. 1.7 - Gr. 3.2
Brown University, Bishop Collection.
Bibliography : RIC II, n° 343.

Hadrian was said to have been adopted as heir to the principate by Trajan on his deathbed in 117 AD. Doubts arose about the legitimacy of this adoption. Despite these doubts, Hadrian's leadership was soon well established in both foreign and domestic matters. He gave up the rebellious Eastern provinces, which had been created by Trajan, and affirmed Roman control over Dacia. Thus, he presented a firm and coherent provincial policy. The most serious disruption of peace during Hadrian's reign was the revolt of Judea, finally subdued after three years in AD 134. In Rome, when several senators, suspected of sedition, were executed, Hadrian put the blame on the praetorian prefect, Attianus ; yet, the Senate reacted with doubt and suspicion[1]. The Pantheon in an example from Hadrian's enormous building campaign in Rome[2].

Hadrian is famous for his remarkably extensive journeys around the Empire. Each city along the emperor's route made elaborate preparations, storing quantities of food, to host the imperial court, and Hadrian in turn performed administrative services, gave money, founded buildings, or attended to the Roman troops stationed in each place[3].

Hadrianic art is clearly oriented toward Greek art. Numismatic portraiture under Trajan had developed from a heavy, strong type to a depiction showing smoother, more ideal features and finer lines[4]. Hadrianic portraits show the use of deep incision, particularly in the rendering of hair, and smooth, even, sensuous handling of flesh[5].

DCS

1. GRANT, M., *The Roman Emperors*, New York, 1985, p. 76-66 ; SYME, R., *Hadrian and the Senate*, in *Athenaeum*, 62.1, 1984, p. 31-60.
2. BOATWRIGHT, M.T., *Hadrian and the City of Rome*, Princeton, 1987.
3. THORNTON, M.K., *Hadrian and his Reign*, in *ANRW*, 2.2, 1975, p. 439-443 ; SIJPESTEIJN, P.J., *A New Document Concerning Hadrian's Visit to Egypt*, in *Historia*, 18, 1969, p. 109-118 ; VAN GRONINGEN, B.A., *Preparatives to Hadrian's Visit to Egypt*, in *Studi in Onore di A. Calderini*, II, Milan, 1956, p. 253-256.
4. BMC II, p. lix.
5. TOYNBEE, *The Hadrianic School*, Cambridge, 1934 ; MARCONI, *Antinoo. Saggio sull'arte dell'età Adrianea*, in *Monumenti Antichi*, XXIX, 1923, p. 161-302.

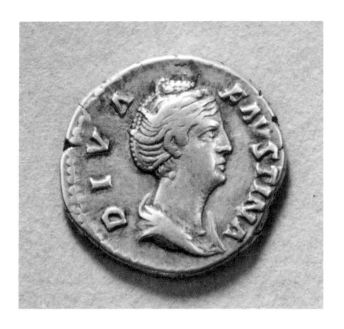 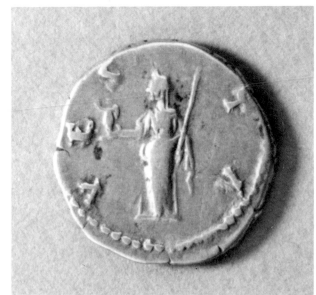

18. Faustina I

AR Denarius - c. AD 147
Obv. DIVA - FAVSTINA Bust r., draped, with hair elaborately waved and banded, drawn up at back and piled in coil on top.
Rev. VES - TA Vesta standing l., holding palladium r. and sceptre l.
Cm. 1.7 - Gr. 3.3
Brown University, Bishop Collection
Bibliography : BMC IV, n° 485 ; RIC III, n° 400.

This well preserved coin, on which individual strands of hair, pearl accessories, and drilled pupils are all readily visible, stands as one of a plethora of examples of the deified Faustina. Faustina died in AD 141, only three years after her husband Antoninus's accession, and within a year coinage was struck celebrating her deification. Interestingly, Antoninus continued for the duration of his reign to issue coins in honor of his deified wife, and evidence indicates that a substantial part of the circulating money during his reign was devoted to the Diva[1]. Thus, coins of Diva Faustina were far more common than most consecration issues[2].

The consecration of empresses was a common occurrence in the Roman empire ; nevertheless, there was something unusual in the breadth and persistence of Antoninus's devotion to his wife's image as Diva. Ordinarily, a new *diva* was celebrated with a large inaugural ceremony following which the cult gradually disappeared or at least

faded into the background of Roman religious life[3]. Antoninus, however, continued to propagate Faustina's image together with the Senate, and the mints persisted in striking coins that kept her memory alive in the hearts of the people at least for the duration of Antoninus's reign, if not longer. Marcus Aurelius did much the same after the death of Faustina II[4].

ACW

1. MATTINGLY, H., *The Consecration of Faustina the Elder and her Daughter*, in *Harvard Theological Review*, XLI, 1948, p. 148.
2. *Ibid.* In a recent examination of a great hoard from Valeni in Rumania, compared to 502 coins of Antoninus there were 563 of Faustina, of which 539 were of her as Diva. At Réka Dévina there were 4,158 of Faustina compared to 7,734 of Antoninus.
3. *Ibid.*, p. 149.
4. *Ibid.*, p. 150.

19. Antoninus Pius

AR Denarius - AD 154-155
Obv. ANTONINVS AVG PI - VS PP TRPXVIII Bust r., laureate.
Rev. COS - IIII Vesta standing l., veiled and draped, holding patera in r. hand over lighted and garlanded altar, palladium in l. hand.
Cm. 1.8 - Gr. 3.1
Brown University, Harkness Collection
Bibliography : RIC III, n° 238.

During Antoninus Pius's reign the tribunician years of both the Emperor (here TRP XVIII) and his successor began to establish the means of dating their coinage. Tribunal power was usually conferred on, or very shortly following, the day of accession and was renewed each year on the anniversary[1]. Thus, this coin is dateable to a narrow span of only two years.

Antoninus's portraiture still reflects the revived interest in Hellenism popular during Hadrian's rule. Consequently, his tranquil and idealized features are similar to those of his predecessor[2]. However, more varied and enlivened examples are to be found on coins devoted to his wife and daughter, the Faustinae, and to his successor, Marcus Aurelius.

A few changes are to be noted during Antoninus's reign. In the year AD 139 or 140 the pupils in the eyes began to be drilled, thus lending the image more vivacity[3]. A variety of representations also emerge in the treatment of the bust ; besides frontal, side, and back views, they are also bare, lightly draped on one or both shoulders, with aegis, paludamentum or cuirass. This variety is believed to have helped divide the work of the mint[4].

ACW

1. RIC III, p. 1.
2. BMC IV, p. xix.
3. *Ibid.*, p. xxxviii.
4. *Ibid.*, p. xx1.

20. Septimius Severus

AR Denarius - AD 198
Obv. L SEP SEVERVS PER - AVG PM IMP XI Head, laureate r.
Rev. PAR AR AD TR - P VI COS II PP Victory advancing l. holding wreath and palm.
Cm. 1.9 - Gr. 2.0 - Courtesy of The Museu Historico Nacional, Rio de Janeiro
Bibliography : C. IV, n° 369 ; RIC IV, n° 496a.

This coin appears to have been minted in celebration of the recent victory over Parthia and the conclusion of the Eastern wars, referred to in the obverse legend PAR and in the reverse image of Victory. These events in themselves heralded a new phase in Severus's reign typified by the introduction of new governmental policy, the burgeoning assurance of the Severan rule and the increased security of the dynasty itself. Severus had by this time restored the Roman Empire to a stability that it had not enjoyed since Commodus, and he was successful against foreign and internal foes alike.

JWH

21. Julia Mamaea

AE Sestertius - c. AD 228-231
Obv. IVLIA MAMA - EA AVGVSTA Bust r., draped, diademed.
Rev. FELICITAS PVBLICA / SC Felicitas draped, seated l. on chair, holding caduceus r. and cornucopiae l.
Cm. 3.0 - Gr. 21.3 - Courtesy of the Museu Paulista, Universidade de Sâo Paulo, Brazil
Bibliography : BMC VI, n° 661 ; RIC IV(02), n° 670.

Severus Alexander became Emperor while still in his youth ; thus, for the first nine years of his reign, which started in AD 222, Severus's mother Julia Mamaea had primary control over the government[1].

Her coinage likely began in AD 226 and in most cases the obverse portrait remained unchanged for its duration. Usually Mamaea is depicted facing right and draped with a frontal view of her bust ; her elaborately waved hair is always arranged in stiff horizontal ridges[2].

Because the portraits remain stagnant, the chronology of Mamaea's coins is often based on parallel developments in the coinage of Severus. Here, various hoard evidence conclusively places some coins earlier and some later than this, and so the coin is dated by a process of elimination[3].

Additionally, it is interesting to note that in this period, only the women from the Imperial house of Severus ever bore the title *Augusta* on coinage[4]. Paulina, whose death came shortly before or just after Maximinus's accession, had the title *Diva* but not *Augusta*. And the subsequent reign of Maximinus Thrax and the joint reigns of Gordianus I, Pupienus and Balbinus were too brief to allow for coinage of Empresses if they even existed[5].

ACW

1. RIC IV (part 2), p. 64.
2. BMC VI, p. 25-26.
3. *Ibid.*, p. 67.
4. *Ibid.*, p. 28. Orbiana and Julia Maesa, Severus's wife and grandmother, also shared the title *Augusta*.
5. *Ibid.* It is unknown if either Pupienus or Balbinus were married.

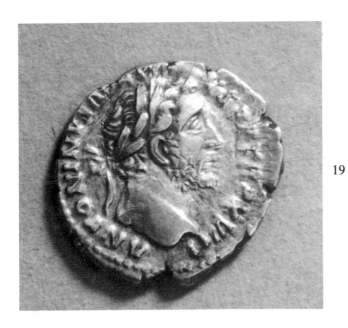
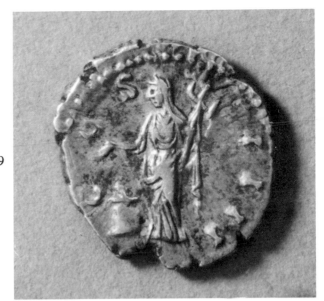

19

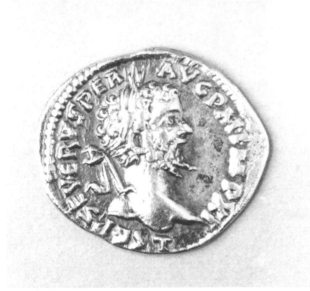
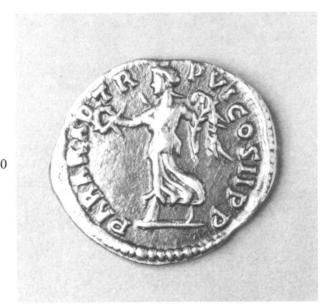

20

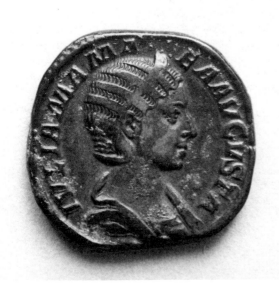
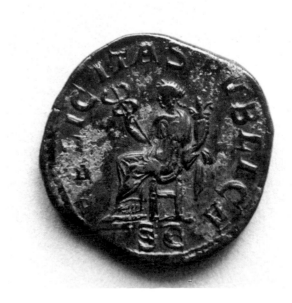

21

22. Gordian III

AR Antoninianus - AD 241-243
Obv. IMP GORDIANVS PIVS FEL AVG Bust of Gordian III radiate, draped and cuirassed r.
Rev. IOVI STATORI Jupiter standing, head r., holding a long sceptre in r. and a thunderbolt in l.
Cm. 2.7 - Gr. 4.7
Brown University, Harkness Collection
Bibliography : RIC IV, n° 84.

In July of AD 238, the ever more common factional fighting over the right to rule and ended with the assassination of the Senate-approved rulers Balbinus and Pupienus and the Praetorian's declaration of Gordian as Emperor.

This subtlely modelled, high relief portrait of Gordian differs from Severan portraiture. Here, a simpler, linear style is preferred, emphasizing his protruding nose and overbite. Wearing faint sideburns and the nondescript, closely cropped hair that was fashionable in the mid third century, Gordian appears older than in his earliest portraits, although the number of distinct official portrait types is still debated[1].

Placed among the fourth issue (AD 241-243) of Gordian's coinage[2], the obverse legend refers to both his imperial title and the peace that he brought to the Empire. The reverse type of Jupiter Stator was meant to encourage the Roman armies fighting the Persians[3].

KLB

1. WOOD, S., *Subject and Artist : Studies in Roman Portraiture of the Third Century*, in *AJA*, 85, 1981, p. 56-69 ; and BRACKER, J., *Gordianus III. bis Carinus*, Berlin, 1979, p. 13-29.
2. RIC IV, p. 4.
3. *Ibid.*, p. 10.

23. Philip I

AR Antoninianus - AD 244-249
Obv. IMP M IVL PHILIPPVS AVG Bust of Philip I r., with radiate crown, draped and cuirassed.
Rev. VICTORIA - AVG Victory advancing r., and holding a wreath and a palm on her hands.
Cm. 2.2 - Gr. 4.4
Brown University, Harkness Collection
Bibliography : RIC IV, n° 50.

Philip I, also known as Philip the Arab, appears in a brilliantly detailed portrait on this coin. There is an emphasis on the largeness of form, and also a characteristic dotlike stroking of the hair, which signifies a turning away from the late Severan style towards a new harshly realistic trend in portraiture. This new style is used to serve this aggressive era of the self-made soldier emperors[1].

During this period of instability and interior revolt (AD 238-284), the standard of the coinage had been steadily falling. Finally, there was a decisive step taken in replacing the old denarius as the normal silver coin by the antoninianus[2]. This was a coin introduced by Caracalla in AD 215.

The Victory that appears on the reverse assures the Roman peace and valor of the Emperor. The peace recently concluded with Persia was to endure forever[3]. But unfortunately, the anarchy was not to be terminated with this Emperor : Philip I was killed at Verona by his own troops in AD 249.

EG

1. HANNESTAD, N., *Roman Art and Imperial Policy*, 1986, p. 284-286. See also : TOYNBEE, J.M.C., *Art of the Romans*, New York, 1965, p. 38-39.
2. RIC IV, p. 54-55.
3. *Ibid.*, p. 63.

24. Probus

AR Antoninianus - Rome - c. AD 276
Obv. IMP PRO - BVS AVG Probus helmeted, cuirassed l.
Rev. ROMAE - AETER / R * Γ Temple with Roma inside.
Cm. 2.2 - Gr. 3.4
Brown University, Harkness Collection
Bibliography : RIC IV, n° 186.

In the tumultuous third century, Probus's reign from AD 276 to 282 was one of the longest. After the murder of Severus Alexander in 235, no less than fifteen different men seized power, hence the group is known as the Soldier Emperors. Appropriately, this coin of Probus displays the military nature and strength of the Emperor by means of military attire.

Artistically, the coin reflects the transition of Roman art moving from a more naturalistic form to an increasingly abstract and linear style ; this is evidenced in the portrait's high stylization and abstractness of crisp lines blocking out areas of the image such as the jawline, the profile, and the eyes. The success of the delicate and intricate description of the armor lies in the repetition of lines and dots. These strong lines and hard contrasts of dark and light replace the realism and soft naturalism of previous styles.

HBR

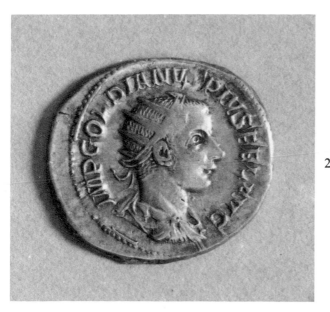

22

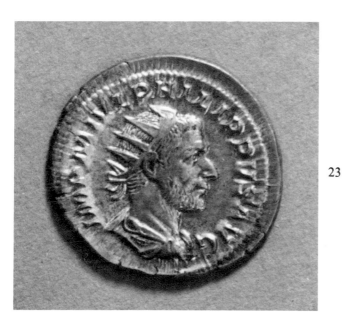
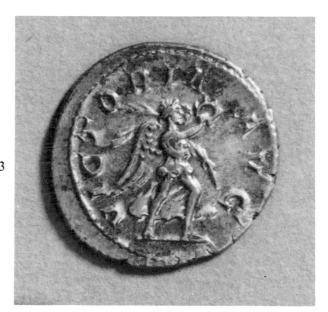
23

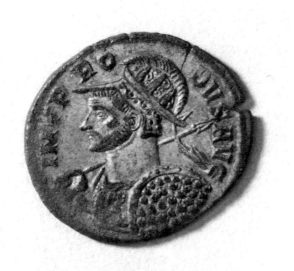
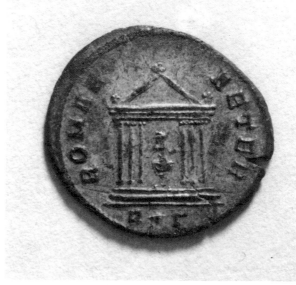
24

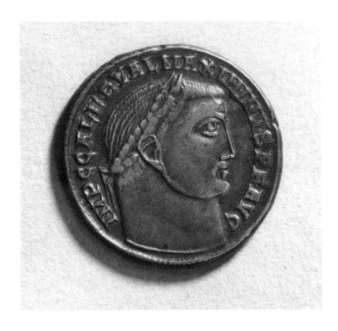

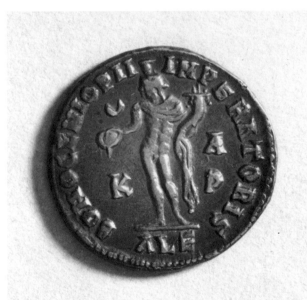

25. Maximinus II

AE Follis - Alexandria - AD 310-311
Obv. IMP C GALER VAL MAXIMINVS P F AVG. Head of Maximinus II, r., laureate.
Rev. BONOGENIOP II - IMPERATORIS / in field on l. U/K, on r. A/P, in exergue ALE Genius standing l., holding patera and cornucopia.
Cm. 2.3 - Gr. 6.9
Brown University, Harkness Collection
Bibliography : RIC VI, n° 135.

Diocletian became Emperor in AD 284. As a result of external threats to the Empire, he established the Tetrachy in AD 293, which included Maximinus II, who governed Syria and the Eastern provinces. In AD 294 Diocletian instituted a monetary reform : antoniniani were discontinued and new issues of denarii and aes appeared[1]. The silver content in denarii increased, while the follis replaced the antoninianus, whose weight rapidly reduced. In Egypt, the follis marks the end of their traditional coin[2]. When, in AD 305, Diocletian and Maximian abdicated, Constantius and Maximinus II became Augusti. Minted in AD 310-311 in Nicomedia, this coin is a fine example of a rare issue[3]. The archaic treatment of the face, with a flat, simple design, and pronounced and serious features, repeats the standard Tetrarchic effigy. The reverse image of a Genius is an assertion of the Emperor's benificience, and a symbol of unity in a divided Empire[4].

JS

1. RIC VI, p. 2.
2. KENT, p. 47.
3. RIC VI, p. 564.
4. KENT, p. 326.

26. Constantine the Great

AE Follis - AD 317-318
Obv. IMP C CONSTANTINVS PF AVG Bust, laureate, draped, cuirassed, r.
Rev. SOLI IN - VI - CTO COMITI Sol standing l., radiate, chlampys over shoulder.
Cm. 2.2 - Gr. 4.3
Brown University, Harkness Collection
Bibliography : J. MAURICE, *Numismatique Constantinienne*, Paris, II, 1911, p. 158, n° 2, pl. v, n° 16 ; RIC VII, n° 144 (see note 144).

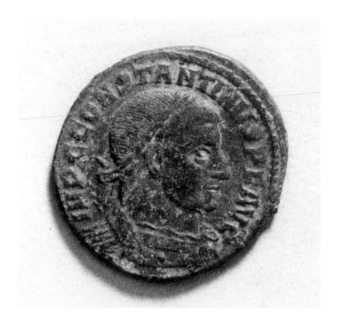

Struck in c. AD 317-318 at the mint of Arles, this follis is an example of the coinage of Constantine during the Dyarchy (AD 313-324)[1]. On coins produced in the Western mints at this time, Constantine appears with a relatively individualized physiognomy — particularly evident in the aquiline nose and prominent chin — whereas in the East his image remains deeply rooted in the abstracting tradition of Tetrarch portraiture[2].

A certain re-affirmation of sculptural plasticity is present in this portrait as well as a deliberate attempt to recall images of the hallowed Emperor Trajan[3]. However, the emphatic linearity of the image and the de-emphasis of anatomical naturalism apparent in the ruler's large eye imbue the portrait with a Late Antique style. A characteristic of Late Roman portraiture is the replacement of the attention to the physicality of the subject with an interest in its spiritual being. Because it establishes a primacy of the internal self over external materialism, Roman portraiture of the third and fourth centuries has been associated with the transcendentalism of contemporary philosophy and lays the foundation for Medieval art[4].

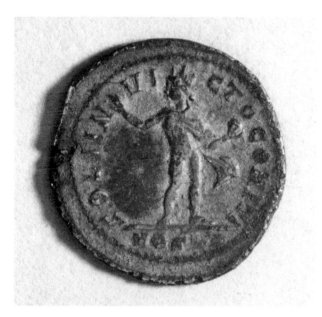

GW

1. See BRUUN, P.M., *The Constantinian Coinage of Arelate*, Helsinki, 1953 for a detailed account of the coinage from the mint of Arles under Constantine.
2. L'ORANGE, H.P., *Das spätantike Herrscherbild von Diokletian bis zu den Konstantin-Söhnen*, Berlin, 1984, p. 51.
3. BRECKENRIDGE, J.D., *Likeness : A Conceptual History of Ancient Portraiture*, Evanston, 1968, p. 244.
4. Discussions of the spiritualizing aspects of late Roman portraiture are given in : L'ORANGE, *Likeness and Icon : Selected Studies in Classical and Early Mediaeval Art*, Odense, 1973 ; MCCANN, A.M., *Beyond the Classical in Third Century Portraiture*, in ANRW, II, 12.2, p. 623-645 ; WEITZMANN, K., ed., *The Age of Spirituality : Late Antique and Early Christian Art, Third to Seventh Centuries*, New York : The Metropolitan Museum of Art, 1978.

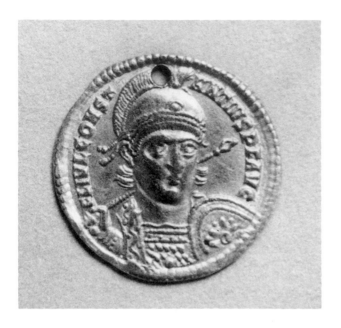

27. Constantius II

AV Solidus - Rome - c. AD 355-357
Obv. FL IVL CONST - ANTIVS PF AVG Helmeted head
of Constantius II facing, cuirassed.
Rev. GLORIA REI - PVBLICAE / RSMZ palm in
exergue. Roma on l., Constantinopolis on r., VOT XXX
MVLT XXXX on shield.
Cm. 2.1 - Gr. 4.4
Courtesy of the Museu Paulista, Universidade de Sâo
Paulo
Bibliography : RIC VIII, n° 293.

There were no great changes in the coinage of
Constantius II during the first of his reign. This
coinage reiterated the major styles and themes of his
father, the Emperor Constantine I.

The most profound innovation in the issues of
Constantius II were expressed in his gold coinage.
Previous to the minting of this coin the common
bust type was in profile. Here the facing bust opens
up a new area for presentation of the human effigy.
It was to be discontinued before the end of the reign
of Constantius II but is was used in later reigns
through the sixth century.

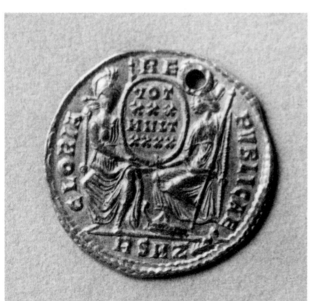

This coin was minted in Rome and bears the mark
RSMP. It was minted to commemorate the first entry
of Constantius II into Rome in AD 357. It differs
slightly from the same coin type minted in the East.
In the East stars were added to the helmet and a
diadem of pearls came to a point centered over the
nose. Usually a galloping horseman embellished the
shield on the eastern type whereas here a star is used.

MRW

COMMEMORATIVE COINAGE

28. Ancus Marcius

AR Denarius - c. 56 BC
Obv. ANCVS Diademed head of Ancus Marcius r., lituus L.
Rev. AQVA MAR PHILIPPVS Equestrian statue r. on arcade of five arches ; below flower.
Cm. 1.8 - Gr. 3.7
Brown University, Harkness Collection
Bibliography : BMCRep. I, n° 3890 ; Syd., n° 919 ; Crawford 425.

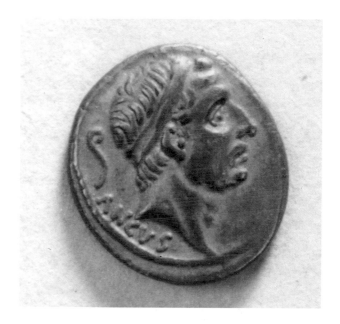

Following the tradition in Republican coinage, these images honor the moneyer's ancestors. The son of L. Marcius Philippus, who was consul in 56 BC, may have been the moneyer responsible for this issue. Ancus Marcius, the fourth king of Rome, is celebrated in history for being the first to provide Rome with a water supply by means of an aqueduct (Pliny, *Hist. Nat.*, xxi.3)[1]. He is further remembered for founding Ostia, the seaport of Rome[2]. The reverse commemorates Q. Marcius Rex, whom the Senate commissioned to repair the old aqueducts of Rome when he was praetor in 144 B.C. The Senate also commissioned him to build the Aqua Marcia to supply the Capitol with water[3]. This aqueduct, on the reverse, was the first to be composed of long arche sectors ; an equestrian statue of him is also depicted, which the Senate had erected in acknowledgement of his civic deeds[4]. The flower pictured below the aqueduct, an *arum martialis*, seems to be a phonetic allusion to the gens Marcia[5]. The individualized features of Ancus Marcius and the realistic rendering mean that the coin is characteristic not only in its iconography, but in its execution as well.

JS

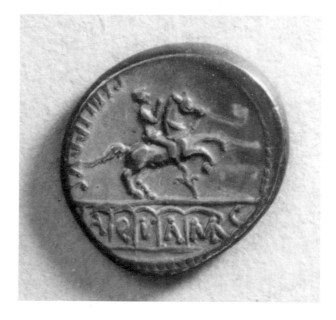

1. BMCRep. I, p. 485.
2. DRC, p. 44.
3. BMCRep. I, p. 485.
4. BIEBER, M., *Archaeology*, 20, 1967, p. 194-196.
5. DE LONGPÉRIER, A., *Oeuvres*, publiées par G. Schlumberger, p. 235-236.

29. Cn. D. Ahenobarbus

AR Denarius - 41-40 BC
Obv. AHENOBAR Ahenobarbus head r.
Rev. CN DOMITIVS L F IMP / NE - PT Tetrastyle temple
Cm. 1.6 - Gr. 3.8
Brown University, Harkness Collection
Bibliography : Syd. n° 1176 ; BMCRep II, n° 93 ; Crawford 519.

Both legends identify the obverse portrait as Domitius Ahenobarbus[1]. This coin commemorates Ahenobarbus's victories at sea in 42-40 BC, when he commanded a fleet that gained control of the Ionian Sea, thus posing a serious threat to Octavian[2]. For his victory, Ahenobarbus was proclaimed Imperator by his troops[3]. The tetrastyle temple on the reverse credits his successes to the god Neptune. According to Pliny[4], a Neptune Temple was built by a Cnaeus Domitius in the Circus Flaminius. Pliny may not be referring to the same person, but rather to one of Ahenobarbus's ancestors, who as consul in 192 BC and may have erected a Neptune Temple after his victory over Antiochus the Great. Therefore, the portrait could refer to the ancestor as well as Ahenobarbus himself[5]. This fine portrait displaying peculiar hair patterns and a distinctive face is a fine example of Roman pictorial realism, while the head and eye's slight upward tilt give the image a slightly idealized flavor.

HBR

1. Bab. I, p. 466.
2. Dio Cassius, XLVII.7.
3. BMCRep II, p. 488.
4. Pliny, *Natural History*, XXXVI.4.
5. BMCRep II, p. 288.

30. Claudius

AE Sestertius - c. AD 41-52
Obv. TI CLAVDIVS CAESAR AVG P M TR P IMP PP Head of Claudius r., laureate.
Rev. NERO CLAVDIVS DRVSVS GERMAN IMP S - C Triumphal arch surmounted by an equestrian statue, r., between two trophies.
Cm. 3.5 - Gr. 26.9
Courtesy of The Museu Historico Nacional, Rio de Janeiro
Bibliography : RIC I, n° 98 ; BMC 122.

This sestertius commemorates the military successes of Claudius's father, Nero Drusus, who led a campaign to Germany from 12-9 BC. The title Imperator had been given to him by Augustus[1], and the Senate honored him with the construction of a triumphal arch decorated with trophies[2].

Dating Claudius's coinage is difficult ; the title Pater Patriae, assumed in early AD 42, is not common on his gold and silver obverses until AD 50-51. Sutherland therefore proposes that bronze coinage bearing the PP title, such as this sestertius, is most likely produced around AD 50 as well[3].

LLA

1. BMC I, p. clv.
2. RIC I, p. 129.
3. Sutherland, C.H.V., *The Emperor and the Coinage*, London, 1976, p. 115.

31. Octavian

AR Denarius - c. 41 BC
Obv. M. ANT. IMP. AVG. III.VIR. R. P. C. BARBAT Q.P. Head of M. Antony r.
Rev. CAESAR. IMP. PONT. III.VIR. R.P.C. Head of Octavian r.
Cm. 1.8 - Gr. 2.5
Brown University, Harkness Collection
Bibliography : Syd. n° 1181 ; Crawford 517/2.

Around 41 BC, M. Antony established a mint at Ephesus[1], his headquarters and capital of the Asian province. These portraits commemorate the desire for friendly relations between M. Antony and Octavian, to which M. Antony's marriage to Octavia in 40 BC testified[2]. Along with Lepidus, M. Antony and Octavian were Triumvirs for the five year period that began in 43 BC. Their relationship endured until the Battle of Actium, when M. Antony committed suicide. The head of M. Antony, cut with heavy lines, shows strong, determined features ; by contrast, the head of Octavian is more youthful and more finely rendered. These formal differences are consonant with their standard portrayals, although there may be an element of propaganda in their juxtaposition.

JS

1. Syd, p. 489.
2. See Gross, W., *Ways and Roundabout Ways in the Propaganda of an Unpopular Ideology*, in *Age of Augustus*, ed. Rolf Winkes, Providence, 1985, p. 31.

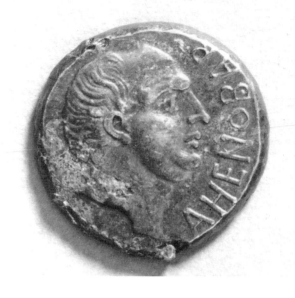
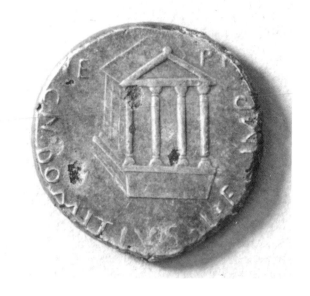

29

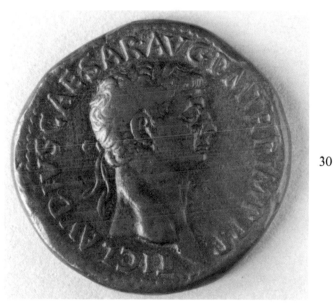
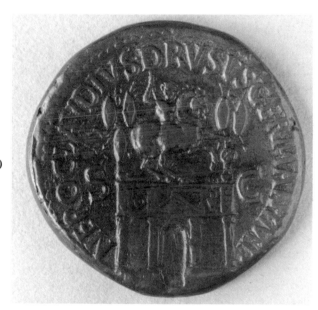

30

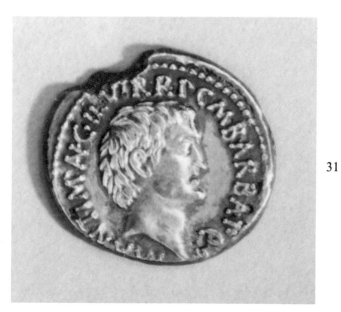
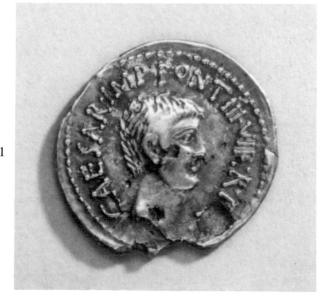

31

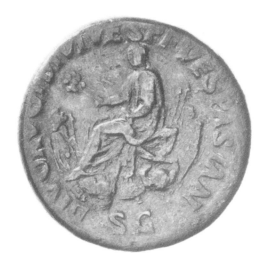
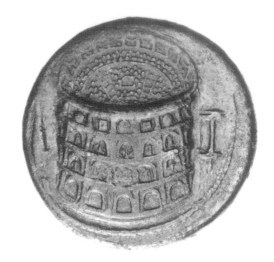

32. Titus

AE Sestertius - AD 81

Obv. DIVO AVG T DIVI VESP F VESPASIAN S C.
Titus, togate, bare-headed, seated l. on curule chair,
holding branch in r. and roll(?) in l., shields, helmets,
spears and a cuirass (?) in field around him.

Rev. Exterior and interior view of the Colosseum ; to r.
Titus's Baths, to l. Meta Sudans.

Cm. 3.2 - Gr. 24.5

Courtesy of The American Numismatic Society, New
York

Bibliography : C. I, n° 399.

Intended to publicize Titus's recent deification,
this sestertius issued by Domitian duplicates the
type of what is often regarded as one of « the
most interesting » coins of Titus's reign[1]. Refer-
ring to Titus's successful military career on the
obverse, this coin was initially minted to comme-
morate the dedication of the Flavian Amphithea-
tre, or Colosseum, that is prominently featured on
the reverse.

Begun by Vespasian, and completed in AD 80, the
Colosseum has dimensions of 188 meters and 156.4
meters along its axes and a height of 48.5 meters.
Constructed with three arcaded stories and a po-
dium at the top, it allowed for three tiers of seating
with standing room above. Audiences were estima-
ted to have been near 50,000. This structure and
some of the exterior sculptural decoration are
indicated in the reverse's image. The interior view
illustrates the vast number of people who would
fill it.

Two additional structures are described on the
reverse. On the left is a conical fountain identified
as the Meta Sudans. The porticoed building on the
right has recently been identified as a representation
of the Baths of Titus, also dedicated in AD 80[2].
Based on these attributions, it is also argued that
this reverse type may not only celebrate the comple-
tion of the Colosseum, but may have also been
intended to illustrate Titus's rebuilding program for
Rome[3].

KLB

1. BMC II, p. lxxvi.
2. PRICE, M.J. and TRELL, B.L., *Coins and Their Cities*,
 London, 1977, p. 61.
3. *Ibid.*, p. 61.

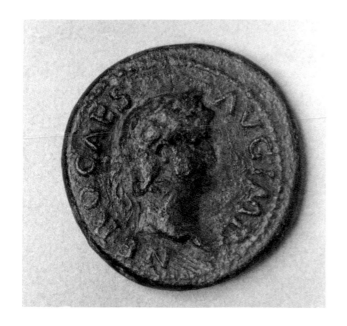
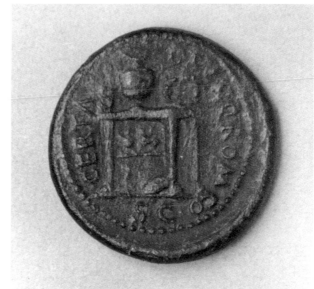

33. Nero

AE Semis - AD 65
Obv. NERO CAES - AVG IMP Nero, head r., laureate.
Rev. CERTA - QVINQ ROM CO / SC Vase l. and wreath
r., on gaming table. Two griffons l. and r. facing each
other ; below them, r., a round shield. Value mark S
above table.
Cm. 1.9 - Gr. 4.9
Courtesy of The Museu Historico Nacional, Rio de
Janeiro
Bibliography : KENT, n° 200 ; RIC I, n° 243 ; BMC I,
n° 273.

The gaming table on the reverse, with its wreath
for the victor, urn for the judges' votes, and athletic
shield, is a direct historical reference to the *Certamen Quinquennale*. This was a musical, athletic and
equestrian event held in Rome in AD 60 and
reinstituted in AD 65. These games, also known as
the Neronia, exemplified Nero's interest in Greek
culture, for they are modelled after Greek customs[1].

Quite different from other more savage types of
entertainment, the first Neronian Games took place
on 13 October AD 60, the anniversary of the
Emperor's accession[2]. Nero took part in these
games and was given the first prize for oratory, a
contest in which he had not entered his name. In
AD 65 the Senate tried to prevent him from
participating in the games which they disapproved
of by voting him, in advance, the first prize for
singing and oratory[3]. Nero, nevertheless, played in
the games and issued coins to celebrate and commemorate them.

EDG

1. KENT, p. 286.
2. GRANT, M., *Nero*, London, 1970, p. 103.
3. GARZETTI, A., *From Tiberius to the Antonines*, trans. J.R.
 Foster, London, 1960, p. 158 and 168.

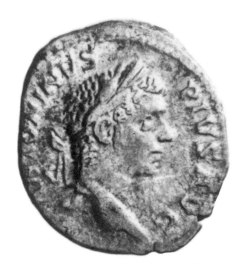

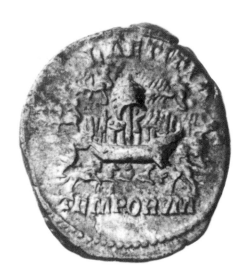

34. Caracalla

AR Denarius - AD 206
Obv. ANTONINVS PIVS AVG Head, laureate, r.
Rev. LAETITIA TEMPORVM Ship in a circus ; above on l. and r., four quadrigae ; below, from l. to r., an ostrich, a lion, a tiger, a bear, a stag, a bull, a second bear.
Cm. 2.0 - Gr. 3.4
Courtesy of The American Numismatic Society, New York
Bibliography : BMC V, n° 508 ; RIC IV, n° 157.

This coin, an example of a re-issue of AD 206, can best be discussed if it is related to the events which the original issue of 202 commemorated[1]. The reverse shows the legend, LAETITIA TEMPORVM, which has been translated as These Joyful Days[2], and the image of a galley, lowered into an arena, from which a menagerie of exotic beasts emerges. The inscription and the scene of the spectacle refer to the festivities of the Imperial jubilee of 202 that marked Septimius Severus's and Caracalla's return to Rome from the lengthy Eastern Campaign (197-202) and the coinciding Decennalia, or tenth anniversary of Severus's reign[3].

The celebration lasted seven days and was the third of six largesses that Severus offered to the Roman people[4]. The jubilee, of which the scene on the coin's reverse is a descriptive vignette, was the fruit of the Emperor's role as provider of entertainment for the public, a role he assumed in order to promote the myth of his generosity[5].

GW

1. For a discussion of dating, see CARLSON, C., *The* Laetitia Temporum *Reverses of the Severan Dynasty Redated*, in *Journal of the Society for Ancient Numismatics*, 1969, p. 20f.
2. BMC V, p. cxlix.
3. The relation of the reverse theme and the imperial family's return is dealt with in BMC V, p. cxlix. Severus entered the capital on 13 April 202 on what was actually the ninth anniversary of his being proclaimed Emperor by his troops at Carnuntum on that date in 193. See CAH XII, p. 3.
4. BMC V, p. cl.
5. For a discussion of the Roman Circus, see HÖNLE, A., and HENZE, A., *Römische Amphitheater und Stadien : Gladiatorenkämpfe und Circusspiele*, Zürich and Freiburg, 1981 ; HUMPHREY, J., *Roman Circus : Arenas for Chariot Racing*, Berkeley and Los Angeles, 1986. For a structuralist analysis of the circus and its relation to society, see BOUISSAC, P., *Circus and Culture : A Semiotic Approach*, Bloomington and London, 1976.

35. Augustus

AR Denarius - c. 17 BC
Obv. CAESAR AVGVSTVS Head of Augustus, laureate, r.
Rev. DIVVS. IVLIVS Comet with eight rays and tail.
Cm. 1.90 - Gr. 3.5
Courtesy of The Museu Historico Nacional, Rio de Janeiro
Bibliography : BMC I, n° 357 ; KENT, n° 144.

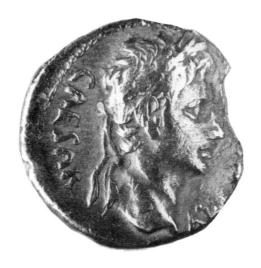

Minted in Spain[1], this coin's portrayal of Augustus reflects his eternal, god-like characterization. Here, however, his face is thinner and his laurel wreath — an attribute of Apollo and an established symbol of victory during the Republic — rests higher up on the nape of his neck.

Faithfully illustrating the Latin term for a comet, *stella crinita or stella comans*, a star with long hair, the reverse conveys Augustus's interpretation of the 17 BC appearance of a comet. According to Pliny the Elder, Augustus publically declared that « the common people believed that this star signified the soul of Caesar received among the spirits of the immortal gods »[2]. Pliny asserts, however, that privately Augustus believed that the comet came in honor of himself : « to confess the truth, it did have a health giving influence over the world »[3].

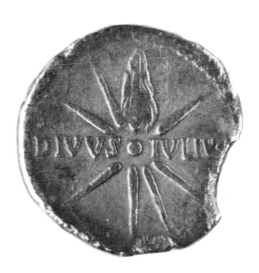

KLB

1. Mattingly suggests that the mint was in Colonia Patricia. BMC I, p. cix-cx.
2. See Pliny's *Natural History*, II.22-23 for his discussion of comets. Chapter 23 contains the specific references to his comet.
3. Pliny, *Natural History*, II.23.

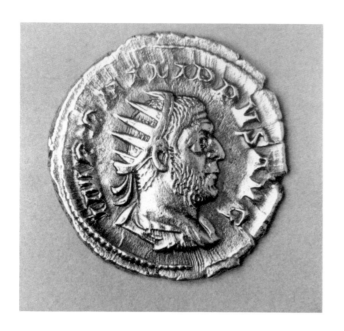

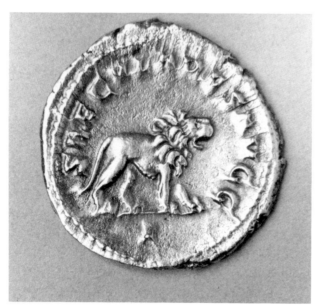

36. Philip I

AE Antoninianus - AD 248
Obv. IMP PHILIPPVS AVG Radiate, draped and cuirassed bust of Philip I, r.
Rev. SAECVLARES AVGG Lion r., I in exergue.
Cm. 2.4 - Gr. 4.2
Courtesy of the Museu Historico Nacional, Rio de Janeiro
Bibliography : KENT, n° 455 ; BMC III, n° 44.

Philip I took this unique opportunity of the thousandth year of Rome to delight the populace with magnificent shows and games, and to strengthen his own Dynasty. The theme of this issue is clearly stated in the reverse legend, SAECVLARES AVGG., meaning celebrations of the close of one age and the beginning of another[1].

The reverse shows one of the many animals that were exhibited and slaughtered for the entertainment of the public. The *Historia Augusta* gives an account of these games, which were the most magnificent for many years to come (V. Gordiani Tres XXXIII, 1-2) :

> « There were 32 elephants at Rome in the time of Gordian, ten elk, ten tigers, sixty tame lions, thirty tame leopards ..., six hippopotami, one rhinoceros ..., twenty wild asses ..., All these animals, wild, tame and savage, Gordian intended for a Persian triumph ... but Philip presented all of them at the secular games, consisting of both gladiatorial spectacles and races in the circus ».

According to Hannestad, these coins provide a refreshing addition to the stereotype series of the time with their consistent pleas for unity, and their futile promises for victory over the barbarians[2].

EG

1. RIC IV, p. 62.
2. HANNESTAD, N., *Roman Art and Imperial Policy*, Aarhus, 1980, p. 286.

37. Augustus

AR Denarius - 18 BC

Obv. CAESARI - AVGVSTO Head of Augustus, r., laureate.

Rev. MAR - VLT Round temple with domed roof and *acroteria* and six columns on a podium of three steps, *aquila* between the two central columns, and a standard both l. and r. of the central columns.

Cm. 1.9 - Gr. 3.6

Brown University, Harkness Collection

Bibliography : RIC I, n° 105a ; BMC I, n° 373 ; Giard, n° 1202.

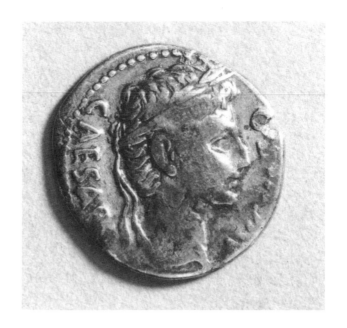

The reverse of this denarius commemorates the return of the Parthian standards in 20 BC. The two standards and *aquila* depicted represent those lost by the Romans to the Parthians in the Battles of 53, 40 and 36 BC. Augustus's diplomatic and military efforts secured the standards' return to Rome[1]. There they were housed in a small provisional temple, shown here, until a permanent structure was dedicated to Mars Ultor in 2 BC.

Weinstock has suggested that the initial plan for construction of a temple to Mars Ultor belonged to Julius Caesar, who intended it to be constructed following his return from Parthia[2]. After Caesar's murder, Octavian and the Triumvirate took up this pledge and the temple was finally realized by Augustus in 2 BC. This temple would therefore be a suitable resting place for the returned standards, as the temple, dedicated to the god of war as Avenger, actually represented a triple revenge against the Parthians : first by Julius Caesar, then by the Triumvirate, and finally by Augustus, who secured the standards' return.

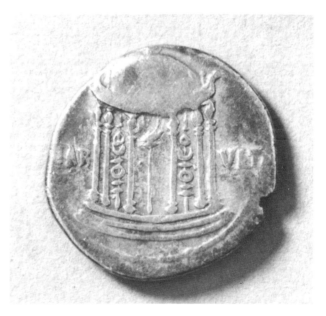

LLA

1. SUTHERLAND, C.H.V., *Roman History and Coinage, 44 BC to AD 69*, 1987, p. 14.
2. WEINSTOCK, S., *Divus Julius*, 1971, p. 132.

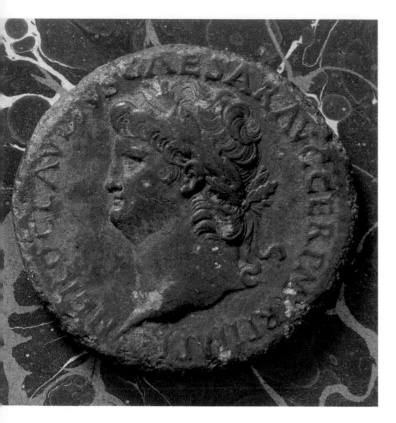
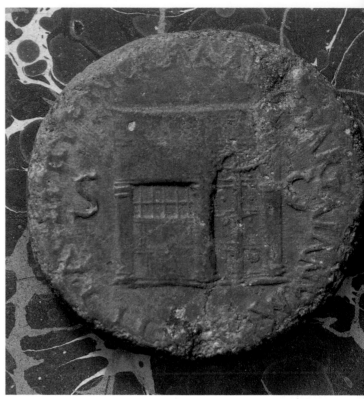

38. Nero

AE Sestertius - 66 AD
Obv. NERO CLAVDIVS CAESAR AVG GER P M TR P
IMP PP. Laureate head l.
Rev. PACE P R TERRA MARIQ PARTA IANVM
CLVSIT / S - C in field. Temple of Janus with closed
doors r.
Cm. 3.3 - Gr. 23.2
Brown University, Harkness Collection
Bibliography : RIC I, n° 267[1].

This coin celebrates the closing of the doors of the Temple of Janus, thus signifying universal peace for the Roman people. Corbulo, a general under Nero, established this peace with his victory in AD 63 over Armenia and its ruler Tiridates which forced Parthia to recognize the superiority of Rome. The temple doors, then, were closed in Ad 64 for one year as shown on the coin's reverse[2]. Suetonius's account, however, dates the closing of the doors with Tiridates's visit to Rome in AD 66[3]. According to Suetonius, Nero's title of Imperator as a praenomen was the result of this same visit, since prior to AD 66, Nero used the title as a cognomen. Unfortunately, the veracity of Suetonius's account is questionable as the title appears as a cognomen on the obverse, while the doors are closed on the reverse. So, in addition to this coin depicting a specific event in Roman history, it also demonstrates one of the many problems involved with using ancient sources.

HBR

1. For a similar coin also see KENT n° 203.
2. RIC I, p. 166.
3. Suetonius, XIII.1.

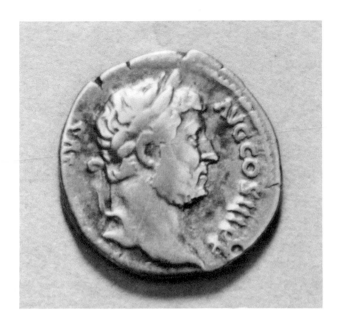
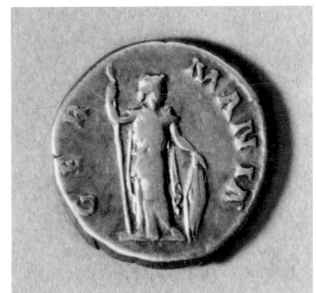

39. Hadrian

AR Denarius - AD 134-138
Obv. HADRIANVS - AVG COS III PP Head of Hadrian, r.
Rev. GER - MANIA Germania standing, head r., holding spear, resting l. hand on shield.
Cm. 1.6 Gr. 3.1
Brown University, Bishop Collection
Bibliography : RIC II, n° 302.

In Germany, Hadrian concerned himself with army reforms. On this example, Germania, holding a spear and German shield, celebrates these improvements ; she is therefore represented as a peaceful native, prepared to defend Roman culture[1]. Furthermore, the denarius alludes to Hadrian's trip from Gaul to Germany in Ad 120, when he imposed a king on the Germans[2]. Although Hadrian's province series is given a more thorough treatment with aes than with denarii, Germania, like Asia, Italia, and Alexandria, appears only on denarii and on aurei[3]. The balanced and monumental depiction of Germania is in keeping with the Greek revival common to the province series.

JS

1. TOYNBEE, J.M.C., *The Hadrianic School*, Cambridge, 1934, p. 95 96.
2. DRC, p. 414.
3. BMC III, p. cxlii ; p. clxxiv.

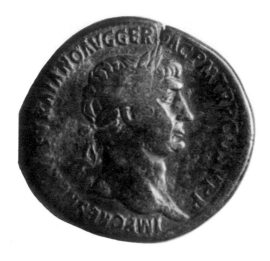

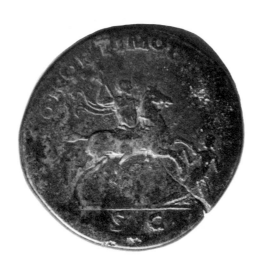

40. Trajan

AE Sestertius - AD 103-111
Obv. IMP CAES NERVAE TRAIANO AVG GER DAC PM TR P COS V PP Trajan facing r., laureate, with drapery on l. shoulder.
Rev. SPQR OPTIMO PRINCIPI / SC Trajan riding r., thrusting spear at fallen Dacian in front of horse.
Cm. 3.4 - Gr. 22.9
Courtesy of The Museu Paulista, Universidade de São Paulo
Bibliography : C. II, n° 503 ; RIC II, n° 534.

Trajan is known both for his policy of territorial expansion and for his frequent military operations in the outlying parts of the Empire. One of his more famous military endeavors involved Dacia, an area now situated in Romania. Unfortunately, many of the details concerning the Dacian Wars are unknown since no contemporary historian wrote of them. Consequently, much of our information comes from the reliefs found on Trajan's Column. In fact, the reverse type of this coin is perhaps taken from a similar group sculpted on the column[1].

The Dacian Wars began in AD 101 because Decebalus, the Dacian king, had been openly challenging the forces of the Empire. After surrendering in 102, he was reprimanded and pardoned. Shortly afterwards, however, he resumed hostilities. Trajan declared war again in 105 and, by the autumn of 106, had completely defeated Decebalus's forces[2].

Trajan's SPQR OPTIMO PRINCIPI issue is mainly concerned with the celebration of these victories and began shortly after his return to Rome in 102. The issue was struck as an act of homage and tribute paid to Trajan by a grateful Senate, and shows Trajan in various conquering and triumphal roles[3].

EDG

1. RIC II, p. 239.
2. GARZETTI, A., *From Tiberius to the Antonines*, trans. J.R. Foster, London, 1960, p. 318-329.
3. BMC III, p. xcviii.

41. Vespasian

AR Denarius - AD 69-70

Obv. IMP CAESAR VESPASIANVS ΛVG Head of Vespasian, laureate, r., border of dots.

Rev. IVDAEA Jewess seated r. on ground, mourning, behind her, a trophy, border of dots.

Cm. 1.9 - Gr. 3.2

Courtesy of The Museu Historico Nacional, Rio de Janeiro

Bibliography : BMC II, n° 35 ; RIC II, n° 266.

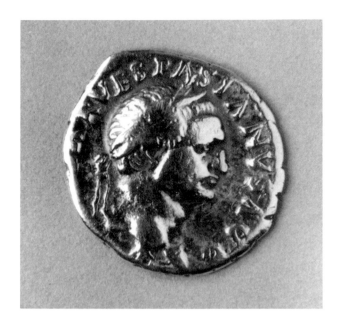

Vespasian's simplified, blocky appearance is indicative of his initial experimental characterizations. It is distinct from his earliest portrait types that were patterned after images of Vitellius. Nevertheless, traits common to his later portraits the hooked nose, numerous wrinkles and folds of skin are still absent.

The reverse type commemorates Vespasian's and Titus' popularly supported subjugation of the rebel province of Judea[1]. A common theme of Vespasian's reign most coins illustrating this subject were minted c. AD 71 and bear the legend IVDAEA CAPTA[2]. These later coins celebrate the return of Rome's complete domination of Judea brought by Titus's taking of Jerusalem in September AD 70. Presumably fashioned prior to Titus's triumph[3], this denarius honors the victories Vespasian had realized as commander of the Roman legions in Judea from AD 67-69. By recalling the military prowess with which he had earned the populace's support, Vespasian was emphasizing his right to imperial power, despite his lack of ties to the preceeding imperial family.

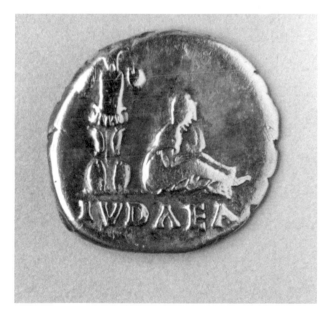

KLB

1. Mattingly observes that Vespasian created the « Captive Province » type with this series of coins. See BMC III, p. xxl.
2. See, for example, BMC II n° 533.
3. Mattingly dates the coin to December AD 69 - November 70. See BMC II, p. xxviii.

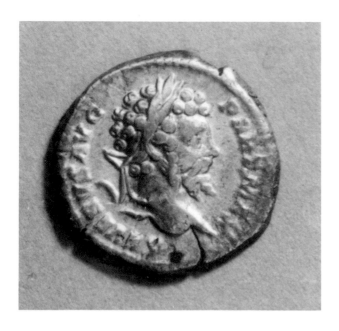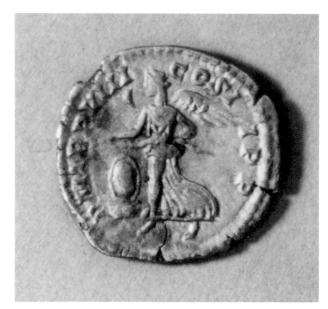

42. Septimius Severus

AR Denarius - c. AD 200
Obv. SEVERVS AVG - PART MAX Septimius Severus laureate, bearded r.
Rev. P M TRP VIII - COS I - I PP Victory l., with wreath and shield.
Cm. 1.8 - Gr. 2.8
Brown University, Harkness Collection
Bibliography : RIC IV, n° 150.

The winged Victory on the reverse of this coin commemorates Septimius Severus's victory over the Parthians in AD 197, which was the military climax to the series of civil wars that preceded the event. Like Vespasian, Septimius Severus brought peace back to the Roman Empire by defeating two rivals. The Emperor Pertinax was murdered in AD 193 without having established his son or anyone else as his successor. In the East, Niger rose in rebellion but was soon defeated in Byzantium by Septimius Severus. In the West, Albinus challenged but was defeated in battle in Germany. This left Septimius as sole ruler[1].

He entered Parthia, in the Eastern Empire, at the end of the civil wars, to intimidate the Eastern rulers. This was meant to be a temporary measure to secure peace throughout the Empire. However, the show of force turned into a permanent occupation.

Severus used the occasion to proclaim to the Roman people and any potential rivals the superiority of the Roman Empire. On the coinage that commemorates this victory Septimius Severus adopts the title Parthicus Maximus : the abbreviated form appears here. Not only was the coin intended to disseminate the strength of the new ruler throughout the Empire, but it was also meant to erase any lingering memories of the civil war which came before this event[2].

MRW

1. KENT, p. 35.
2. BMC V (part 1), p. cxli.

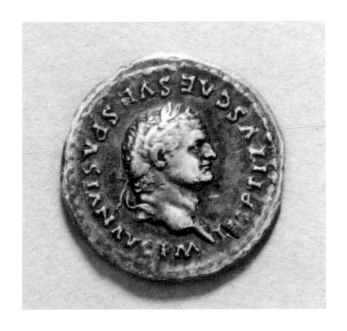
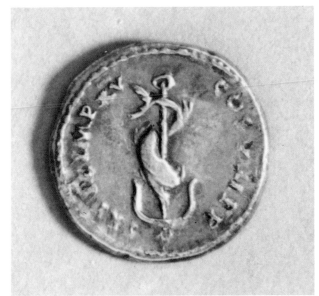

43. Titus

AR Denarius - AD 80
Obv. IMP TITVS CAES VESPASIAN AVG P M
Laureate head of Titus, bearded, r.
Rev. TR P IX IMP XV COS VIII P P Dolphin wrapped
around an anchor.
Cm. 1.7 - Gr. 3.3
Brown University, Harkness Collection
Bibliography : RIC II, n° 26.

In his portraits, Titus's heavy-set build and wide forehead establish a familial resemblance with his father Vespasian. Titus differentiates himself by his fuller hair and firmer musculature. The visual allusion to Vespasian is supplemented by the inclusion of Titus's cognomen Vespasian on the obverse. This, combined with the legends' references to the numerous positions and titles with which Titus had been honored, proclaims the legitimacy of Titus's claim to power.

Titus's association of himself with the reverse type of a dolphin and anchor motif, a symbol for Augustus[1], would be in keeping with his emphasis on sanctifying his right to rule. Mattingly, however,

in dating this coin to AD 80[2], places it among a series of coins issued after the catastrophic eruption of Vesuvius in AD 79, when the Senate ordered a *lectisternium*[3]. The dolphin and anchor is an emblem of Neptune, one of the gods associated with the services of supplication. Thus, going beyond their standard aggrandizing, propagandistic function, this series of coins would have supplemented the *lectisternium's* appeal to the gods.

KLB

1. DRC, p. 339.
2. BMC II, p. lxx.
3. *Ibid.*, p. lxxii-lxxiii.

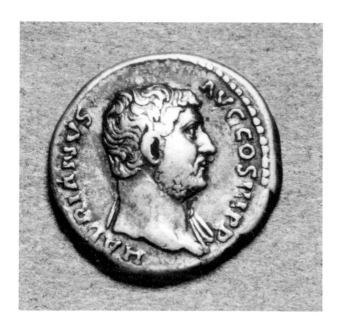

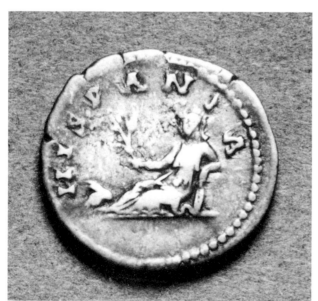

44. Hadrian

AR Denarius - AD 134-138
Obv. HADRIANVS AVG COS III PP Laureate bust of Hadrian r., draped.
Rev. HISPANIA Female draped, reclining with olive branch and rabbit.
Cm. 2.0 - Gr. 3.5
Courtesy of The Museum of Art, Rhode Island School of Design, Providence
Bibliography : BMC II, n° 846.

Hispania is one of the Provinces Series minted between Ad 134 and 138 to commemorate Hadrian's travels. The Emperor visited Spain in the winter of AD 122-123. Breaking with the tradition of Hispania coins, Hadrian's issue makes no references to war. The rock on which the reclining female figure leans is probably Kalpe, the rock of Gibraltar. The olive branch may refer to Spain's unrivalled production of olive oil. The rabbit may allude to the large number of rabbits said to have been in Spain ; furthermore, the burrowing animal may be an allegory of a miner, and thus of Spain's mineral wealth[1].

DCS

1. BMC III, p. cxviii ; TOYNBEE, J.M.C., *The Hadrianic School*, Cambridge, 1934, p. 102-105.

45. Gordian III

AR Denarius - AD 241-243
Obv. IMP GORDIANVS PIVS FEL AVG Draped and cuirassed bust of Gordian III, laureate, to r.
Rev. SECVRITAS PVBLICA Securitas seated l., holding sceptre and propping head on l. hand.
Cm. 2.0 - Gr. 2.8
Brown University, Harkness Collection
Bibliography : RIC IV, n° 130.

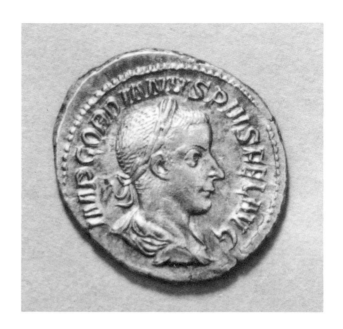

This denarius is believed to commemorate Gordian's marriage in the spring of AD 241 to Tranquillina, daughter of the Praetorian prefect Timesitheus[1]. One of six reverse types associated with Gordian's marriage issue, SECVRITAS PVBLICA, refers to the security and happiness that their marriage would bring to the Roman people.

This issue also represents one of the last issues of denarii to be minted. Pupienus and Balbinus had used a radiate denominatio, the antoninianus, as their basic silver coin in place of the denarius[2]. While Gordian similarly favored the antoninianus, he did create two issues of denarii in AD 241-243[3]. The debased quality of this coin is noticeable in its whitish rather than silver tone and its lighter weight.

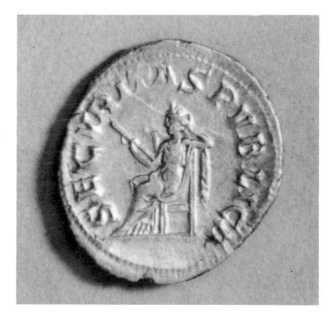

K.J.B

1. ELKS, K.J.J., in her article *The Denarii of Gordian III*, in *NC*, s. 12, 1972, p. 309-310, questions this theory while Mattingly (RIC IV, p. 7 and 10-11) supports it.
2. KENT, p. 38.
3. See RIC IV, p. 6-7.

46. Faustina II

AE Sestertius - AD 161

Obv. FAVSTINA - AVGVSTA Bust of Faustina II, draped, r.

Rev. SAECVLI FELICIT / S - C l. and r. in field. Draped, ornate throne on which two baby boys sit vis-à-vis, with stars above their heads.

Cm. 1.9 - Gr. 20.5

Courtesy of The Museu Historico Nacional, Rio de Janeiro

Bibliography : BMC IV, n° 936 ; RIC III, n° 1665.

Faustina II, born c. AD 125-130, was the daughter of Antoninus Pius and Faustina I. Although Hadrian had wanted her to marry Lucius Verus, in AD 145 she married her cousin Marcus Aurelius, who was closer to her age. They had many children, including Lucilla, who married Lucius Verus, the twins Commodus and Antoninus, Annius Verus, Faustina, Cornificia, and Fadilla[1]. After the birth of her first child in AD 146, she became *Augusta*, thereby indicating the value Antoninus placed on succession. This emphasis continued throughout Marcus Aurelius's reign. Therefore, it is not surprising that most of Faustina's coinage deals with two specific themes ; the life of the Imperial Family and the cult of the goddesses of the Roman state[2].

1. DRC, p. 375.
2. BMC IV, p. cxxxi.

Faustina's and Marcus Aurelius's marriage, with its blessing of many children, was frequently celebrated on Roman coins because it strengthened dynastic feeling. The reverse types of *Fecunditati Augustae* and *Saeculi Felicitas* exemplify the bliss of their age and attest to the birth of Faustina's many children. Specifically, the Fecunditas coin alludes to Faustina's fertility and depicts her four daughters Lucilla, Faustina, Cornificia and Fadilla, while the Felicitas coin depicts the birth of the twins Commodus and Antoninus in AD 161[3].

Faustina's coins rarely have a specific date, for her obverse legend was standardized during her lifetime and many reverse types deal with general family issues. As a result, dating is based on the style of her hair, three different coiffures being apparent[4]. Both of these coins illustrate the first type of hairstyle which dates from c. AD 157-164 ; it is elaborately waved in a single movement downward with the hair knotted low in a bun[5]. It is only the exact date of the births of Commodus and Antoninus that allows the *Saeculi Felicitas* coin to be assigned to 161.

EDG

3. *Ibid.*, p. cxxxii.
4. *Ibid.*, p. cxii.
5. *Ibid.*

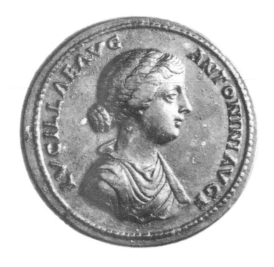 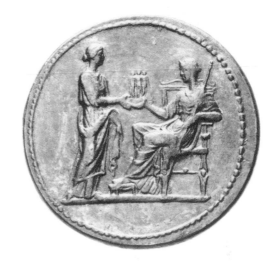

47. Annia Lucilla

AE Medallion - AD 164-169 or later
Obv. LVCILLAE AVG ANTONINI AVG F Lucilla bust r., draped.
Rev. Lucilla standing on l., presenting a statuette of the Three Graces (or three children) to a goddess who is seated on throne at r., with a sceptre in l. hand.
Cm. 3.8 - Gr. 47.3
Courtesy of The American Numismatic Society, New York
Bibliography : J.M. FAGERLIE, *Roman and Byzantine Medallions in the Collection of the American Numismatic Society*, in *ANS Museum Notes*, 15, 1969, p. 80, n° 6.

The physical difference between Roman coins and medallions is often negligible, and there exist a number of cases when a piece may be claimed by either side for equally valid reasons[1]. Medaillons were coin-like pieces that never exactly corresponded to any of the coin denominations. They were ordered by the emperor for a special or solemn purpose and were intended to be distributed as gifts ; any monetary purpose they may have served was strictly secondary.

This medallion of Lucilla represents an extremely rare issue, the purpose of which remains unclear, because of the undetermined identity of the seated goddess. On one hand, the figure has been identified as Vesta being presented with a statuette of the Three Graces by Lucilla[2]. If this is her identity, then the medallion may be interpreted as being of a general allegorical nature. On the other hand, the seated figure could be Venus or Juno[3], and therefore the three little figures may be either Lucilla's children or the Three Graces. In any case, the medal would refer to the Empress's fecundity, and it is likely therefore that it was struck in honor of her marriage to Lucius Verus.

Finally, it should also be noted that Lucilla's mother struck medallions during her own reign with the exact same reverse image on them[4].

ACW

1. TOYNBEE, J.M.C., *Roman Medallions*, in *Numismatic Studies*, 5, 1944, p. 16.

2. BALDWIN, A., *Six Roman Bronze Medallions*, in *NNM*, 17, 1923, p. 25-26.
3. TOYNBEE, p. 97, calls her Venus, and G. PANSI in BALDWIN, p. 24, calls her Juno.
4. GNECCHI, F., *I Medaglioni Romani* II, Milan, 1912, pl. 68, n° 2. See this book for an illustration of Faustina II's medal.

THE IMPERIAL FAMILY

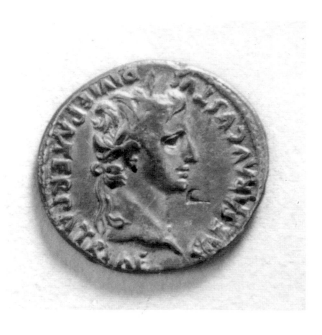

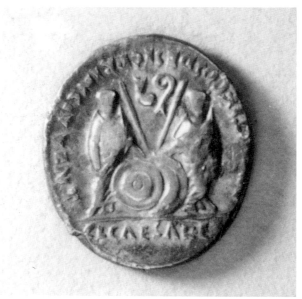

48. Augustus

AR Denarius - 2 BC-AD 11
Obv. CAESAR AVGVSTVS DIVI F PATER PATRIAE Head of Augustus r., laureate.
Rev. C L CAESARES in exergue AVGVSTI F COS DESIG PRINC IVVENT Gaius l. and Lucius r. standing togate and veiled. Between them two shields standing upright behind which are two spears with butts pointing upward ; between the butts, a simpulum on l. and a lituus on r.
Cm. 1.9 - Gr. 3.8
Brown University, Harkness Collection
Bibliography : RIC I, n° 207 ; Giard, n° 1651.
See also no. **12**.

Gaius and Lucius, the sons of Agrippa and Julia, appear on the reverse of this coin wearing the *toga virilis* ; between them lie the silver shields and spears that they received from the knights[1].

The grandsons of Augustus by birth, the brothers were also adopted by him while they were still in their youth in order to become his legitimate heirs. The seriousness with which Augustus viewed his young successors is manifest in the fact that coins bearing images of Gaius and Lucius were copied at provincial mints and are known to have been struck as far East as India[2].

This coin demonstrates the first occasion in which *princeps iuventutis*, or leader of the state's youth[3], appears on a Roman coin ; at the time the title was bestowed by acclamation and was purely honorary, but later in the Roman series it came to signify the heir apparent[4].

Various images of the brothers continued to appear on Augustan coins long after their untimely deaths in AD 4 and 2 ; the persistence of their image reflects a poignant interest, as it evokes both the highest hopes and the deepest disappointment of Augustus's life : « quoniam atrox fortuna Gaium et Lucium filios mihi eripuit »[5].

ACW

1. MACDONALD, D., *Observations on an Augustan Coin Type*, in *Jahrbuch für Numismatik und Geldgeschichte*, 28/29, 1978/79, p. 28.
2. RIC I, p. 58.
3. GROSS, W.H., *Ways and Roundabout Ways in the Propaganda of an Unpopular Ideology*, in *The Age of Augustus*, ed. Rolf WINKES, Providence, 1985, p. 43.
4. BMC I, p. cxvi.
5. Dio Cassius, LV, 12.1.

49. Augustus

AR Denarius - 2 BC
Obv. CAESAR AVGVSTVS - DIVI F. PATER PA-
TRIAE laureate head r.
Rev. PONTIF MAXIM Enthroned female figure holding
sceptre and ears of corn.
Cm. 1.8 - Gr. 3.7
Courtesy of Museu de Valores do Banco Central, Brasilia
Bibliography : C I, n° 223.

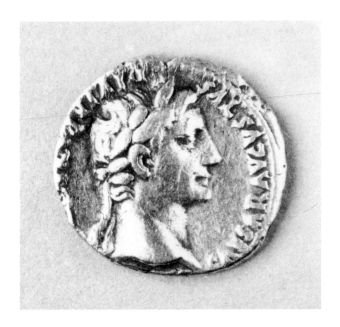

The political significance of Livia, wife of Augustus, is obvious in her appearance on official documents and especially apparent in the representations of divinities[1]. These may carry her features to allude to an association between her and a particular personification and they served in the establishment of dynastic power. This idea of dynastic control probably affected the public perception of the series of coins dated between AD 2-14 to which this denarius belongs. The reverses may represent Augustus's grandsons, Gaius and Lucius, Tiberius or this seated figure. The type of this particular figure is also continued on coins during the reign of Tiberius[2]. In consideration of the fact that the other Augustan obverses show members of the Imperial family and that this figure wears the nodus, the characteristic hairstyle of an early Livia portrait-type, and that her facial features could be interpreted as Livia's, this figure is both a personification and a portrait of the empress. When she is holding ears of corn, the figure has been interpreted as the personification of Ceres ; when holding a branch, she represents Pax, while the scepter has been interpreted as alluding to Iustitia.

The model for all of the seated female deities was the image of the seated Iuno[3].

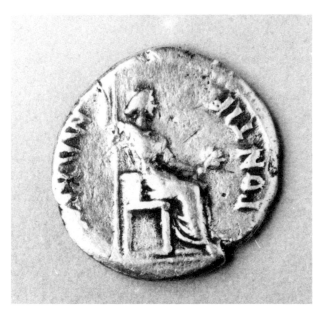

RW

1. Her intervention on behalf of the Samians is mentioned by Augustus in his letter of denial of the request for liberty. See MILLAR, F., in *Caesar Augustus*, Oxford, 1984, p. 42. Also, TAEGER, F., *Charisma. Studien zur Geschichte des antiken Herrscherkultes*, Stuttgart, 1947 ; RITTER, H.W., *Livias Erhebung zur Augusta*, in *Chiron, II*, 1972, p. 313-228.
2. See GROSS, W.H., *Iulia Augusta*, in *Abhandlungen Göttingen, phil.-hist. Kl.* 3F., n° 52, 1962, p. 12-14.
3. See LICHOCKA, B., *Iustitia sur les monnaies impériales*, Warsaw, 1974, p. 94-95.

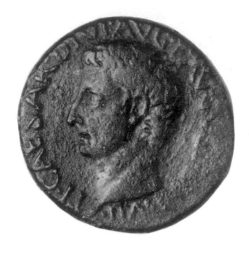

50. Tiberius

AE As - AD 15-16

Obv. TI. CAESAR. DIVI. AVG. F. AVGVST. IMP. VII. Head l., head bare.

Rev. PONTIF MAXIM TRIBVN POTEST XVII S - C Draped female figure seated r., feet on stool ; in r. hand a patera and in l. a long sceptre.

Cm. 2.8 - Gr. 10.8

Courtesy of The Museu Historico Nacional, Rio de Janeiro

Bibliography : RIC I, n° 33 ; BMC I, n° 65.

Tiberius was chosen to succeed Augustus after his biological descendants Gaius and Lucius died in AD 4 and 2. Despite Tiberius's immediate adoption, no coinage appeared reflecting his now prominent status as heir until AD 10-11[1].

It was very common during Tiberius's reign for his coinage to commemorate other members of the Imperial Family ; often, the images on coins excluded reference to the Emperor himself. In this case, the reverse is full of familial propaganda. Most recent scholarship does not agree on the identity of the reverse female figure. There are some who posit that the figure may allude to Livia, Tiberius's mother, under the guise of Pax, and there exists a coin of Cypriot (?) origin bearing this same seated figure on which the legend reads IVLIA AVGVSTA, the name to which Livia is referred after the death of Augustus[2].

This seated figure first appeared in late Augustan coinage and also continued to appear for the duration of Tiberius's lengthy estrangement from Livia. Consequently, this figure is more likely Pax, but we must remain aware that in spite of Tiberius's effort to restrain excessive honors for his mother, a further identification with Livia is quite possible[3].

ACW

1. SUTHERLAND, C.H.V., *Roman History and Coinage 44 BC-AD 69*, Oxford, 1987, p. 41.
2. GROSS, W.H., *Julia Augusta*, in *Abhandlungen der Akademie der Wissenschaften in Göttingen, Phil.-hist. Klasse*, 3, n° 52, 1962, p. 47.
3. *Ibid.*

51. Marcus Agrippa

AE As - c. AD 23-37
Obv. M. AGRIPPA - L. F. COS. III Head of Agrippa l.
wearing rostral crown.
Rev. S - C Neptune with dolphin and trident.
Cm. 2.8 - Gr. 9.6
Courtesy of Museo Paulista, Universidade de Sâo Paulo
Bibliography : RIC I, n° 58 ; BMC (Tib.) I, n° 161.

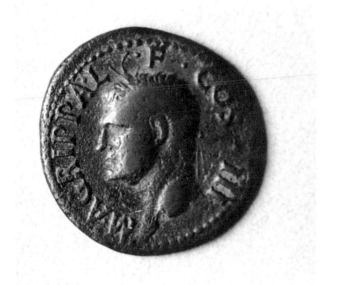

By the time of Caesar's death in 44 BC, Agrippa rose to become Octavian's most trusted military leader. Around 29 BC Agrippa married Iulia which made him son-in-law to Octavian.

The overt message on this coin is Agrippa's association with the Sea. The rostral crown he wears was given to him by Octavian after Agrippa's naval victory in the battle of Mylae[1]. On the reverse Neptune, god of the Ocean, carries symbols sacred to him. By having this god on the reverse of the coin bearing the likeness and legend of Agrippa, the naval commander is further associated with the domain where he carried out his military exploits. The coin is also an important reminder of the exalted position Agrippa held within the Imperial family. This coin was minted during the reign of Octavian's son Tiberius, long after the death of Agrippa in 12 BC[2].

MRW

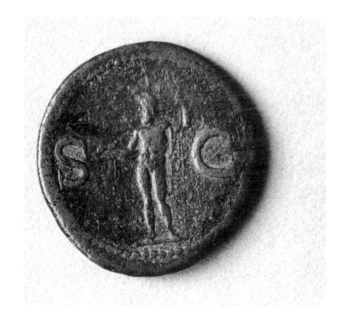

1. DRC, p. 27.
2. RODDAZ, J.M., *Marcus Agrippa*, Rome, 1984.

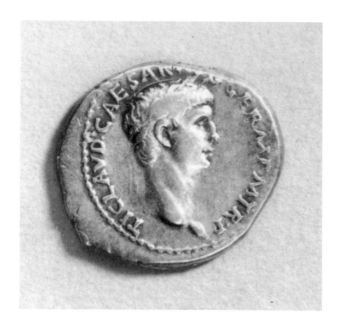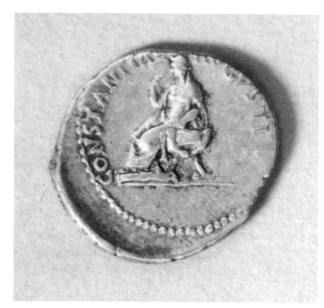

52. Claudius

AR Denarius - AD 41-52
Obv. TI CLAVD. CAESAR. AVG GERM PM TR P
Head of Claudius, laureate, r.
Rev. CONSTANTIAE AVGVSTI Constantia, draped and seated on a curule chair with her r. arm raised with the index finger pointing towards her mouth.
Cm. 2.0 - Gr. 3.8
Brown University, Harkness Collection
Bibliography : RIC I, n° 14 ; BMC I, n° 13.

Claudius was born in 10 BC, and ruled from AD 41 until 54, when he was poisoned by his second wife Agrippina. Even though there existed a blood relation to Augustus's wife Livia[1], his poor standing in the imperial family has often been mentioned. Ancient and modern writers have tended towards a depiction of Claudius as an outcast, and an embarrassment at public functions[2]. However, careful reading of ancient sources and inscriptions has shown that the proved to be a capable ruler, and that earlier in his life Augustus had recognized his potential[3]. The reverse legend and personification are unusual, but have been most convincingly interpreted as a manifestation of Claudius's constancy in the performance of his duties as civil magistrate and military leader[4]. Other variants of the Constantia type are found on coins honoring the memory of the Emperor's mother, Antonia Augusta.

JT

1. He was the youngest son of Drusus the Elder, Livia's son from her previous marriage, and Antonia the younger, daughter of M. Antony. There was no direct blood relation to Augustus himself ; see Julio-Claudian family genealogical table in GRANT, M., *The Roman Emperors : A Biographical Guide to the Rulers of Imperial Rome, 31 BC - AD 496*, New York, 1985, p. 8.

2. For historiography see BOATWRIGHT, M.T., *Tacitus on Claudius and the* Pomerium, Annals 12.23.2-24, in *Classical Journal*, 80, n° 1 (October - November 1984), p. 36-44.

3. CHARLESWORTH, M.P., in *Cambridge Ancient History* X, p. 667-668. Nor should Suetonius's « gossip » lead one to believe that Claudius was always scorned by his mother, Antonia, and grandmother Livia ; see STUART, M., *The Date of the Inscription of Claudius on the Arch of Ticinum*, in *AJA*, 40, 1936, p. 314-322.

4. BANTI, A., and SIMONETTI, L., *CorNumRom*, XIV, 1977, p. 35. After the abuses of power by Caligula, Claudius had promised greater stability through the observance of constitutional laws (RIC I, p. 123, n° 1) ; see also GRANT, M., *Constantiae Augusti*, in *NC*, X, 1950, p. 28, who notes that the curule chair may reflect the curule magistracy and old Republican values ; the index-finger gesture represents silence, a virtue related to that of constancy.

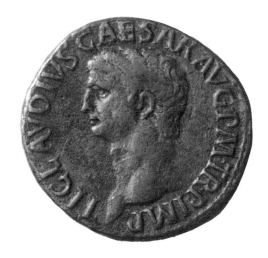
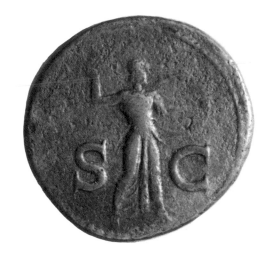

53. Claudius

AE As - AD 41-52
Obv. TI CLAVDIVS CAESAR AVG PM TR P IMP
Head of Claudius l.
Rev. S - C Minerva advancing to r. with a javelin in her r.
hand and shield on her l. arm.
Cm. 2.7 - Gr. 9.5
Brown University, Harkness Collection
Bibliography : RIC I, n° 100 ; BMC I, n° 149.

Ancient and modern writers have often noted Claudius's poor standing in the imperial family, despite his direct blood relation to Livia, Augustus's wife. This approach has often been reflected in assessments of his reign (AD 41-54)[1]. In fact, Claudius instituted an ambitious program of expansion that included the conquest of Britain[2]. His vast military operations may account for the inconsistent quality in much of the coinage during his reign[3]. This particular issue, from the Senatorial mint of Rome, is of very high quality. The robust facial features of the Emperor are modelled forcefully, emphasizing his distinct personality. The figure of a war-like Minerva on the reverse relates to the Emperor's ongoing military campaigns.

JT

1. Claudius was the youngest son of Drusus the Elder, Livia's son from her previous marriage. For historiography, see BOATWRIGHT, M.T., *Tacitus on Claudius and the* Pomerium, *Annals 12.23.2-24*, in *Classical Journal*, 80, n° 1 (October - November 1984), p. 36-44.
2. ANDREAE, B., *The Art of Rome*, New York, 1977, p. 145.
3. GIARD, J.-B., *Pouvoir central et libertés locales : le monnayage en bronze de Claude avant 50 après J.-C.*, in *RN*, 12, 1970-71, p. 33-43, noting the proliferation of « camp moneyers » in the provinces to pay troops.

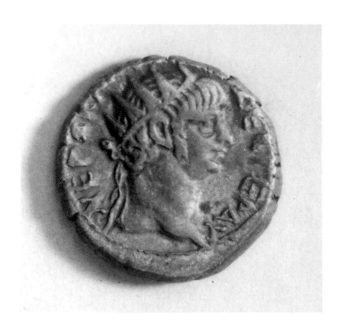

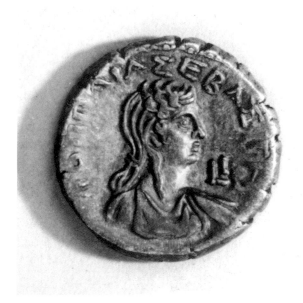

54. Nero and Poppaea

Billon Tetradrachm - AD 64-65
Obv. ΝΕΡΩ ΚΛΑΥ ΚΑΙΣ ΣΕΒ ΓΕΡ ΑΥ Nero facing r., radiate
Rev. ΠΟΠΠΑΙΑ ΣΕΒΑΣΤΗ in field. L - IA Bust of Poppaea, draped, r.
Brown University, Harkness Collection
Cm. 2.4 - Gr. 13.5
Bibliography : D. SEAR, *Greek Imperial Coins and Their Values*, London, 1982, BMC, p. 124, n° 664.

Nero married Poppaea in AD 62 after divorcing and then murdering his first wife Octavia. At the time of her marriage, Poppaea was 27 years old, six years older than Nero. She had been married previously to the senator Otho, one of the short-reigning emperors who succeeded Nero, but was divorced from him shortly after Nero met her in AD 58. In order to marry her, Nero sent Otho away to govern the distant province of Lusitania[1]. He later also murdered his mother, Agrippina II, who disapproved of their marriage. Their union was brief however, since Poppaea died of internal injuries in AD 65 after a beating by Nero[2].

During the reign of Nero, the Alexandrian mint produced vast amounts of tetradrachms, especially from AD 64-68 ; these issues may be connected to Nero's coinage reform in Rome or to his planned expedition into Ethiopia[3].

The style of this coin — with its crude, stylized features and schematic details — indicates that it was produced by local Egyptian artists, even though its type is Roman. Unlike most Emperors, Nero struck as many as ten different Alexandrian reverse types, including five of imperial personages. In the years AD 64-65 three are apparent ; one of them being of Nero and Poppaea[4].

EDG

1. GIACOSA, G., *Women of the Caesars*, trans. R.R. Holloway, Milan, p. 37.
2. GARZETTI, A., *From Tiberius to the Antonines*, trans. J.R. Foster, London, 1960, p. 169.
3. MILNE, p. xvii and xxv.
4. SEAR, p. xvii.

55. Nero

AE Sestertius - c. AD 66
Obv. IMP NERO CLAVD CAESAR AVG GERM P M
TR P PP Head laureate l.
Rev. S C in field, ROMA in exergue. Roma draped seated
on shields and holding Victory in r. hand and spear in l.
Cm. 3.1 - Gr. 26.5
Brown University, Harkness Collection
Bibliography : RIC I, n° 334.

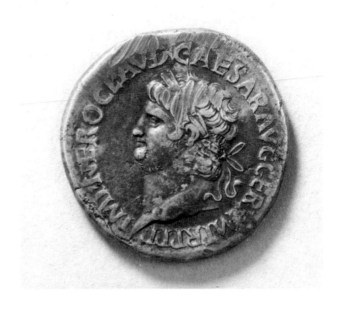

When Claudius died in AD 54, Nero ascended his
adoptive father's throne at the age of 17. In
addition to the list of Nero's titles, the obverse
legend delineates his genealogy, and hence supports
his claim to power, as son of Claudius and grandson
of Augustus[1]. The use of Imperator as a praenomen
dates the coin after AD 66 when, according to
Suetonius, the people of Rome hailed Nero as
Imperator[2].

Nero's hair lies in combed rows or steps, a
hairstyle he adopted after visiting Greece. Suetonius
LI.1 *Circa sultum habitumque adeo pudendus, ut
coman semper in gradus hormaram peregrinatione
Acharca.* The inclusion of a slight beard under
Nero's chin appears to contradict Suetonius's and
Dio Cassius's accounts of Nero's clean shaven
appearance, but such an attribute refers to his great
grandfather, Germanicus, whose coins also depicted
him with a beard[3].

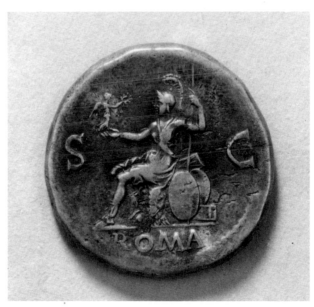

HBR

1. REECE, R., *Roman Coins*, London, 1970, p. 170-171.
2. During the visit of Tiridates, the King of Armenia and a
 prince of Parthia, the people bestowed this accolade. Sueto-
 nius, XIII.1.
3. GRIFFIN, M., *Nero, the End of a Dynasty*, New Haven, 1984,
 p. 22.

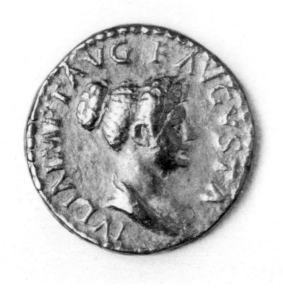

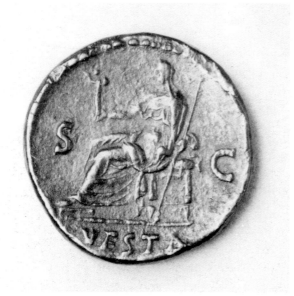

56. Julia Titi

AE Dupondius - c. AD 79-81
Obv. IVLIA IMP T AVG F AVGVSTA Head of Julia r., draped.
Rev. VESTA (in exergue) S - C Vesta seated l., holding palladium in r. hand and sceptre in l.
Cm. 2.6 - Gr. 14.4
Courtesy of the Museu Historico Nacional, Rio de Janeiro
Bibliography : RIC II, n° 180.

As daughter of Emperor Titus by his second wife, Julia would most likely have received the honors of the Vestal Virgins[1]. The image of Vesta on the reverse of this dupondius undoubtedly testifies to this event. As goddess of the Hearth, the worship of Vesta was not only a state cult, but part of home worship as well. The Vestal Virgins were chosen by the Pontifex Maximus from daughters of prominent families aged 6-10, who would serve Vesta for five years. As keepers of the temple of Vesta, the Virgins were also responsible for the care of the Palladium, pictured on this coin in the right hand of Vesta. The Palladium was an ancient and sacred image of Athena, believed to protect the city and the Roman people.

The role of the Vestals was a somewhat contradictory one ; they were at the same time both virgins and matrons, performing symbolic duties similar to those of a *mater familias*, tending the sacred flame and taking part in festivals[2]

The portrait of Julia on this dupondius is the first example of a living woman of the Imperial family, not an empress, being portrayed alone on a coin of the official Roman Senatorial mint[3]. Until this time, women portrayed without the presence of another portrait were only posthumous and commemorative, or their features added to the image of a goddess[4].

LLA

1. BMC II, p. lxxv.
2. BEARD, M., *The Sexual Status of Vestal Virgins*, in *JRS*, 70, 1980, p. 13.
3. GIACOSA, G., *The Women of the Caesars : Their Lives and Portraits on Coins*, Trans. Ross Holloway, Milan, p. 41.
4. *Ibid.*, p. 34.

57. Hadrian

AR Denarius - AD 132-134
Obv. HADRIANVS - AVGVSTVS Bust of Hadrian, l.
Rev. IVSTITIA - AVG COS III PP Justitia seated l. with patera and sceptre.
Cm. 1.7 - Gr. 3.4
Brown University, Harkness Collection
Bibliography : RIC II, n° 214.

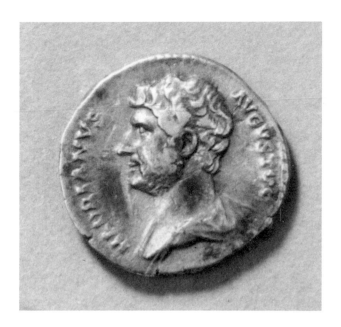

One of a series of personifications of government, this coin introduces a new Iustitia type, and shows the full, bearded draped portrait of the Emperor, common in this period[1].

Hadrian's earliest issues bear the name HADRIANO in the dative which, in juxtaposition which the nominative TRAIANVS, implies a transference of power. Later issues with the name Hadrian in the nominative represent a stronger statemen of Hadrian's ascendence[2]. By the time of this denarius, Hadrian's reign was secure, and the obverse legend refers not to Trajan, but to Augustus. Thus Hadrian claims kinship with the first *Princeps*.

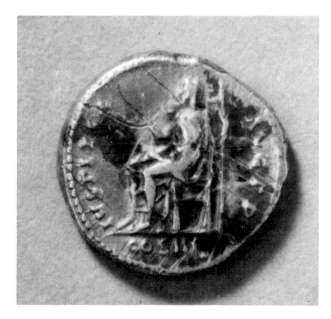

Hadrian's greatest significance in the history of the Imperial family consists of his effective moves to control the succession of the principate. Childless, the Emperor carefully aligned as his adoptive heirs Annius Antoninus, Annius Verus and the young Ceionius Commodus, who, when they accede, took the names, respectively, Antoninus Pius, Marcus Aurelius and Lucius Verus[3].

DCS

1. RIC II, p. 326 and 364.
2. BMC III, p. cxiv.
3. CHAMPLIN, E., *Hadrian's Heir*, in *Zeitschrift für Papyrologie und Epigraphik*, 2.1, 1976, p. 79-89 ; BARNES, T.D., *Hadrian and Lucius Verus*, in *JRS*, 57, 1967, p. 65-79.

58. Faustina I

AR Denarius - After AD 141
Obv. DIVA FAVSTINA Bust r. draped, with hair elaborately waved and banded, drawn up at back and piled in coil at top.
Rev. AETER - NITAS Aeternitas standing l., draped, holding phoenix r., and pulling out fold of skirt l.
Cm. 1.7 - Gr. 3.2
Brown University, Harkness Collection
Bibliography : BMC IV, n° 354 ; RIC III, n° 347.

There were two basic types of consecration coins for Faustina : the earlier one stresses *Aeternitas*, while a later issue with *Augusta* emphasizes the Empress's revered nature. The precise meaning behind *Aeternitas* is elusive and cannot be understood simply as the name of a goddess. It appears to refer to the timeless, eternal sphere in which the goddesses dwell and of which Faustina herself is now an inhabitant[1]. The figures accompanying the Aeternitas legend may be viewed in various ways. The spirit of Aeternitas with attributes and emblems could be borrowed from the numerous goddesses and virtues who reside in the heavenly realm[2] ; or they may be the goddesses themselves ; or finally, the image may be understood to be Faustina herself at last in possession of the attributes of the various eternal goddesses[3].

ACW

1. BMC IV, p. lxii.
2. VOGEL, L., *The Column of Antoninus Pius*, Cambridge, 1973, p. 39.
3. MATTINGLY, H., *The Consecration of Faustina the Elder and Her Daughter*, in *Harvard Theological Review*, LVI, 1948, p. 147.

59. Antoninus Pius

AR Denarius - AD 145-148
Obv. ANTONINVS AVG PIVS [] Antoninus r., laureate head.
Rev. COS III. Concordia with patera and sceptre l.
Cm. 1.7 - Gr. 3.3

Brown University, Harkness Collection
Bibliography : RIC III, n° 129.

The legend on the obverse first appeared in AD 139-140 and referred to honors bestowed by the Senate[1]. The reference to Antoninus's fourth consulship[2] dates the coin. between AD 145 and 147, during which time, the heir apparent, Marcus Aurelius, married Antoninus's daughter Faustina II[3]. This fact explains the allegorical representation of Concordia, the draped and veiled female figure on the reverse[4], who personifies harmony and understanding[5] within the Imperial House.

HBR

1. RIC III, p. 42.
2. *Ibid.*, p. 20.
3. *Ibid.*, p. 8. The marriage occurred in AD 145.
4. *Ibid.*, p. 42.
5. See KENT n° 298.

60. Marcus Aurelius

AR Denarius - AD 156-157
Obv. AVRELIVS CAES - ANTON AVG PII F Marcus Aurelius r., head bare.
Rev. TR POT XI - COS II Virtus helmeted standing l. holding parazónium and spear.
Cm. 1.6 - Gr. 2.5
Brown University, Harkness Collection
Bibliography : RIC III, n° 473.

Marcus Aurelius's adoption, referred to in the obverse legend, by Antoninus Pius in Ad 135 and his marriage to Faustina II in AD 145 assured the succession of an Antonine. Antoninus Pius repeatedly honored his heir with numerous issues of coins of which this is one example. These convey to the public the Concordia, Felicitas, Hilaritas, Honos and Spes that Marcus Aurelius's succession to the throne would bring to the Empire. They also proclaim the quality of *Virtus*, used to personify his military prowess.

HBR

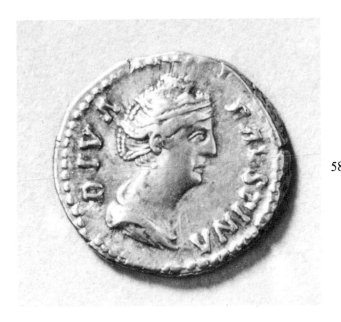
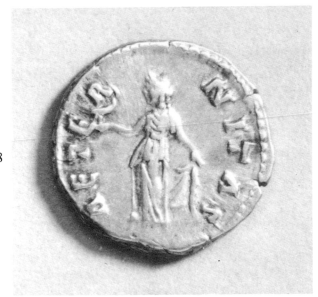

58

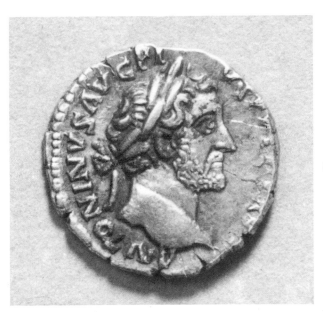

59

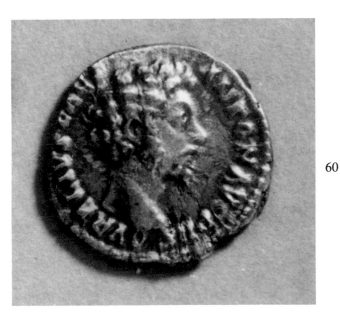

60

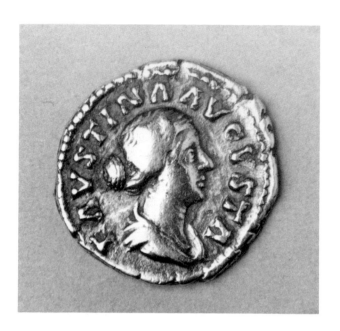

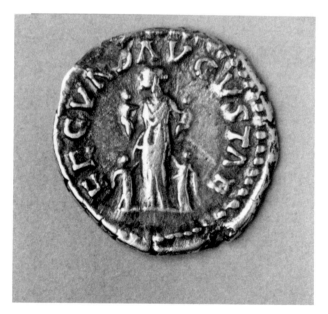

61. Faustina II

AR Denarius - c. AD 157-164
Obv. FAVSTINA AVGVSTA Bust of Faustina II, r.
Rev. FECVND AVGVSTAE Fecunditas standing l. between two girls and holding two infants in her arms.
Cm. 3.3 - Gr. 20.5
Courtesy of The Museu Historico Nacional Rio de Janeiro
Bibliography : C. III, n° 95 ; RIC III, n° 676.

Faustina II, born c. AD 125-130, was the daughter of Antoninus Pius and Faustina I. Although Hadrian has wanted her to marry Lucius Verus, in AD 145 she married her cousin Marcus Aurelius, who was closer to her age. They had many children, including Lucilla, who married Lucius Verus, the twins Commodus and Antoninus, Annius Verus, Faustina, Cornificia, and Fadilla[1]. After the birth of her first child in AD 146, she became *Augusta*, thereby indicating the value Antoninus placed on succession. This emphasis continued throughout Marcus Aurelius's reign. Therefore, it is not surprising that most of Faustina's coinage deals with two specific themes : the life of the Imperial Family and the cult of the godeses of the Roman state[2].

Faustina's and Marcus Aurelius's marriage, with its blessing of many children, was frequently celebrated on Roman coins because it strengthened dynastic feeling. The reverse types of *Fecunditati Augustae* and *Saeculi Felicitas* exemplify the bliss of their age and attest to the birth of Faustina's many children. Specifically, the Fecunditas coin alludes to Faustina's fertility and depicts her four daughters Lucilla, Faustina, Cornificia and Fadilla, while the Felicitas coin depicts the birth of the twins Commodus and Antoninus in AD 161[3].

Faustina's coins bear rarely a specific date, for her obverse legend was standardized during her lifetime and many reverse types deal with general family issues. As a result, dating is based on the style of her hair, three different coiffures being apparent[4]. Both of these coins illustrate the first type of hairstyle which dates from c. AD 157-164 ; it is elaborately waved in a single movement downward with the hair knotted low in a bun[5]. It is only the exact date of the births of Commodus and Antoninus that allows the *Saeculi Felicitas* coin to be assigned to 161.

EDG

1. DRC, p. 375.
2. BMC IV, p. cxxxi.
3. *Ibid.*, p. cxxxii.
4. *Ibid.*, p. cxii.
5. *Ibid.*

62. Lucius Verus

AR Denarius - March-December AD 161
Obv. IMP L AVREL VERVS AVG Verus bare-headed
to r.
Rev. PROV - DEOR TR PII COS II Providentia standing
to l., holding a globe and cornucopia.
Cm. 1.7 - Gr. 3.4
Brown University, Harkness Collection
Bibliography : RIC III, n° 482.

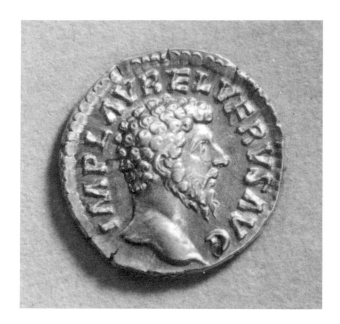

Hadrian compelled his heir apparent, Antoninus Pius, to adopt Lucius Verus along with Marcus Aurelius. This occurred in AD 138, after the death of Verus's father, who had been Hadrian's first choice as successor[1]. When M. Aurelius ascended to the throne in AD 161, his adoptive brother Verus was then invested with imperial power and the cognomen Augustus. Except for the office of Pontifex Maximus that Marcus retained this was an unprecedented full imperial partnership. To seal the bond M. Aurelius gave his daughter Lucilla to Verus in marriage in AD 164. This coin is dated to the earliest months of their joint reign. There is an intentional similarity between coin portraits of Verus and Aurelius at this time. Both men are depicted with a mass of tightly curling hair, close-cut beards, and long straight noses. This was done to stress « the harmony and interaction between the two joint emperors. »[2]

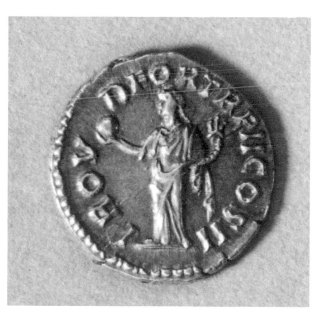

The personification of Divine Providence on the reverse is best understood in terms of the long-standing imperial problem of succession. This cult figure was often invoked for the assurance of a continually stable government *(aeternitas)*, by a related or adopted heir[3].

JT

1. GRANT, M., *The Roman Emperors : A Biographical Guide to the Rulers of Imperial Rome, 31 BC - AD 496*, New York, 1985, p. 83.
2. ALBERTSON, F.C., *The Sculpted Portraits of Lucius Verus and Marcus Aurelius*, Ann Arbor, 1982, p. 107. Verus's coin portraits after c. AD 161 become more reflective of the long, twisting beard as seen on his sculpted portraits (« Main Type ») ; WEGNER, M., *Die Herrscherbildnisse in antoninischer Zeit*, Berlin, 1939, p. 57 ff.
3. CHARLESWORTH, M.P., *Providentia and Aeternitas*, in *Harvard Theological Review*, 29, n° 2, Apr. 1936, p. 107-132.

63. Caracalla

AR Denarius - AD 199-200
Obv. ANTONINVS - AVGVSTVS Bust, laureate, cuirassed, r.
Rev. PONTIF - TR P III Sol standing front, with globe and spear.
Cm. 1.8 - Gr. 3.3
Brown University, Harkness Collection
Bibliography : BMC V, n° 1951 ; RIC IV, n° 30a.

In AD 198 Septimius Severus elevated his son Caracalla to the rank of co-emperor in an attempt to found a Severan dynasty. Much of the iconography of the coin can be interpreted within this political context. Caracalla here is depicted in his so-called second portrait type, which was created in conjunction with his rise to Augustus in 198[1]. The portrait type, exemplified by a head from the Arch of Argentarii, shows the youthful ruler with curly, somewhat bushy hair which flows backward along the scalp and then curls forward at the back of the neck[2]. In accordance with the dynastic nature of the portrait type, the frothing locks of the young Caracalla are meant to connect him with the Antonines — the popular Emperors whom the Severans succeeded and with whom they sought to identify themselves[3].

An additional dynastic reference can be discerned in the portrait's similarity to images of Geta, Caracalla's younger brother, who was made a Caesar when Caracalla became an Augustus. Their physiognomic resemblance arose from a desire to propagate the fiction of their fraternal concord and to project the image of a unified new dynastic order in the wake of the turbulent Wars of the Succession (193-198).

GW

1. HILL, P.V., *The Coinage of Septimius Severus and His Family of the Mint of Rome*, London, 1964, p. 8.
2. WIGGERS, H., *Caracalla, Geta, Plautilla*, in *Das römische Herrscherbild*, ed. WEGNER, M., Berlin, 1971, p. 13.
3. HANNESTAD, N., *Roman Art and Imperial Policy*, Mosgard, 1986, p. 259.

64. Septimius Severus

AR Denarius - AD 200-201
Obv. SEVERVS AVG - PART MAX Severus laureate r.
Rev. RESTITVTOR - VRBIS Severus l. with spear and patera.
Cm. 1.7 - Gr. 3.5
Brown University, Harkness Collection
Bibliography : RIC IV, n° 167a.

The series of coins bearing the legend RESTITVTOR VRBIS does not directly relate to any of Septimius Severus's efforts to rebuild and beautify the city of Rome. Rather, the reverse refers to his efforts to restore the honor and military strength of the Empire after the murder of Pertinax. The defeat of the Parthian forces in the East by his armies and the deaths of his two competitors, Albinus and Niger, secured his position in the East and West. This allowed Septimius to concentrate his efforts on rebuilding the Empire[1].

MRW

1. DRC, p. 688.

65. Geta

AR Denarius - AD 200-202
Obv. P SEPT GETA - CAES PONT Bust of Geta r.
Rev. PRINC IV - VENTV - TIS Geta standing l. before a trophy, holding a laurel branch and spear.
Cm. 1.7 - Gr. 2.2
Brown University, Harkness Collection
Bibliography : RIC IV, n° 18.

Lucius Publius Septimius Geta (189-212) was the second son of Septimius Severus and Julia Domna. He served as co-Emperor with his elder brother Caracalla from 211, until the latter had him assassinated a year later. A *damnatio memoriae* followed, of which this and other coinages are survivors. It comes from the more hopeful, secure period of his life, when his father was still alive and he had been fashioned Caesar at the age of nine. He was being advanced in rank along with his brother, who had been given the cognomen Augustus in the same year[1]. This was all part of Severus's ambitious campaign to establish a dynasty[2]. The portrait on the obverse is executed with delicate modelling which brings out subtle nuances in Geta's features. The *paludamentum* thrown over his shoulder denotes his status, as does the figure on the reverse, with the trappings of military command.

JT

1. FELLETTI MAJ, B.M., in *Enciclopedia dell'arte antica : classica e orientale* iii, Rome, 1959, p. 855.
2. Even to the point of proclaiming a « posthumous adoption » into the family of the Antonines ; MILLER, S.N., in *Cambridge Ancient History*, XII, p. 34.

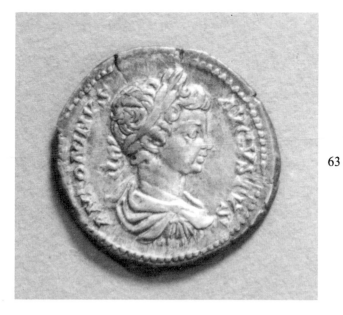
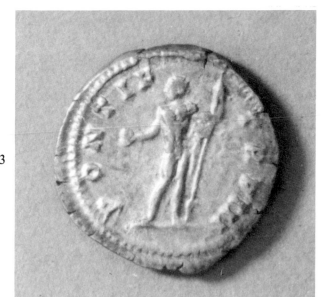

63

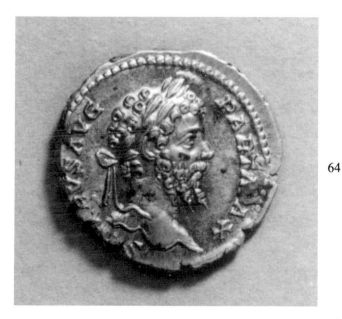
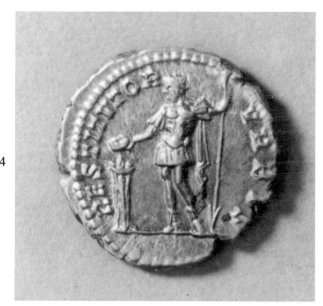

64

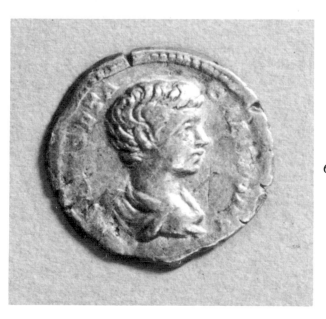
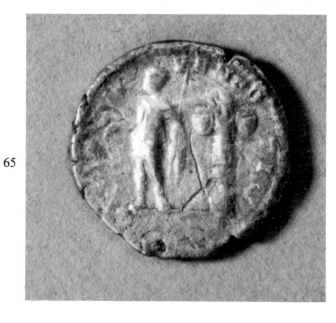

65

66. Septimius Severus

AR Denarius - AD 202
Obv. SEVER P AVG PM - TR P X COS III Severus, laureate, bearded r.
Rev. FELICITAS / SAECVLI Julia Domna f. with Geta and Caracalla.
Cm. 1.9 - Gr. 3.7
Brown University, Harkness Collection
Bibliography : RIC IV, n° 181c

The sons of Septimius, Caracalla, elevated to Augustus, and Geta, elevated to Caesar in AD 198, were established into a line of succession similar to the Antonines, whom Septimius spent much effort emulating[1].

The most important aspect of this coin is the image on the reverse. The wife of Septimius is framed by her two sons, each in profile, with the bust of Julia facing the viewer[2]. FELICITAS SAECVLI, with Julia Domna and her two sons, is meant to represent the happiness of the Imperial family as well as the harmony and security of the Empire under Septimius[3].

MRW

1. Mc CANN, A.M., *The Portraits of Septimius Severus A.D. 193-211*, Rome, 1968, p. 64.
2. KENT, p. 35.
3. For a discussion of coin portraiture under Septimius Severus see HILL, P.V., *The Coin Portraiture of Severus and his Family from the Mint of Rome*, in *NC*, 139, 1979, p. 36-46.

67. Caracalla

AR Denarius - AD 214
Obv. ANTONINVS PIVS AVG GERM Head, laureate, r.
Rev. P M TR P XVII COSIIII P P Apollo seated l., holding branch and lyre on tripod.
Cm. 1.9 - Gr. 3.0
Brown University, Harkness Collection
Bibliography : BMC V, n° 91 ; RIC IV, n° 238a.

The denarius, struck in Rome in AD 214, attests to the waning of Severan dynastic pretentions and to the advent of Caracalla as sole emperor. This change in Severan iconography occurred after Caracalla had his brother and co-ruler, Geta, murdered in 212 and reflects Caracalla's individual agenda rather than any familial interests.

The portrait on the coin, an example of the Emperor's final or sole ruler portrait-type, shows him with short, nubby curls, a short-cropped beard and rather massive, contorted features[1]. The appearance of the Emperor can be explained in light of his adoption of the aspect and behavior of common soldiers[2]. Caracalla's self-styled role as a rugged fellow soldier was partly based on his love for violence and rough manners, but also on a shrewed attempt to win the affections of the Roman army[3], which as Caracalla recognized, had become the true fount of power in the early third century.

GW

1. See WIGGERS, H., *Caracalla, Geta, Plautilla*, in *Das römische Herrscherbild*, ed. WEGNER, M., Berlin, 1971, p. 28-35 ; HILL, P.V., *The Coinage of Septimius Severus and His Family of the Mint of Rome*, London, 1964, p. 8.
2. HANNESTAD, N., *Roman Art and Imperial Policy*, Mosgard, 1986, p. 284.
3. CAMPBELL, J., *The Emperor and the Roman Army*, Oxford, 1984, p. 53.

68. Julia Mamaea

AR Antoninianus - AD 232-235
Obv. IVLIA MA - MAEA AVG Bust r., draped, diademed.
Rev. FECVND - AVGVSTAE Fecunditas seated l., holding hand of a child and resting l. arm on seat.
Cm. 1.8 - Gr. 2.9
Brown University, Bishop Collection
Bibliography : RIC IV (part 2), n° 332.

Fecunditas is a type usually associated with new motherhood, but considering the date of this coin, no earlier than the last four years of her son Severus Alexander's reign, it is correct to assume that it had no more specific meaning than that of Empress-Mother[1].

The image of Fecunditas on the reverse constitutes one of three common types on Julia Mamaea's coinage, which is paired with the unusual genitive *Augustae* as opposed to the more usual *Augusta*[2]. It is generally assumed that the other two types — Juno and Pietas — were struck at about the same time. While the sequence of the *Augustae* types is not definite it is thought that the Fecunditas type is the latest of the three. Hoard evidence proves it to be six or seven times more common than either of the others, and because final issues of a reign can be repetitive and persistant in their address of familary members, it is probable that Fecunditas post-dates the others[3].

ACW

1. BMC VI, p. 82.
2. *Ibid.*, p. 77.
3. *Ibid.*

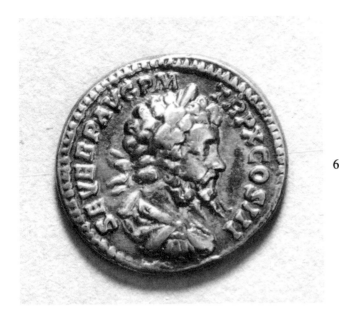
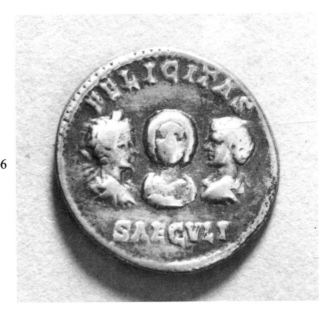

66

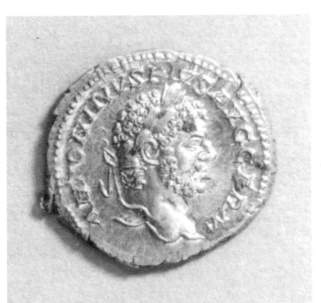
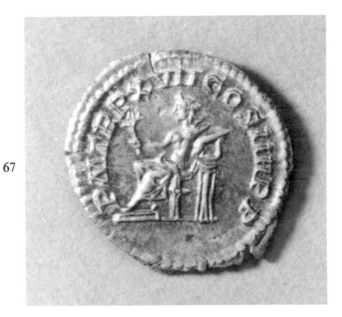

67

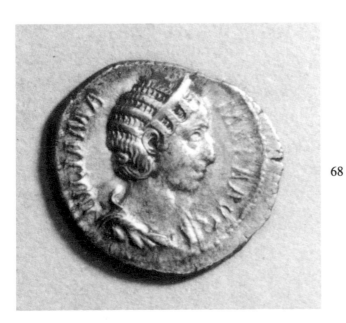
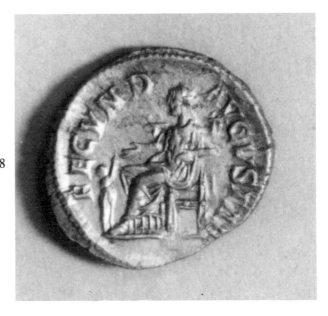

68

69. Otacilia

AE Medallion - AD 248

Obv. MARCIA OTACIL SEVERA AVG Bust of Otacilia to r., draped and wearing a stephane. Hair in horizontal ridges ; plait up back of head.

Rev. PIETAS AVGVSTORVM III ET II COS in exergue. Confronting busts of Philip I, to r. and laureate, and Philip II, to l. and bareheaded. Both are draped and cuirassed.

Cm. 3.8 - Gr. 37.2

Courtesy of The American Numismatic Society, New York

Bibliography : C. V., n° 4 ; RIC IV, n° 212 ; FAGERLIE J. M., *Roman and Byzantine Medallions in the Collection of the American Numismatic Society* (*ANS Museum Notes*, 15), 1969, n° 15.

Normally of gold, silver or some copper alloy, medallions were commemorative pieces, larger than normal coins and more finely designed and struck. Often noted for their beauty and complexity of design, medallions were not generally used as a media of exchange. They were usually issued by the emperor to commemorate important events in the empire, such as significant occurrences in the life of the imperial family, religious ceremonies and customs, civic and military events, etc. The emperor presented these pieces to court and government leaders as a mark of favor[1].

Otacilia (Marcia) Severa married Philip I around AD 234. The birth of their son, Philip II, occurred seven years before Philip I became Emperor. In addition to Philip II, she is said to have had a daughter, but her existence is unverified[2].

Otacilia was an ambitious woman who played an active role in Philip I's political affairs ; most noteworthy, she participated with Philip in the murder of Gordian III[3]. She declared herself a Christian and raised Philip II in her faith. As a result of her religious beliefs, Christians were not persecuted during her husband's reign[4]. Philip II was murdered in her arms by the the Pretorians, in whose camp they jointly had sought refuge at the approach of Trajanus Decius to Rome. Earlier her husband had been killed by his own troops while marching against Trajanus Decius.[5]

Philip I, also known as Philip the Arab, is depicted with Philip II on the reverse of this medallion. The reverse legend proclaims the love and good will shared between father and son. The presence of Otacilia on the obverse implies that this piety is shared by all family members. The legend also signifies the affection which the Imperial Family had for its subjects.

The medallion is dated to AD 248 because of the inscription in the exergue. Philip I was in his third consulship in 248 while Philip II was in his second[6].

EDG

1. SCHWARTZ, M.D., *Medal*, in *McGraw-Hill Dictionary of Art*, IV, ed. B.S. Myers, New York, 1969, p. 26.
2. DRC, p. 590.
3. *Ibid.*
4. *Ibid.*
5. *Ibid.*
6. RIC IV, p. 55.

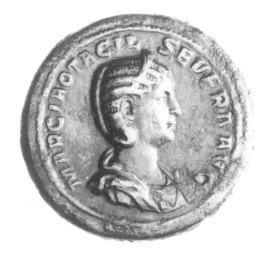
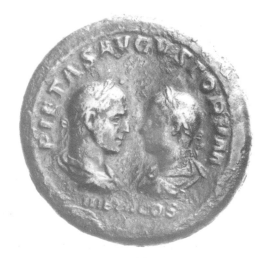

VIRTUES

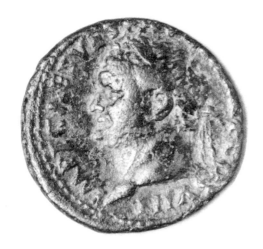 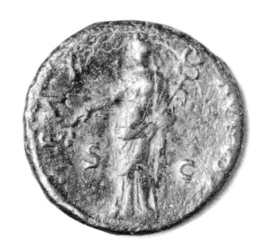

70. Titus

AE Sestertius - AD 80
Obv. IMP T CAES VESP AVG P M TR P P P COS VIII
Laureate head of Titus, bearded, l.
Rev. PAX - AVGVST S - C Pax standing l., holding a
branch and cornucopia.
Cm. 2.7 - Gr. 10.1
Courtesy of The Museu Historico Nacional, Rio de
Janeiro
Bibliography : BMC II, n° 171 ; RIC II, n° 94.

Exhibiting Titus's characteristic short curly hair
and heavy, muscular build, this sestertius associates
him with Pax.

Titus was initially known for his military succes-
ses, particulary his AD 70 capture of Jerusalem for
which his troops saluted him Imperator[1]. Minted

some ten years later, however, Titus followed a
common imperial practice of focusing on the bene-
fits of war. Namely, his reverse type illustrates the
bringing of peace and the prosperity associated with
it (symbolized here by the cornucopia) to the Roman
Empire.

Because of its abbreviated form, the specific
meaning of PAX AVGVST is ambiguous. PAX
AVGVSTA would refer to The Peace of the Empire
or « Augustan Peace » while PAX AVGVSTI
would attribute the qualities of Pax to the Empe-
ror[2]. Perhaps deliberately done, this enabled Titus
to benefit from both the comparison of his peaceful
Empire with Augustus's revered Empire and his
being credited with the god-granted ability to instill
and keep the peace desired by the populace.

KLB

1. The IMP in the obverse legend may refer to this as well as to
 the Senate's granting of that title in AD 70-71 when he and
 Vespasian became co-rulers.

2. See BMC II, p. xxi-xxii.

71. Trajan

AR Denarius - AD 112-117
Obv. IMP CAES NER TRAIANO OPTIMO AVG GER DAC Trajan facing r., laureate and draped.
Rev. PM TR P COS VI PP SPQR Mars walking r. with spear and trophy.
Cm. 1.9 - Gr. 2.7
Brown University, Harkness Collection
Bibliography : RIC II, n° 337.

Mars was commonly struck on Roman coins to proclaim the emperor's valor, strength and courage. Trajan, for example, repeatedly issued Mars types besides standardizing many of his obverse and reverse legends[1]. Trajan used both official titles and reverse types to convey and illustrate his excellence. In the case of this coin, Mars, as well as the titles *Optimus, Germanicus* and *Dacicus* allude to Trajan's victory over the Dacians and Germans[2]. Previously, Trajan had used the word *Optimus* on his victory coins as an adjective, but in early AD 115 he made it part of his official title[3].

In depicting Mars, Trajan meant to convey the stability and prosperity of an Empire ruled by a highly capable leader. Specifically, Trajan is stating that he has successfully protected Rome from her enemies. By using the titles *Germanicus* and *Dacicus*, Trajan cites specific military campaigns.

EDG

1. RIC II, p. 237-238.
2. BMC III, p. lxxii.
3. *Ibid.*, p. lxxxiii.

72. Diocletian

AE Antoninianus - AD 291-292
Obv. IMP C C VAL DIOCLETIANVS PF AVG. Radiate bust of Diocletian to r.
Rev. CONCORDIA MILITVM. In the exergue, a mint mark. Diocletian, helmeted, l., receives a Victory statuette from Jupiter, veiled and holding a spear at r. In the field, A. In exergue, XXX.
Cm. 2.20 - Gr. 4.2
Courtesy of The Museu Paulista, Universidade de Sâo Paulo
Bibliography : RIC V (part 2), n° 284.

This coin is dated to AD 291-292, when Diocletian was co-Emperor with Maximian[1]. Diocletian was also engaged in a variety of military campaigns at this time, which is expressed in CONCORDIA MILITVM. Diocletian sought to reassert the position of Emperor by aligning himself closely with Jupiter and conferring the designation of Herculius on his co-

Augustus Maximian[2]. Jupiter himself appears on the reverse handing Victory to Diocletian, which is a clear visual statement of the Emperor's divine right to rule. He and his colleagues came to enjoy an unprecedented courtly ritual, surrounded by the aura of those acting as representatives of the gods[3]. The obverse portrait is an example of the geometrical abstraction that characterizes late third-century Roman art. This is evident in the strong, cylindrical neck and the block-like head of the Emperor.

JT

1. Maximian became part of the Tetrarchy in AD 293 ; MATTINGLY, H., in *Cambridge Ancient History*, XII, p. 325.
2. GRANT, M., *The Roman Emperors : A Biographical Guide to the Rulers of Imperial Rome, 31 BC - AD 496*, New York, 1985, p. 210.
3. MATTINGLY, H., *Roman Coins*, London, 1960, p. 238.

73. Hadrian

AR Denarius - c. AD 130-131
Obv. HADRIANVS - AVG COS III PP Hadrian, bearded, r.
Rev. ALEXA - NDRIA Alexandria, standing l., holding sistrum and a snake in a basket.
Cm. 1.8 - Gr. 3.0
Brown University, Harkness Collection
Bibliography : RIC II, n° 300.

Alexandria, a personification of the Egyptian city, is shown seated holding a *sistrum*, which was used by priests in the rites of Isis, and a snake in a basket, or *situla*. The *situla* was used to indicate the flow and rise of the Nile. The coin is probably from the late part of Hadrian's reign, which began in AD 117, when in Antioch he succeeded Trajan as Emperor. In AD 119 he was elected Consul for the third and last time and in AD 138 he died at Baiae. The PP on the obverse legend pushes the dating of this coin to the end of his rule, possibly around AD 130-131, the winter of which he spent in Egypt. Despite his widespread travels, Hadrian's coinage was minted, for the most part, in Rome and thereafter sent to the provinces for distribution. According to biographers he never covered his head — whatever the weather — and was « the first emperor who allowed his beard to grow » (Dion)[1]. The head itself is finely modelled with finely detailed beard and hair, presenting a powerful and memorable portrait.

JWH

1. DRC, p. 441-445.

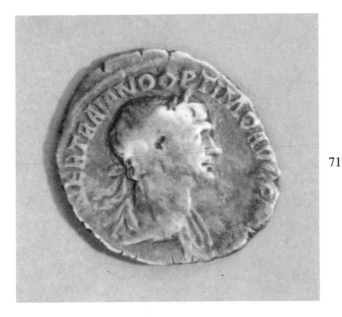
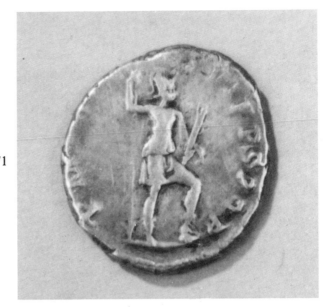

71

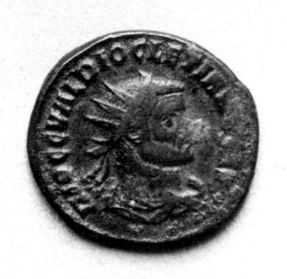
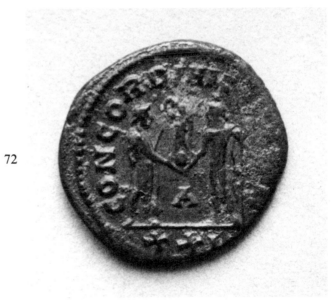

72

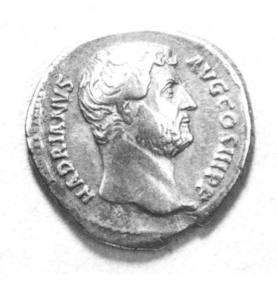
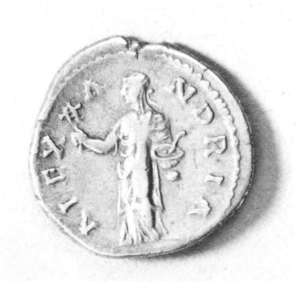

73

74. Titus

AE - AD 80-81
Obv. IMP T CAES VESP AVG PM TR P COS VIII
Laureate head of Titus, bearded, l.
Rev. GENI P R S C Genius standing l., holding
cornucopia and sacrificing out of patera over altar.
Cm. 2.7 - Gr. 11.3
Courtesy of the Museu Historico Nacional, Rio de Janeiro
Bibliography : BMC II, n° 210 ; RIC II, n° 126.

Portrayed with his characteristic low-lying rippling hair and protruding nose and chin, Titus has chosen to connect himself with the figure of Genius Populi Romani, Genius of the Roman People.

Originating in the ancient belief that every man was born with a good and a bad genius — one of whom would ultimately dominate and guide that individual's activities — genii became associated with provinces and cities and could represent vices or virtues. His sacrifical act and the inclusion of a cornucopia attest to the goodness of this spirit.

The Genius type is one of several that honor the emotions inspired by the celebration of the public vows undertaken for the first five years of a reign[1]. Dated to the second and third years of Titus's solitary rules, this coin was minted approximately five years after Vespasian had, in AD 76, issued a coin of Titus with an identical reverse type[2]. Since Titus had been governing jointly with Vespasian from AD 70-71, both Vespasian's and Titus's minting of coins with this type can be regarded as renewals of vows made to this venerated, benevolent spirit of the Roman People.

KLB

1. BMC II, p. lxxvi.
2. See RIC II, n° 677.

75. Maximianus

AE Follis - Ticinum - AD 296-297
Obv. IMP C MAXIMIANVS P F AVG Bearded head of
Maximianus, laureate, r.
Rev. GENIO POPV - LI ROMANI Standing profile l.
with chlamys, cornucopia, modius and patera. In the
field on l., *, in exergue ST.
Cm. 2.7 - Gr. 11.3
Brown University
Bibliography : RIC VI, n° 31b.

This coin of Maximianus, a man of peasant stock who reached the rank of Caesar in AD 292, bears a remarkable obverse portrait : strong and finely modelled vet abstract and reductive, of a man whose contemporaries described as ignorant, arrogant and brutal, as well as one of the most common reverse types of this period. The association with *Genius Populi Romani* relates to the constant struggle Maximianus faced in order to retain and affirm his power in an Empire with as many as four separate leaders. From AD 294 the use of GENIVS POPVLI ROMANI was universal and the figure is commonly shown crowned by a *modius*, with a *chlamys* over one shoulder, holding a *patera* and a *cornucopia*.

JWH

76. Caracalla

AR Denarius - AD 199-200
Obv. ANTONINVS AVGVSTVS. Bust of Caracalla
laureate, draped, r.
Rev. RECTORI ORBIS. Sol standing front, head l.,
holding globe and inverted spear.
Cm. 1.85 - Gr. 3.20
Courtesy of the Dewit Collection, Belgium
Bibliography : RIC IV, n° 40.

The appellation *Master of the Universe* is first employed by Didius Junius but rarely thereafter until Septimius Severus when the inclusion of the sun, as a deity, is referred to as RECTOR ORBIS. His son, Caracalla, is the third major employer of this virtue and possibly deliberately exploits the inherent ambiguity : does he intend that we read Sol as Rector Orbis or Caracalla himself ? The figure of Sol is here invoked following the restoration of peace in the East and homage is paid to him as arbitrator of the world's destinies[1]. Association with this virtue is extremely rare and mainly limited to the three men listed above.

JWH

1. DRC, p. 679.

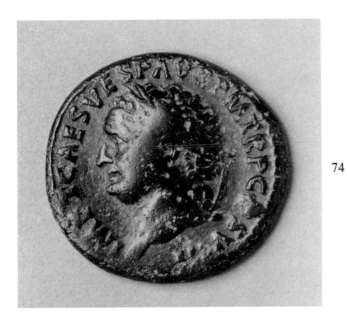
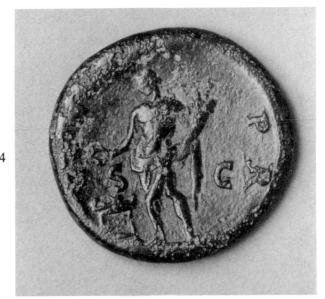

74

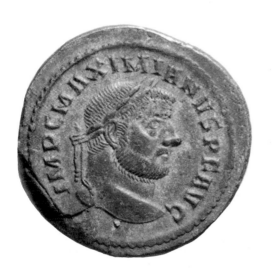
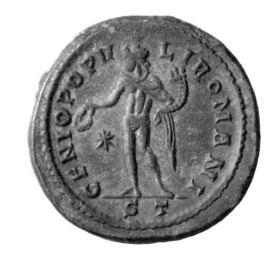

75

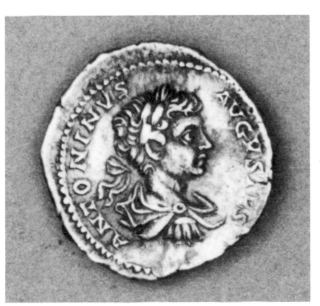
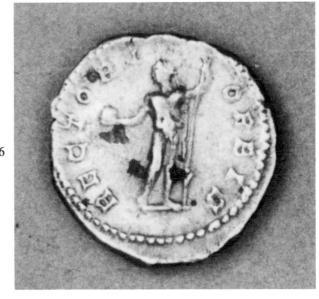

76

77. Vespasian

AR Denarius - AD 76
Obv. T CAESAR - IMP VESPASIANVS Titus, laureate, r.
Rev. COS - V Eagle on cippus.
Cm. 1.8 - Gr. 3.2
Brown University, Harkness Collection
Bibliography : RIC II, n° 191a.

The eagle is the symbol of Jupiter and it was frequently used by the Romans as a representation of the Empire. During the funeral of an emperor an eagle was released near the pyre which was meant to carry the soul of the Emperor toward heaven[1].

The eagle here probably represents the strength of the Roman Empire which was fortified by the co-regency between Vespasian and his sons. The period of Vespasian's reign following the Civil Wars was a time when the Roman people needed to be reassured of the strength of the Roman Empire. Coins portray this strength while specific acts by the Emperor worked toward actually rebuilding the economic viability of the Empire.

MRW

1. BMC II, p. xii.

78. Vespasian

AR Denarius - AD 77-78
Obv. CAESAR VESPASIANVS AVG Laureate head of Vespasian r.
Rev. IMP XIX Modius.
Cm. 1.6 - Gr. 2.8
Brown University, Harkness Collection
Bibliography : RIC II, n° 110.

The reverse legend of this coin dates it to AD 77 or AD 78, Vespasian's nineteenth year as Imperator, commander of the army. On 22 December, AD 69, Vespasian was proclaimed Emperor by the Senate. Vespasian took control of the Empire during a time of uncertain peace following the death of Nero and the Civil Wars. To secure peace Vespasian worked at restoring the economic strength of the Empire. He also rebuilt many of the buildings destroyed during the Civil Wars.

By AD 77 the reforms of the coinage of Nero and the reduction in the weight of aurei and denarii begun in AD 69-70 had helped to stabilize the economy. A series of coins from this period illustrates one of Vespasian's other goals, a program of agricultural restoration[1]. In AD 77-78 coins were minted depicting sows, women carrying budles of wheat, goats being milked and the modius, as depicted on this coin brimming with corn, or with wheat or poppies in other examples. The symbols were meant to create a sense of regeneration of the importance of the country towns which provided the food for the Empire. Also, the modius represents the food distribution programs of the Emperors.

MRW

1. BMC II, p. xii.

79. Severus Alexander

AR Denarius - AD 226
Obv. IMP C M AVR SEV ALEXAND AVG Laureate bust of Severus Alexander, r.
Rev. AEQVI - TAS AVG Aequitas standing l. holding scales and cornucopiae.
Cm. 1.8 - Gr. 3.5
Brown University, Harkness Collection
Bibliography : RIC IV (part 2), n° 127.

This coin was probably issued in AD 226. All other Aequitas issues showed tribunician years other than AD 226. Scholars have debated whether Aequitas Augusti refers to the impartial delivery of justice or to the equable administration of finances. The word *aequitas* was used in the courts, and it was associated with the word *iustitia* in literature. At the same time, in coinage Aequitas and her identifying attribute, the scales, often relate a message of financial fairness[1]. This denarius of Aequitas may refer to monetary reform. Historians believe that Severus Alexander was probably involved in some reform of the coinage, because in his reign an issue of sestertii, dupondii and silver medallions with the legend MON RESTITVTA, money restored, was minted[2].

DCS

1. WALLACE-HADRILL, A., *Galba's Aequitas*, in *NC*, 141, 1981, p. 21 and 30-31.
2. BMC VI, p. 56 ; RIC IV (part 2), p. v.

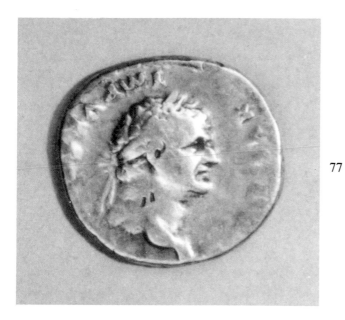
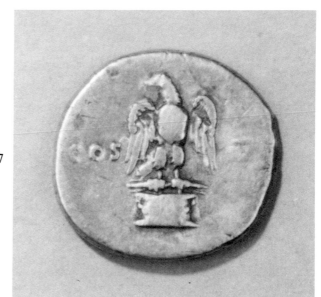

77

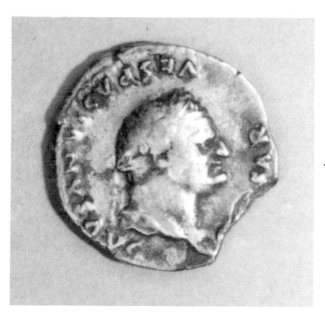
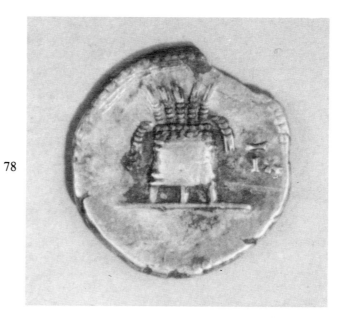

78

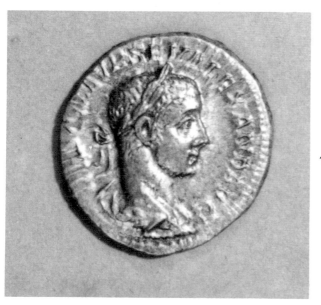
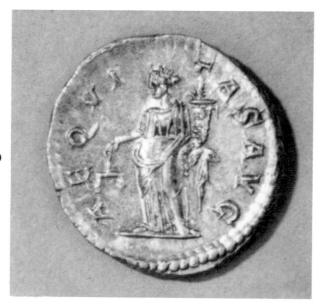

79

80. Vespasian

AE Dupondius - c. AD 71
Obv. IMP CAES VESPASIAN AVG COS III Head of Vespasian, r. radiate.
Rev. CONCORDIA AVGVSTI Concordia seated l., patera in extended r. hand and cornucopiae in l. In exergue, SC.
Cm. 2.5 - Gr. 11.2
Brown University, Harkness Collection
Bibliography : RIC II, n° 472.

The reverse image of Concordia undoubtedly refers to themes promoted by the Emperor in AD 71, the third year of his consulship, when this coin was minted in Rome[1]. By this time, the civil wars that followed Nero's death had ended, and Vespasian's coinage celebrates the subsequent peace[2]. The presence of a cornucopia in the hands of Concordia underscores the renewed confidence and prosperity. At this time, Vespasian also heralded the establishement of the Flavian dynasty with his sons Titus and Domitian, which the legend CONCORDIA AVGVSTI celebrates[3].

LLA

1. RIC II, p. 12.
2. *Ibid.*, p. 7.
3. *Ibid.*, p. 5.

81. Septimius Severus

AR Denarius - AD 208
Obv. SEVERVS - PIVS AVG Head, laureate, r.
Rev. PM TR P XVI - COS III PP Concordia seated l., holding patera and sceptre.
Cm. 1.7 - Gr. 2.8
Brown University, Harkness Collection
Bibliography : C. IV, n° 514 ; DRC, p. 738-740 and 241-244 ; RIC IV, n° 218.

This coin dates from the third and final period of Severus's reign, which in itself builds up towards a scantily-documented military campaign in Britain, culminating in Severus's death at York in AD 211. On this expedition Severus was accompanied by both his sons, Geta and Caracalla. The inclusion of Concordia on the reverse is most likely a reference to the ending of the long and bitter Eastern wars. This was followed by the inauguration of the next *saeculum*, marked by the Games in Rome[1]. Severus is shown with his hair and beard drawn into ringlets, a feature common with sculpted portraits of the same Emperor. The reverse, in a sample, clear and effective style stresses the association of Severus with Concordia.

JWH

1. The personification (which Cohen tentatively interprets as Clementia) holds a *patera* and a sceptre.

82. Faustina II

AR Denarius - c. AD 176-180
Obv. DIVA FAV - STINA PIA Head of Faustina II, r., draped.
Rev. CONSECRATIO Throne with transverse sceptre, diadem ; in front, a peacock.
Cm. 1.8 - Gr. 2.6
Brown University, Harkness Collection
Bibliography : RIC III, n° 745.

This denarius is one of the posthumous issues (176-180) with which Marcus Aurelius honored the memory of his wife. Four different posthumous issues can be isolated, this being an example of the fourth[1]. The elements portrayed do not refer to the actual ceremony of consecration, as in previous issues, but rather to her status. Throne, sceptre, and diadem are symbols of her rank as Augusta while the peacock, attribute of Juno, places Faustina in the divine realm.

DIVA, a title that followed her consecration, not only alluded to her pious qualities, but was also added in recognition of her father, Antoninus Pius.

LLA

1. BMC IV, p. cxii.

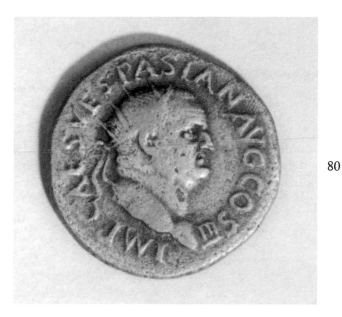

80

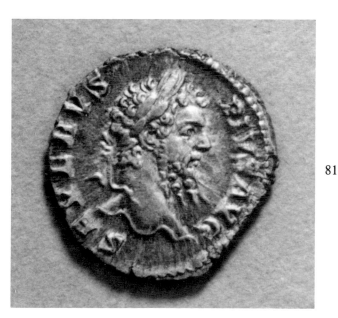 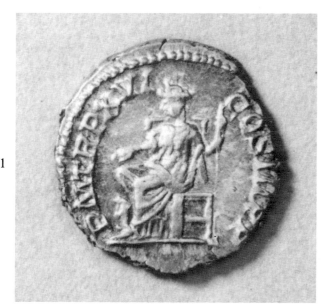

81

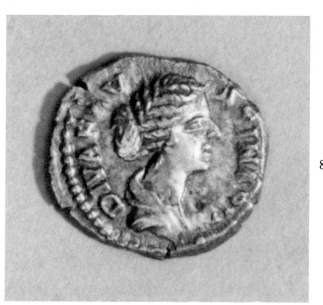 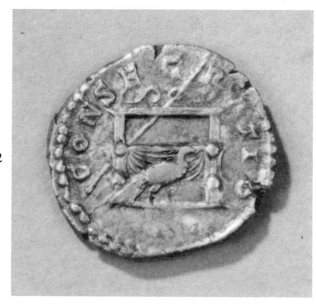

82

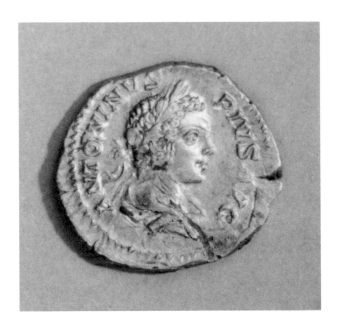

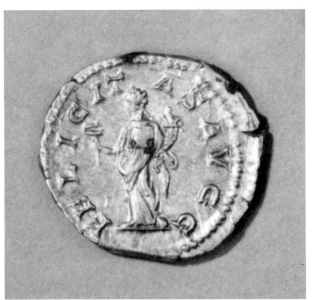

83. Caracalla

AR Denarius - AD 201-206
Obv. ANTONINVS - PIVS AVG Bust, laureate, draped, r.
Rev. FELICIT - AS AVGG Felicitas, standling l.,
holding a caduceus in her l. hand a cornucopiae in her r.
Cm. 1.9 - Gr. 3.3
Brown University, Harkness Collection
Bibliography : RIC IV, n° 127.

That Caracalla appears draped rather than nude
on the coin can be explained in light of his joint rule
with his father, Septimius Severus. Although Cara-
calla was an Augustus when the coin was struck, he
was still subordinate to his father in certain respects.
To be shown in the nude, a god-like form of
representation, was a privilege that Caracalla ceded
to Septimius in his coinage until AD 206, when
Caracalla himself begins to appear undraped, after
he had been an Augustus for eight years[1].

The denarius's reverse, which bears the inscrip-
tion, FELICITAS AVGG, or Felicitas Augusti, also
alludes to Caracalla's co-rule with Septimius. The
legend makes reference to the glad tidings that the
rulers bestowed on the Roman people and represents
an attempt on the part of the Augusti to convince
the citizenry that Rome had embarked on a Golden
Age of domestic happiness[2].

GW

1. BMC V, p. cxlv-cxlvi.
2. BMC V, p. cxliv. A consideration of the development and
 usage of Felicitas, as well as other virtues is provided in
 FEARS, J.R., *The Cult of the Virtues and Roman Imperial
 Ideology*, in *ANRW*, II 17.2, p. 1844-76.

84. Julia Domna

AR Denarius - c. AD 210
Obv. IVLIA - AVGVSTA Bust r., draped.
Rev. FORTVNAE - FELICI Fortuna seated l., holding cornucopiae and rudder on globe. At l., child standing.
Cm. 1.8 - Gr. 2.4
Brown University, Harkness Collection
Bibliography : RIC IV (part 1), n° 554.

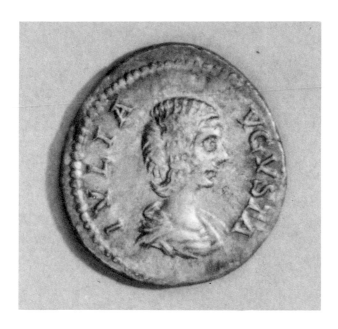

The image of Fortuna Felix on the coins of Julia Domna between c. AD 207 and 211 was common and had several variations[1]. This variant depicts Fortuna seated and naked to the waist cradling a cornucopia, her invariable attribute. Standing before her, a small naked child extends his right hand up toward her ; unfortunately, the identity of this little figure remains unknown[2].

The meaning inherent in Fortuna's presence on the coin is two-fold. On one hand, it refers to the good fortune of Severus, who was known to have married Julia for her favorable horoscope[3]. On the other hand, Fortuna simply indicates that Julia was blessed and so, then, was the Empire for having her as Empress[4]. In either case, by striking this type, she layed claim to a more definite share in the ruling of the Empire than most empresses did[5].

<div align="right">ACW</div>

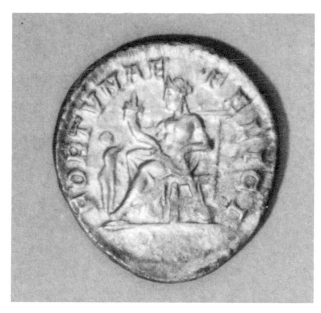

1. BMC V, p. cxxxii. The other types show Fortuna without the child and standing or seated with a caduceus instead of a cornucopiae.
2. BMC, DRC, HCC, and HILL, P.V., *The Coinage of Septimius Severus and his Family of the Mint of Rome AD 193-217*, London, 1964, all cite the child but none attempt to identify it.
3. *CAH* XII, p. 35.
4. BMC V, p. cxxxv.
5. RIC IV, p. 74.

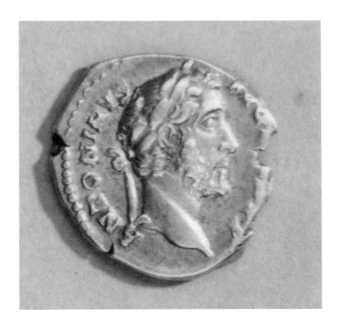

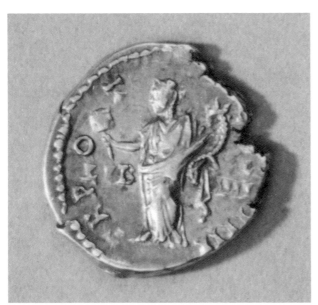

85. Antoninus Pius

AR Denarius - AD 145-146
Obv. ANTONINVS AVG PIVS PP Antoninus Pius facing r., laureate and beared.
Rev. TR P-O-T - COS IIII LIB IIII Liberalitas standing l., holding account - board and cornucopiae.
Cm. 1.7 - Gr. 3.0
Brown University, Harkness Collection
Bibliography : C. II, n° 490-491 ; RIC III, n° 155.

One of the most popular virtues that Roman emperors depicted on their coins, following Hadrian's initial example, is that of Liberalitas, which appears both as a legend and as a type[1]. As a type, this virtue is personified as a woman, holding in one hand a tessera with a certain number of points. These points show the number of times the Emperor generously gave gifts to his people. Generally, this gift consisted of money, grain or bread. On this coin, the cornucopiae which Liberalitas holds indicates the abundance of wheat that was contained in the public granaries during Antonius's reign[2].

Coins that bear the legend Liberalitas also frequently refer to the number of times that the Emperor bestowed such a generosity[3]. In this case, it is Antonius Pius's fourth out of nine given on the occasion of the marriage of his daughter Faustina to Marcus Aurelius[4].

As Antonius Pius's reign was tranquil and prosperous, Liberalitas symbolizes not only the peace that Rome enjoyed, but also the material blessings of good rule.

EDG

1. DRC, p. 515.
2. *Ibid.*
3. *Ibid.*
4. BMC IV, p. xlvi.

86. Titus

AE Dupondius - AD 79-81
Obv. PIETAS Veiled, bust of Livia or Pietas, r., wearing diadem.
Rev. IMP T CAES DIVI VESP F AVG RESTIT / In center, SC.
Cm. 2.9 - Gr. 13.61
Courtesy of the Dewit Collection, Belgium
Bibliography : BMC II, n° 291.

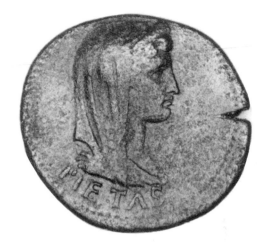

The so-called restored series of coins minted under Titus revived types from the early Empire, and in so doing emphasized the links between the Flavians and the Julio-Claudians. Titus's restored coins reflected a careful selection of past emperors to emulate. Tiberius was among those whose issues were favored, while the coins of such emperors as Caligula and Nero were excluded. This dupondius of Pietas was copied from a Tiberian issue[1]. The features of the Pietas type may have been meant to portray Livia[2].

In his Natural History, Pliny gives an example which he deems a paradigm of Pietas. A woman of humble birth visited her mother starving in prison, where a guard made certain that no food could be brought to her. The mother's health was returned by her daughter's piety. The daughter fed the old woman with the milk from her breasts. In recognition of this *miraculum*, a temple to Pietas was erected on the site of the jail[3]. This respect for family duty above all personal concern is the primary ideal embodied in Pietas. The virtue comes to have broader meanings related to the theme of considering one's elders. Pietas could imply observance of religious duties, loyalty to country and allegiance to the Emperor[4].

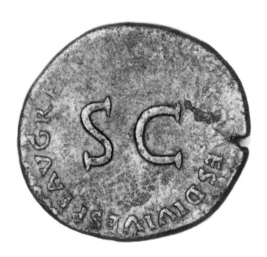

DCS

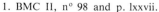

1. BMC II, n° 98 and p. lxxvii.
2. BMC I, p. cxxxv.
3. Pliny, *Natural History*, VII.121.
4. CHARLESWORTH, M.P., *Pietas and Victoria, the Emperor and the Citizen*, in *JRS*, 33, 1943, p. 1-10.

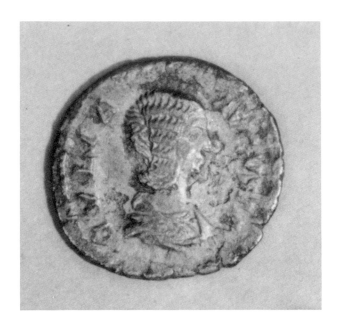

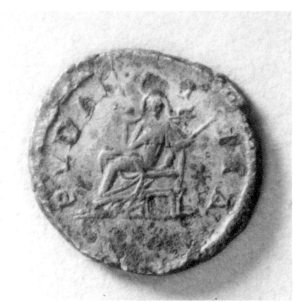

87. Julia Domna

AR Denarius - AD 196-211
Obv. IVLIA - AVGVSTA Bust, draped, r.
Rev. PVDICI - TIA Pudicitia veiled, draped, seated ; r. hand on breast ; l. hand holding sceptre.
Cm. 1.9 - Gr. 2.7
Brown University, Bishop Collection
Bibliography : BMC V, n° 72 ; RIC IV, n° 575.

The reverse shows an image of Pudicitia, who represents the concept of chastity or sexual modesty. A cult to the goddess of Pudicitia developed in the early third century BC, but it later declined and fell into oblivion[1]. Because the denarius dates to the beginning of the third century AD, the figure of Pudicitia appears not as a deity, but as a personification of an idea. Although the Romans deified abstract concepts[2], a distinction nonetheless exists because the image does not represent a divine being, but signifies in tangible form an otherwise disembodied virtue. Thus, the image of Pudicitia does not have definite theological significance, although the transcendence of the concept lends a spiritual quality to the representation[3].

During imperial times, empresses and occasionally emperors used the theme of Pudicitia in a self-referential way[4]. Seen here, the figure is emblematic of the Empress's chastity. Whether or not Julia Domna herself was chaste is immaterial ; the celebration of Pudicitia on her coins implies her possession of this stock virtue and underscores her womanly honor.

GW

1. ROSCHER, W.H., *Ausführliches Lexikon der griechischen und römischen Mythologie*, reprint Hildesheim, 1965, III, 2, p. 3276 ; see also *Paulys Realencyclopädie der classischen Altertumswissenschaft*, Stuttgart, 1959, p. 1942-6.
2. See FEARS, J.R., *The Cult of Virtues and Roman Imperial Ideology*, in *ANRW*, II, 17.2, p. 827-948, for a discussion of the Roman sanctification of virtues.
3. See BELLONI, G.C., *Casi di identità, analogie e divergenze tra la testimonianza monetale romana imperiale e quella di altre fonti sulla religione e sui culti*, in *ANRW*, II, 16.3, p. 1859.
4. Pudicitia occurs on the coins of, among others, Plotina, Sabina, Faustina the Younger, Crispina and Salonina and on those of the Emperors Hadrian and Septimius Severus. ROSCHER, p. 3276-7.

88. Tiberius

AE Dupondius - AD 22
Obv. IVSTITIA Bust of Iustitia diademed r.
Rev. TI CAESAR DIVI AVG F PM TR POT XXIII SC
Cm. 2.85 - Gr. 13.14
Courtesy of the Dewit Collection, Belgium
Bibliography : RIC I, n° 22.

The coinage of Tiberius rarely includes a portrait of the Emperor himself, any allusion to his imperial person being made in the reverse legend (as here). Instead the obverse portrait and main legend often refer to another member of the Imperial house. Although it is known that Tiberius was reluctant to bestow otherwise excessive honors on Livia, his mother, we find her portrait on coins. This image of Iustitia has been identified by some scholars as Livia. It belongs to a group of three, the others bearing the legends PIETAS and SALVS AV-GVSTA[1]. Scholars are agreed that the SALVS issue portrays Livia, but the images of Pietas and Iustitia are questioned in their identification as Livia[2]. Their obverse portraits are deliberately ambiguous. In AD 22, when these coins were struck, Livia was seventy-nine years old, which is not reflected in the idealistic image on coins.

JWH

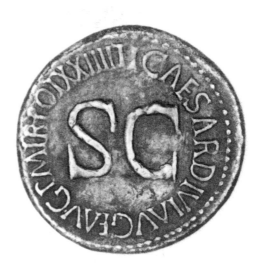

1. RIC nos. 23 and 24 respectively.
2. GROSS, *Julia Augusta*, in *Abhandlungen Göttingen, Phil.-hist. Klasse*, 3.f. n° 52, 1962, p. 17-21.

89. Severus Alexander

AR Antoninianus - c. AD 223
Obv. IMP C M AVR SEV ALEXAND AVG Head r., laureate ; bust draped.
Rev. P M TR P II - COS P P Salus seated l., on throne, feeding snake coiled around altar.
Cm. 1.8 - Gr. 2.5
Brown University, Harkness Collection
Bibliography : RIC IV, n° 32.

During the first half of Severus Alexander's rule, conventional reverse types were struck : personifications of virtues, such as Salus, frequently appeared[1]. This may reflect not only the general peace or uneventfulness of the early part of Alexander's reign, but also his attempt to restore order to Roman religion. Severus's cousin and predecessor, Elagabalus, was renowned for his excesses and for his involvement in Eastern mysticism. By contrast, Severus Alexander presented himself as a sensible man, given to reforms[2]. Salus's symbolism relates to the salubrity of the Empire as a whole, and to Severus's rationality in particular. Formally well balanced and evenly depicted, Salus's portrayal serves to visually underscore the conceptual propaganda.

JS

1. RIC IV, p. 64.
2. *Ibid.*, p. 63.

90. Divus Augustus

AE As - c. AD 22
Obv. DIVVS AVGVSTVS PATER Radiate head of Augustus facing l.
Rev. PROVIDENT Square altar between S - C.
Cm. 2.7 - Gr. 10.0
Brown University, John Hay Library
Bibliography : RIC I, n° 6.

Augustus died on August 19, AD 14. A month later he was officially elevated into the pantheon of the state gods[1]. He had discouraged the worship of himself in the city of Rome during his lifetime, yet he seemed to prepare for deification already by building the Mausoleum and other related structures in the Campus Martius[2]. The deft modelling of the highly idealized portrait place this coin among finer issues after AD 22[3].

The reverse image and inscription are related to the apotheosis of Augustus. Since the late Republic, Providentia had been associated, with the quality of foresight in gods and men which secured the safety and continuity of the state[4]. Augustus came to be viewed as having been sent by Divine Providence, and in choosing Tiberius as his successor, he assured through his foresight the survival and safety of Rome. The altar shown here may represent an actual building, and probably relates to the cult of Divine Augustus[5].

JT

1. ANDREAE, B., *The Art of Rome*, New York, 1977, p. 608.
2. WALKER, S., and BURNETT, A., *The Image of Augustus*, London, 1988, p. 29.
3. RIC I, p. 94, noting the relatively poor quality of aes issues at the beginning of Tiberius's reign.
4. CHARLESWORTH, M.P., *Providentia and Aeternitas*, in *Harvard Theological Review*, 29, n° 2 (April 1936), p. 108.
5. RIC I, p. 94.

91. Sabina

AE Sestertius - c. AD 128-134
Obv. SABINA AVGVSTA - HADRIANI AVG PP Bust of Sabina r., draped with triple tiara.
Rev. SC. Ceres seated l. on basket, holding corn-ears and torch.
Cm. 3.3 - Gr. 23.9
Courtesy of The Museu Historico Nacional, Rio de Janeiro.
Bibliography : RIC II, n° 1019.

Two main types of obverse legend in the coinage of Sabina assist in dating ; this sestertius is an example of the first, and dates the coin to c. AD 128-134[1].

As the wife of Hadrian, Sabina received the title of Augusta upon his ascension to power ; the Senate hailed her as *Nova Ceres*[2]. As such, she acted as priestess in the cult of the Divine Augustus ; from the time of Livia forward, the Augusta is associated with Ceres in his role. The reverse image may be a reference to such a position.

LLA

1. BMC III, p. cxlix.
2. DRC, p. 703.

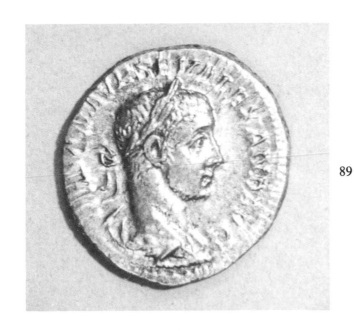
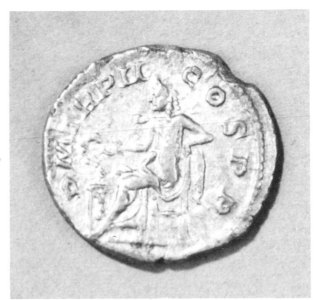

89

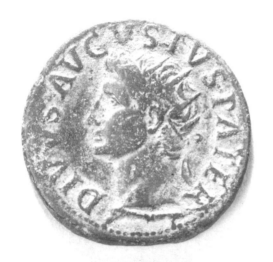
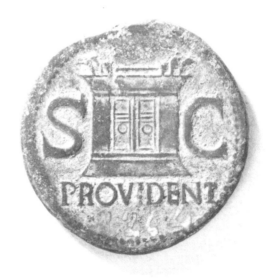

90

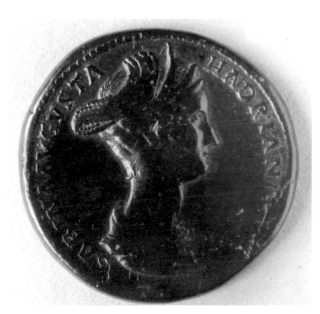
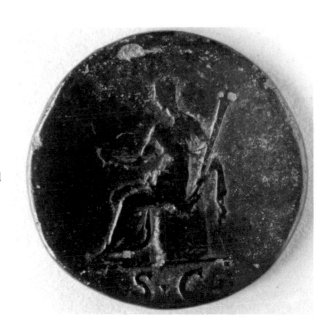

91

92. Julia Domna

AR Denarius - c. AD 199/200-209
Obv. IVLIA - AVGVSTA Bust r., draped.
Rev. IVNO Juno veiled standing l., holding patera and sceptre. At l. peacock.
Cm. 1.9 - Gr. 3.0
Brown University, Harkness Collection
Bibliography : RIC IV, n° 559.

As wife of Septimius Severus, Julia appears on coinage in which she is compared or associated with Juno, protectoress of women and the sanctities of marriage. On this and other coins, it is unclear whether the image of Juno is intended to be Julia or whether the Empress is merely to be associated as having the goddess's attributes.

In attempting to distinguish the coin's intention, it is interesting to note other instances in which the Imperial Family is associated with the gods. Inscriptions on an altar from the Raetian *limes* erected in honor of Caracalla, Geta, and Julia Domna, *mater Augustorum et castrorum*, as well as the Capitoline Trinity and the *genius cohortis*, names the Emperors before the gods, there by indicating their full divinity[1]. Also, when a shrine at Lambaesis was erected, sculpture and other portraits of the ruling family, the *domus divina*, are mentioned in advance of the deities[2]. Both these examples reflect Severus's desire to exalt and assure the Imperial Family's divine consecration ; this understood, one cannot say with certainty whether this coin merely seeks to compare Julia to Juno, or whether it insinuates their full-equality.

ACW

1. *Cambridge Ancient History* XII, p. 356.
2. *Ibid.*

93. Sabina

AR Denarius - c. AD 134
Obv. SABINA AVGVSTA HADRIANI AVG PP Bust of Sabina, r.
Rev. IVNONI REGINAE Juno draped wearing diadem, standing holding patera and sceptre.
Cm. 1.7 - Gr. 3.0

Courtesy of The Museum of Art, Rhode Island School of Design, Providence
Bibliography : BMC III, n° 908.

Depictions of the goddess Juno and of Sabina illustrate two second-century conventions. On their coinage, women of the Imperial family were frequently associated with virtues and deities[1]. The propaganda on this example connects Sabina's reign on earth with Juno's rule over heaven, and furthers Hadrian's welfare policies[2]. Moreover, Juno's idealized form is in accordance with the Greek revival in artistic styles that accompanied Hadrian's reign. Although Sabina married Hadrian in AD 100, she was not granted the title of Augusta, and with it the right of coinage in her name, unitl AD 128.

JS

1. Green and Rawson, *Antiquities*, Canberra, 1981.
2. BMC III, p. cl.

94. Probus

AR Antoninianus - Rome - c. AD 276
Obv. IMP PROB - VS P F AVG Radiate bust l., cuirassed with mantle.
Rev. SOLI INVICTO Sol in spread quadriga. R - Γ in exergue.
Cm. 2.25 - Gr. 3.9
Courtesy of The Museu Historico Nacional, Rio de Janeiro
Bibliography : RIC V (part 2), n° 203.

The depiction of Eastern gods on Roman minted coins begins with the coinage od Elagabalus. While his overzealous worship of Emesa may have brought the demise of Elagabalus's rule, Aurelian later reintroduces imperial worship of eastern gods. The Emperor Probus, in Aurelian tradition, continued such worship of Eastern cults which remained a prominent imperial practice until Constantine's conversion to Christianity. Driving a quadriga, Sol Invictus's similarities to Apollo are obvious ; yet, Sol Invictus never replaced the previous Roman sun gods. Instead, his worship and depiction parallels the other gods' representation.

HBR

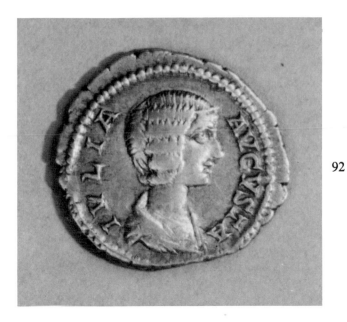
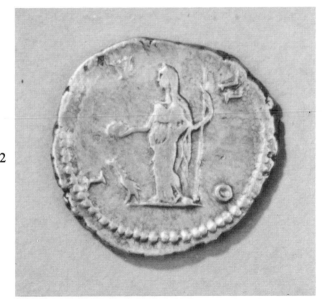

92

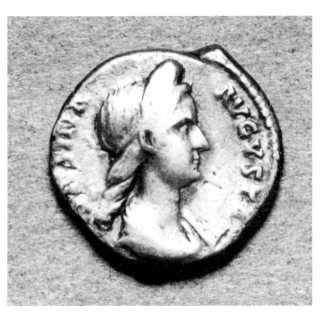
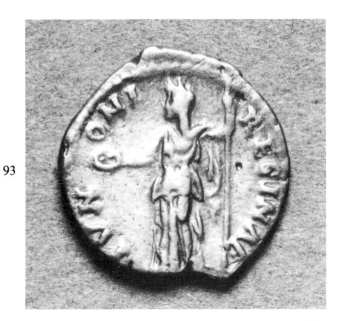

93

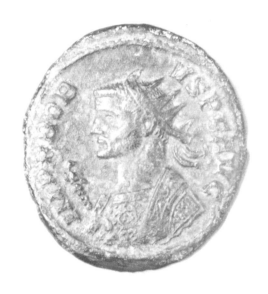
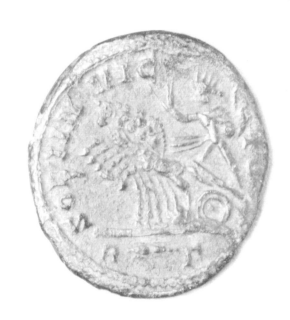

94

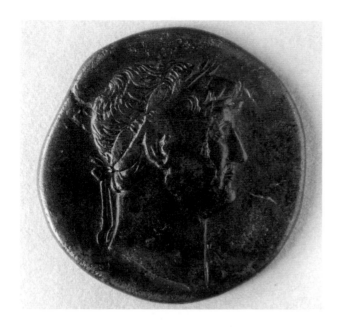

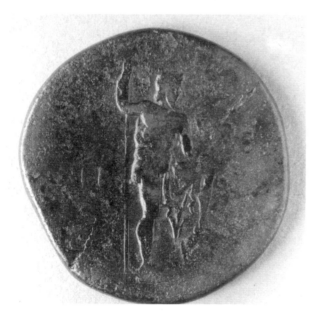

95. Hadrian

AE Sestertius - AD 125-128
Obv. HADRIANVS AVGVSTVS Bust of Hadrian r., laureate, with drapery on l. shoulder.
Rev. NEP RED Neptune standing r., l. foot on prow, cloak over l. thigh, holding dolphin and trident.
Cm. 32.7 - Gr. 19.5
Courtesy of the Museu Historico Nacional, Rio de Janeiro
Bibliography : RIC II, n° 651.

During his reign, Hadrian undertook two great journeys, one between AD 122 and 125 and then one between AD 128-132, to visit the provinces. It seems likely that when he was away from Rome the mint output was cut down to a minimal production, or stopped altogether, but produced vast quantities of very fine coins every time the Emperor returned[1].

This coin was minted after his return from the first trip and exhibits a new portrait type along with a new legend. The new portrait is on a larger scale than the earlier ones and very often fills the entire fiels : it is finely modelled and expressive. Also the obverse legend is shortened and the use of the name AVGVSTVS accompanying his own may be due to his wish to associate himself with his great predecessor[2].

The reverse type is quite common for bronze coins issued at this time. Neptune holds his attribute, the trident, along with a dolphin, which was sacred to the god and often appeared in his hand. Neptune is referred to here by name, NEPTVNVS REDVX, signifying his role in bringing the Emperor back home[3]. He is thus given due recognition for Hadrian's safe return to Rome.

EG

1. REECE, R., *Roman Coins*, London, 1970, p. 89.
2. RIC II, p. 323.
3. *Ibid.*, p. 325.

96. Sabina

AR Denarius - c. AD 134-138

Obv. SABINA - AVGVSTA Bust of Sabina, r., diademed.

Rev. VENERI - GENETRICI Venus standing r., drawing up robe on shoulder with r. hand, holding apple in l.

Cm. 1.9 - Gr. 3.3

Courtesy of The Museu Historico Nacional, Rio de Janeiro

Bibliography : RIC II, n° 396.

This is one of two main types of obverse legend in the coinage of Sabina, and dates this denarius to c. AD 134-138[1].

The reverse of this denarius protrays Venus Genetrix, the goddess associated with fertility. Early representations of this goddess depict her with an exposed shoulder and breast ; this was apparently later considered inappropriate for association with the empresses, for later types have both breasts covered, often by the pulling up of drapery onto the shoulder, as here depicted[2]. A statue of Sabina at Ostia portrays the Empress in the guise of Venus Genetrix, and here both breasts are covered, also through the action of pulling the drapery up over the shoulder[3][4].

LLA

1. BMC III, p. cxlix.
2. BIEBER, M., *Ancient Copies : Contributions to the History of Greek and Roman Art*, New York, 1977, p. 46.
3. *Ibid.*
4. *Ibid.*, p. 46.

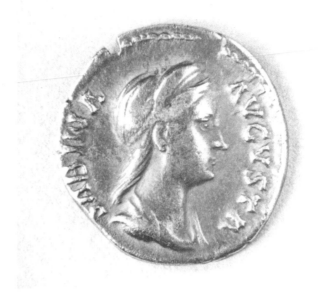

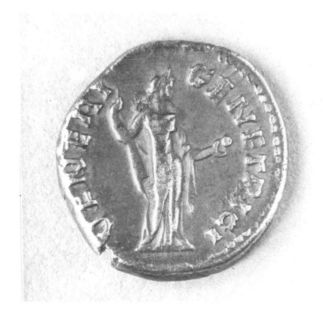

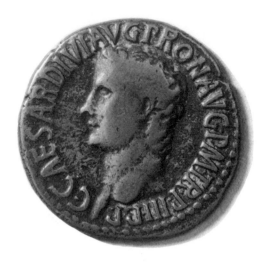

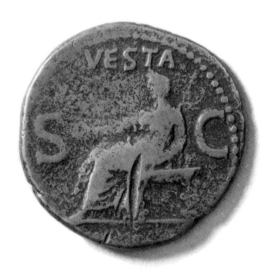

97. Caligula

AE As - 37-41 AD
Obv. C CAESAR DIVI AVG PRON AVG P M TR P III PP. Head bare, l.
Rev. VESTA S - C Vesta veiled, seated l., holds patera and sceptre.
Cm. 2.9 - Gr. 9.8
Brown University, Harkness Collection
Bibliography : RIC I, n° 47 ; BMC I, n° 59.

All the aes coined during Caligula's reign have the same reverse type of Vesta, and were minted in Rome[1]. The cult of Vesta was one of the oldest and most respected in Rome, and as Pontifex Maximus, the Emperor wielded power over the Vestal Virgins and the cult itself. Moreover, his three sisters were accorded the honors of the Vestal Virgins, further associating Caligula and the cult of Vesta[2]. Vesta's depiction, therefore, emphasized the unity of the imperium, and promulgated Caligula as a paternal figure. The obverse inscription dates the coins with relative certainty to AD 39-40, and although the aes of Vesta is the most common coin of Caligula's reign, those minted in 39-40 are the least common[3]. Vesta's monumental image, seen in her simple and idealized forms, continues the tradition begun during the middle years of Tiberius's reign[4]. Coins of Vesta occur frequently, from the reign of Caligula through the last years of the Empire[5].

JS

1. RIC I, p. 112-113.
2. See TRILLMICH, W., *Julia Agrippina als Schwester des Caligula und Mutter des Nero*, in *Hefte des Archäologischen Seminars der Universität Bern*, Bern, 1983.
3. KENT, p. 22.
4. KENT, p. 22.
5. DRC, p. 854.

98. Commodus

AR Tetradrachm - AD 186-187
Obv. MAKOMANTΩCEBEVCEB Laureate head r.
Rev. K Zeus Ammon.
Cm. 2.4 - Gr. 9.36
Courtesy of the Dewit Collection, Belgium
Louvain-la-Neuve, Belgium
Bibliography : POOLE 1402 ; MILNE 2668[1].

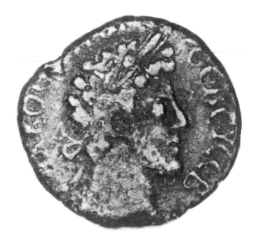

When Commodus succeeded to the throne in AD 164, he continued his predecessor's practice of minting numerous tetradrachmas in Alexandria. The depiction of Zeus Ammon was quite appropriate for this province. Worshiped as a sun god and a fertility god, his origins were in Thebes prior to his greater worship in Egypt[2]. By the second millennium BC, Ammon took dominance over the other deities and became associated with Ra, the already recognized sun-god[3]. Ammon later became the center of an oracle for the State. His popularity continued and its zenith during the visit of Alexander the Great to the oracle in 331 BC[4]. The combination of Zeus, the Roman sun-god, and Ammon, was an obvious way to incorporate Roman and provincial dieties into imperial cults.

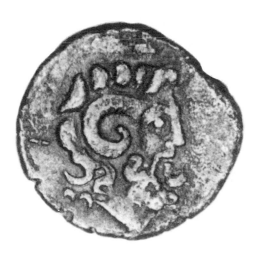

HBR

1. Additional bibliography : *Coins from Karanis, The University of Michigan Excavations, 1924-1935*, Ann Arbor, MI., n° 440 ; CURTIS, J.W., *The Tetradrachms of Roman Egypt*, Chicago, 1969, n° 785. GEISSEN, V.A., *Katalog Alexandrinischer Kaisermünzen der Sammlung des Instituts für Altertumskunde der Universität zu Köln*, 3 (1982), n° 225.
2. ROSCHER, W.H., *Ausführliches Lexikon der Griechischen und Römischen Mythologie*, 1, Leipzig, 1884-1886, p. 283.
3. PARKE, H.W., *The Oracles of Zeus, Dodona, Olympia, Ammon*, Oxford, 1967, p. 194.
4. *Ibid.*, p. 222. For another example of Ammon on coinage, please see Catalogue n° 3.

THE PROVINCES

99. Octavian

AR Denarius - 25-22 BC
Obv. Octavian r., head bare.
Rev. AVGVSTVS Capricorn r., holding a globe with a rudder and carrying a cornucopia on its back.

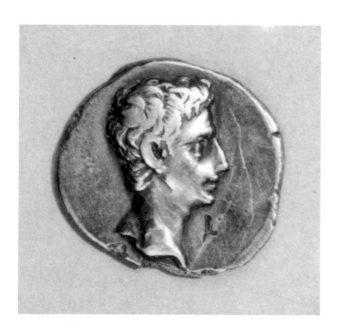

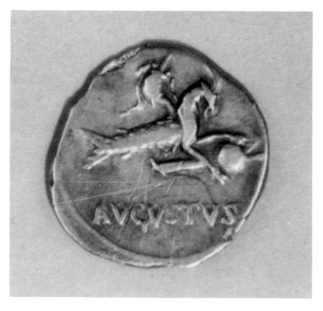

Cm. 1.9 - Gr. 3.6
Brown University, Harkness Collection
Bibliography : RIC I, n° 239[1] ; BMC, I, n° 347 ; Giard, n° 1266.

Tantam mox fiduciam fati Augustus habuit, ut thema suum vulgaverit nummumque argenteum vota sideres Capricorni, quo natus est, percusseret[2].

The Capricorn personally alludes to Augustus, who, accordind to Suetonius, was born under this sign[3], but according to his birthdate, was actually born under Libra[4]. One possibile explanation for its inclusion on this coin is that the constellation Capricorn was in the moon under which Augustus was born[5]. Evidence supporting this proposition exists in the Gemma Augustea[6], where a moon inscribed with a Capricorn floats above Augustus's head.

Suetonius relates how Augustus's faith in his zodiac sign resulted in the minting of coins such as this one. Its minting, however, had to originate in the provinces rather than in Rome because, according to Dio Cassius, astrologers were expelled form Rome in 33 BC[7]. Thus, Eastern mysticism and references to astrology were limited to provincial production, and to Gaul specifically[8].

The Capricorn seen here with a globe and rudder refers to the Roman Empire's good fortune and alludes to Augustus's divinity as well as promoting the imperial cult that was practiced at that point only in the Provinces.

HBR

1. For a similar coin also see KENT n° 141.
2. Suetonius, I.94.
3. *Ibid.*
4. KRAFT, K., *Zum Capricorn auf den Münzen Augustus, Gesammelte Aufsätze zur Antiken Geldgeschichte und Numismatik I*, Darmstadt, 1978, p. 262.
5. *Ibid.*, p. 264.
6. RICHTER, G.M.A., *Engraved Gems of the Romans*, London, 1971, n° 501.
7. Dio Cassius, XLIX, 43.
8. RIC I, p. 82.

100. Augustus

AR Quinarius - 28-26 BC
Obv. CAESAR IMP VII Bare head of Augustus r.
Rev. ASIA RECEPTA Victory on cista l.
Cm. 1.3 - Gr. 1.6
Brown University, Harkness Collection
Bibliography : RIC I, n° 276 ; BMC I, n° 647 ; Giard, n° 899.

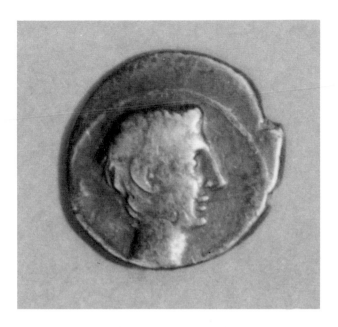

This coin commemorates the recovery of the province of Asia from Antony, and the acquisition of Egypt. The bare head of Augustus appears very much in the Asiatic style, occupying most of the space[1]. He is shown with regular and rather youthful features and without a beard. The figure of Victory expanding her wings and holding a crown, stand on a cista between two serpents. The serpent is the sign of Asia[2]. And the basket is the mystical cista of Bacchus, which served as another symbol of Asia[3].

Coins of this type with a Victory and the legends CAPTA or RECEPTA, passed on the political message that the traitors had been punished and Rome had taken back her old territories. It was essential at this point to depict provinces as conquered lands. Victory became one of the most important themes of the Augustan propaganda, and Augustus was very often portrayed as a liberator, appealing in this way to the sentimental, traditional and antiquarian feelings of his people an especially of those in Italy who at that time formed the nucleus of the Empire and her armies[4].

<div align="right">EG</div>

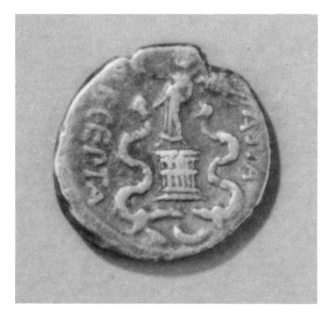

1. RIC I, p. 49.
2. DRC, p. 734.
3. *Ibid.*, p. 89.
4. GRANT, M., *Roman History from Coins*, Cambridge, 1958, p. 23.

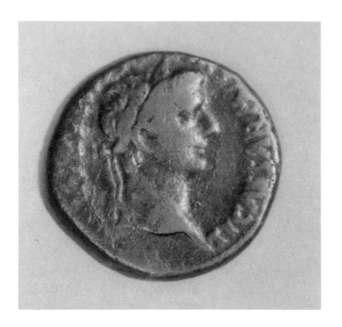
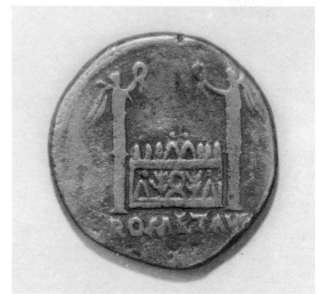

101. Tiberius

AE Sestertius - AD 9-11
Obv. TI CAESAR AVGVSTI F IMPERATOR V Laureate head of Tiberius r.
Rev. ROM ET AVG Altar of Lugdunum with Victory and Corona Civica.
Cm. 2.4 - Gr. 9.6
Brown University, Harkness Collection
Bibliography : RIC I, n° 365.

Lugdunum, modern Lyon, was a center of the Roman Empire in Gaul following Caesar's conquest of the area. The altar depicted on the reverse of this coin symbolized a vital part of the Roman subjugation of the native people. It represents the cult of Roma and Augustus, who were worshipped simultaneously throughout the Empire except within the walls of Rome itself[1].

The altar, dedicated in 10 BC, was a popular subject on coins from Lugdunum. The first bronze coins with the image of the altar appeared from 2 BC on. Under Augustus there were two active mints in Lugdunum. The imperial mint produced gold and silver coins and was governed by Augustus. The other produced bronze, copper and orichalcum coins and was governed by a Concilium Gallarium[2]. The mint governed by the Concilium Gallarium took over bronze coin production from Nîmes in 15 BC[3]. Both mints in Lugdunum produced altar series. Augustus intended for the altar to be means of converting the local population to the worship and acceptance of the Roman Empire. By establishing the bronze coin mint under Gallic rule, Augustus furthered the integration of these people into the Roman Empire.

MRW

1. DRC, p. 697.
2. RIC I, p. 58.
3. KENT, p. 20.

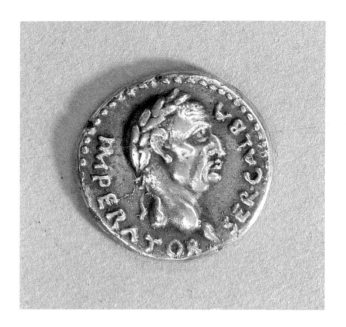
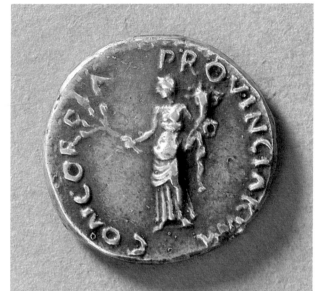

102. Galba

AR Denarius - AD 68
Obv. SER GALBA - IMPERATOR Head, laureate, r.
Rev. CONCORDIA - PROVINCIARVM Concordia standing l., holding olive branch and cornucopia.
Cm. 1.7 - Gr. 2.4
Brown University, Harkness Collection
Bibliography : BMC I, n° 164 (see note) ; RIC 1, n° 49 ; WEST, R., *Römische Porträt-Plastik*, Munich, 1933, pl. lxx, n° 108.

The burgeoning influence of the provinces over the Roman political structure is apparent in Galba's rise to Emperor. Galba, who had been the Governor of Hispania Terraconensis, joined in a revolt against Nero and was thereupon hailed Emperor by his troops at Carthago Nova in AD 68[1]. Galba's successful bid to lead the Roman Empire resulted in large measure from the considerable provincial support that he was able to muster. The reverse legend of this denarius and the representation of Concordia allude to the solidarity of the provinces in their support of him.

To pay the troops who had proclaimed him Emperor, Galba immediately began to issue coins in the Western provinces and employed the local mints of Tarraco, in Spain, and those of Vienna, Narbo and Lugdunum, in Gaul[2]. The denarius derives from the mint at Tarraco and was struck in the middle of AD 68, while Galba was still in the provinces, before he undertook his triumphal journey to Rome.

GW

1. RIC I, p. 216.
2. RIC I, p. 217.

103. Hadrian

AE - AD 133-134

Obv. AYTKAICTPAIANAΔPIANOCCEB Bust of Hadrian laureate and cuirassed to the r.

Rev. LIZ Isis breast-feeding Harpokrates. She is seated on a throne to r., crowned with disc and horns and placing her right hand on her breast. With the left she is supporting the infant Harpokrates, who wears the *pskhent* and holds a lotus flower in his l. hand.

Cm. 3.6 - Gr. 25.4

Brown University

Bibliography : DATTARI, n° 1751.

This particular coin was minted in Alexandria, which was producing Greek style coins. The regnal years of every emperor are shown in Greek numeral and are always accompanied by the symbol L, which stands for the word year[1]. Thus, this Hadrianic coin comes from the Emperor's seventeenth regnal years. These Greek coins provide a good selection of portrait series often including wives, sons, mothers and mistresses not otherwise depicted. A revival occurred in the Alexandrian mint under Hadrian. By year twelve, the execution of the dies was really fine and quite equal to that of the coinage in any part of the Empire[2].

The reverse type of this coin, showing Isis breast-feeding Harpokrates was among the most popular ones during the second century AD. The cult of Isis was very powerful throughout the Graeco-Roman world. Her bust first appeared on the coinage of Galba and continued to be depicted down to Diocletian's times[3]. This coin thus combines two of the most important deities of the Eastern Roman world, who along with Serapis formed the great triad of gods.

EG

1. REECE, R., *Roman Coins*, London, 1970, p. 132. He also says that Alexandrian coins are not very popular with many collectors because they are difficult to find in prime condition and also because of the language barrier.
2. MILNE, p. xxii.
3. *Ibid.*, p. xxix.

104. Hadrian

AE Drachm - AD 135
Obv. AVTKAICTPAINO - AΔPIANOCCEB Laureate
head of Hadrian r.
Rev. LI - H Sphinx l. with forepaw on wheel, wings
curled.
Cm. 3.4 - Gr. 24.6
Brown University
Bibliography : POOLE, n° 848.

This bronze drachm, minted in Alexandria, dates
from the eighteenth year of Hadrian's reign. The
sphinx appears in Greek art often in a form similar
to that depicted on the reverse of this drachm : a
woman's head and breasts above a lioness's body
with dugs. Although the Egyptian sphinx is male, in
Greek mythology the half-human, half-lion creature
is female[1].

The sphinx on this drachm was a local image,
conveyed in a Hellenized form. At Giza, a colossal
statue of a sphinx, famous in ancient literature,
guards the IV Dynasty (2723-2563 BC) pyramid of
Chephren. The statue's face is a portrait of Cheph-
ren. The sphinx is thought to have had apotropaic
power[2]. The balancing of Roman, Egyptian and
Greek subjects on the reverses of Alexandrian coins
was a measure of the Roman's authority and
recognition of indigenous culture[3].

<div align="right">DCS</div>

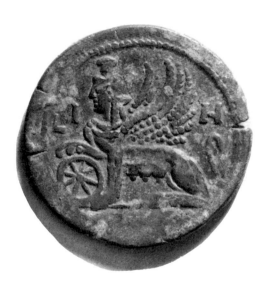

1. DRC, p. 441 ; MILNE, p. xxxiv ; OCD, p. 856 ; POOLE,
p. lxxxvii.
2. MICHALOWSKI, K., *Great Sculpture of Ancient Egypt*, New
York, 1978, p. 123 and 177 ; MICHALOWSKI, K., *The Art of
Ancient Egypt*, London, 1969, p. 146 and 489.
3. MILNE, p. xxxiv and 34.

105. Hadrian

AE Drachm - c. AD 134
Obv. AVTKAI - TPAIAΔPIACEB Bust of Hadrian, laureate, draped, to r.
Rev. Nilus, to l. holds cornucopia and reed, on rocks up of which crocodile climbing.
Cm. 3.6 - Gr. 22.8 - Brown University
Bibliography : MILNE, nº 1329.

Hadrian is well known for his imperial policies and journeys into the provinces. As relics, we have the province series-coins commemorating his visits by personifying over 25 countries and cities in the Roman Empire : The province of Egypt is represented by three reverse types : Aegyptus, Alexandria, and Nilus[1]. Nilus appears with his attributes, the cornucopia and the reed ; presumably, this type derives from a statue, perhaps from the colossal *Nilus* in the Vatican[2]. Beyond alluding to the river god and to Egypt, coins with Nilus also refer to Hadrian's visit to Egypt and to the death of Antinous, who drowned in the Nile[3]. The design's apparent symmetry was conventional in the province series[4], and corresponds to the Greek revival in Hadrianic art. The confident rendering of Nilus and his comfortable occupation of space, then, are characteristic of the times.

JS

1. BMC, p. cxliii.
2. TOYNBEE, J.M.C., *The Hadrianic School*, Cambridge, 1934, p. 32-33.
3. DRC, p. 574. Toynbee holds that Nilus was represented to stimulate interest in Egypt only. See TOYNBEE, p. 30.
4. TOYNBEE, p. 4.

106. Antoninus Pius

AR Tetradrachm - AD 150-151
Obv. ANTΩNINOCCEBEVCEB Bust laureate r.
Rev. LΛ ΔOΔEKATOV Dikaiosyne seated holding scales in r. hand and cornucopia in l. hand.
Cm. 2.4 - Gr. 13.9
Brown University, Bishop Collection
Bibliography : POOLE 955 ; MILNE 1975 ; CURTIS 600[1].

Antoninus Pius's Alexandrian coinage was similar to the coinage of his predecessor Hadrian[2]. As tetradrachmas were issued yearly except for the years 138 and 161, Antoninus Pius continued Hadrian's prolific coin output. On the reverse, Dikaiosyne, kindred to the Moneta holding scales and a sceptre[3], was the Greek equivalent of Justice or Aequitas as symbolized by the scales in her right hand. This type was one of the most common in Greek coins[4]. The cornucopia, of course, refers to the wealth resulting from this condition of balance.

HBR

1. Additional bibliography : GEISSEN, V.A., *Katalog Alexandrinischer Kaiser-Münzen der Sammlung des Instituts für Altertumskunde der Universität zu Köln*, 3 (1982), nº 1591.
2. MILNE, p. xxii.
3. POOLE, p. l.
4. CURTIS, p. xvii.

107. Caracalla

AE - AD 210
Obv. Bust, laureate, r.
Rev. Eagle facing r., holding an animal thigh in talons and a wreath in beak.
Cm. 2.5 - Gr. 12.6
Brown University, Harkness Collection
Bibliography : Compare with D. SEAR, *Greek Imperial Coins and Their Values : The Local Coinage of the Roman Empire*, London, 1982, nº 2651 ; British Museum, *Catalogue of the Greek Coins of Galatia, Cappadocia, and Syria*, London, 1899, p. 195, nº 362.

The coin is an example of Roman currency struck at the provincial mint of Antioch, Syria. Antioch was one of several mints in the Near East during Imperial times and produced Roman coins from the time of Augustus to that of Valerian[1]. Unlike the Roman coins produced at other Eastern mints, however, the coinage of Antioch tends to be rather crude[2].

The Antioch coinage of Caracalla began in AD 202, when he and his father, Septimius Severus, became consuls in the Syrian city. It was significantly expansed in AD 216 when Caracalla and his troops set up camp in Antioch in conjunction with the Emperor's Parthian campaigns[3].

The coin's reverse symbolizes the city of Antioch. Along with representations of the Tyche and the Orontes, the eagle clutching an animal thigh in its talons is a standard reverse image on coins minted in Antioch. It alludes to the legendary founding of the city, when an eagle indicated to Seleucus I the site for a new capital by carrying the severed leg of a sacrificial animal to the top of the Silpius Hill[4].

GW

1. British Museum, *Catalogue of the Greek Coins of Galatia, Cappadocia and Syria*, London, 1899, p. lix.
2. *Ibid.*, p. lx.
3. BELLINGER, A., *The Syrian Tetradrachms of Caracalla and Macrinus*, New York, 1940, p. 6.
4. British Museum, p. lx.

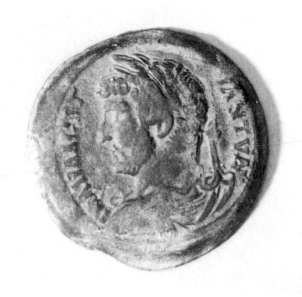
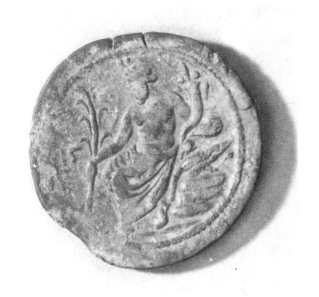

105

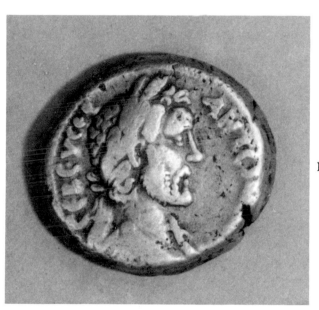
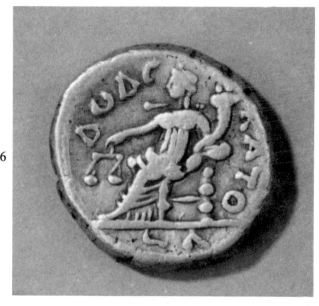

106

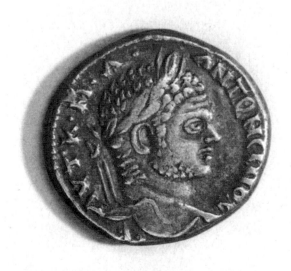
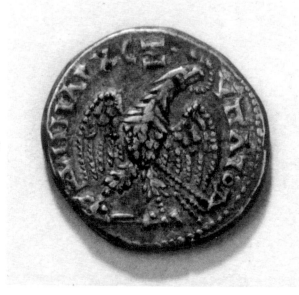

107

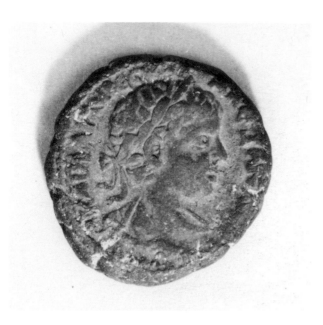

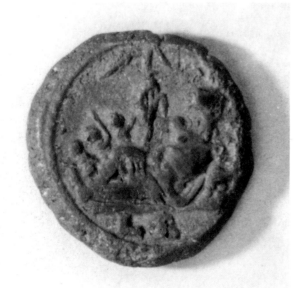

108. Severus Alexander

AE Tetradrachm - AD 223
Obv. AKAIMAPAVPCEVHPAΛEΞAN[ΔPOCEVCEB]
Bust of Severus Alexander r., laureate, wearing cloack.
Rev. Reclining Nilus l., head r., crowned with reed. One
genius cornucopia by r. shoulder, three on knee of Nilus,
himation on l. In exergue, LB.
Cm. 2.3 - Gr. 13.1
Brown University
Bibliography : MILNE, n° 2895.

Minted in Alexandria during the first part of
Severus Alexander's reign, the coin's reverse pre-
sents a traditional image of the Egyptian deity,
Nilus[1]. As an embodiment of a province, Nilus
appeared throughout Alexandrian coinage. Since
this issue derives from an Eastern mint, it is unlike
Roman representations of Nilus in its depictions of
attributes and artistic quality. In particular, the
children symbolize the Nile's fertility by signifying
the cubits the Nile had risen[2]. The change in artistic
standards, seen in the awkward compression of the
portrait, might be attributed to a local aesthetic.
The in the exergue stands for Alexander's second
regnal year, when this coin was minted[3]. That year,
the Nile rose the necessary 16 cubits required to
flood the surrounding plains, which the child
emerging from the cornucopia effectively signifies.

JS

1. MILNE, p. xxix.
2. DRC, p. 575.
3. POOLE, p. xi.

109. Severus Alexander

AE Tetradrachm - AD 226
Obv. AKAIMAPAVPCEVHPAΛEΞANΔPOCEVCEB
Bust draped, laureate, r.
Rev. Seated Athena l., holding winged Nike. L-Δ
Cm. 2.2 - Gr. 12.0
Brown University
Bibliography : CURTIS, n° 1053.

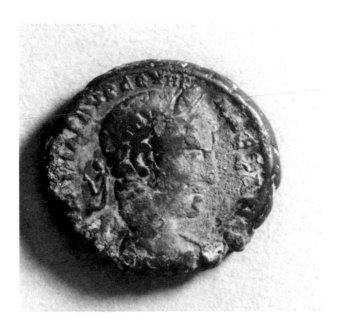

Starting in the time of Domitian, Alexandrian coinage often referred to the traditional associations of Greek and Egyptian deities. These figures usually appeared in their Greek forms[1]. This tetradrachm of Severus Alexander, minted in Alexandria, shows Athena who was connected with the Egyptian hippopotamus goddess Taurt, probably because of shared attributes[2]. Thus, the Roman moneyers showed a specifically Egyptian deity in a more familiar Hellenized form.

This tetradrachm might have served a special economic purpose. A distinct group of Egyptian tetradrachms, minted under Severus Alexander, has Roman-style reverse types, metal content, size, legends and portraits. This group first appears in the same year as this Athena tetradrachm. One possible explanation for these unusual coins is that the Alexandrian moneyers imported dies from Rome. Imported dies would have given some Alexandrian coins a Roman appearance. Andrew Burnett and Paul Craddock suggest instead that officials might have sent the coins themselves from Rome to Alexandria in order to supplement local issues. These extra coins would probably have aided in preparation for war[3]. This tetradrachm of Athena is clearly not a Roman style coin. Still, if Burnett and Craddock's theory is correct, this coins might have been used similarly for the purposes of war.

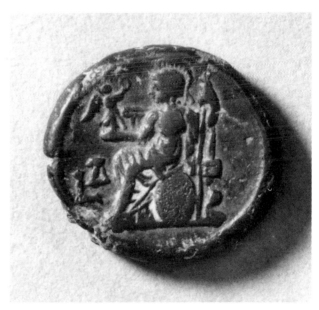

DCS

1. MILNE, p. xxviii-xxxi.
2. MILNE, *A History of Egypt under Roman Rule*, London, 1924, p. 180 and 187.
3. BURNETT, A. and CRADDOCK, P., *Rome and Alexandria : The Minting of Egyptian Tetradrachms under Severus Alexander*, in *ANS Museum Notes*, 28, 1983, p. 109-118.

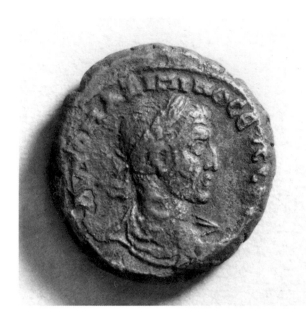

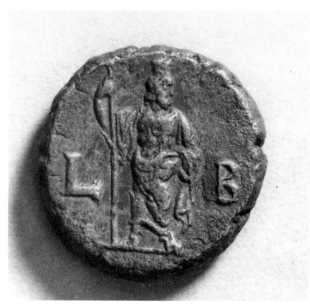

110. Maximinus Thrax

AE Billon - AD 235-238
Obv. AVTO ΜΑΞΙΜΙΝΟC EVCCE B Bust r., laureate,
wearing cloack and cuirass, back view
Rev. L - B in field. Serapis crowned with modius, wearing
chiton and himation. Resting r. hand on sceptre and l.
hand in folds of himation.
Cm. 2.1 - Gr. 12.9
Brown University
Bibliography : MILNE, n° 3209.

After the mutiny and murder of Severus Alexander in AD 235, Maximinus's Pannonian troops declared him Emperor near Mainz, Germany. Recognized as the first soldier-emperor, Maximinus was the son of a Thracian peasant. As a man of considerable size, he advanced through the equestrian ranks and achieved great prominence. Although he had little education and no previous civil appointments, he was proclaimed Emperor at Severus's death.

Maximinus immediately doubled his soldiers' pay upon his accession, and probably due to the great financial burden of war, he also taxed his citizens severely and is said to have confiscated public funds. Along with the fact that Maximinus never visited Rome in his nearly four years as Emperor, the financial strain was enough for the Empire to rejoice at his murder in AD 238.

The reverse of this coin, bearing the image of Serapis, was common in Alexandria. Here, nearly all coin types derived from Egyptian religious sources and belinged either to the official triad of Serapis, Isis, and Harpokrates, or to Nilus and Euthenia[1].

ACW

1. MILNE, p. xxix.

111. Gordian III

AE - AD 238-244

Obv. M ANT ΓΟΡΔΙΑΝΟϹ ΑVΓ Radiate, draped and cuirassed bust of Gordian III r.

Rev. NIKAIEΩN. Two aquilae between two standards.

Cm. 1.8 - Gr. 3.4

Brown University, Harkness Collection

Bibliography : SEAR D.R., *Greek Imperial Coins and Their Values*, London, 1982, n° 3671.

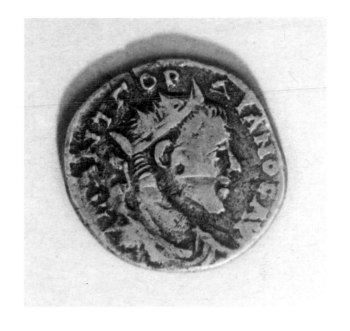

In AD 242 Gordian III and Timesitheus began their successful military campaign against the invading Persians. Gathering troops from the Danubian army, their march from Thrace to Syria would have included a passage through Nicaea on the western Bithynian coast. Nicaea's importance for such journeys is recorded here.

On the obverse, Gordian's name and title Augustus are written in Greek. Accompanying this legend is a low relief portrait that lacks Gordian's characteristic features found on his Roman coinage. A common legend identifying the Nicaean mint appears amidst the military standards, which include the Roman legions' traditional eagle-topped standards. The eagle simultaneously alludes to Jupiter and to Rome's military prowess. The reverse type signifies the critical role Nicaea played as both a staging area for Roman reinforcements and as a major thoroughfare for the region due to Nicaea's location near the sea and the access it gave to neighboring cities[1]. Thus, rather than referring to a specific event, this coin testifies to Rome's continual reliance on Nicaea.

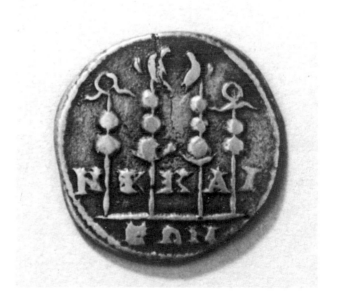

KLB

1. See WEISER, W., *Katalog der Bithynischen Münzen der Sammlung des Instituts für Altertumskunde der Universität zu Köln*, I, Köln, 1983, p. 203, n° 15.

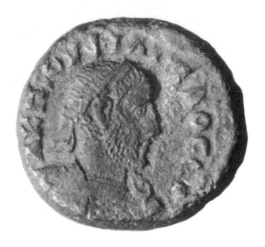
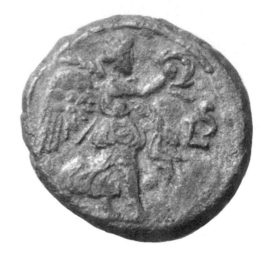

112. Philip I

Billon tetradrachm - AD 249
Obv. ΑΚΜΙΟΥ ΦΙΛΙΠΟCCEB Bust of Philip r., laureate with cuirass.
Rev. Nike flying r., holds palm over shoulder and wreath.
Cm. 2.2 - Gr. 12.0
Brown University
Bibliography : CURTIS, n° 1352.

The accession of Philip I was followed by an expansion in the Alexandrian coinage ; in the fifth month which made up his first regnal year, the total output was quite as great as in the last seven months of Gordianus III, and in his second regnal year, the average of recent years was more than doubled[1]. During this reign there is a slight improvement in workmanship by the Alexandrian artists ; however, the general trend was towards a commonplace monotony[2].

The troubled years of this century are well reflected in the provincial coinage. The pronounced militarization of the third century is evident in the cuirassed depiction of the Emperor, who is shown as an actual warrior ready to defend the Empire against any barbarian invasion[3].

The figure of Nike is one of the most common types, but while it has no specific historical reference, it does refer to the Emperor himself. In the coinage of Alexandria events of the history of the city were not mentioned.[4]

EG

1. MILNE, p. xxiii.
2. *Ibid.*, p. xli.
3. HANNESTAD, N., *Roman Art and Imperial Policy*, Aarhus University Press, 1986, p. 286.
4. POOLE, p. lix.

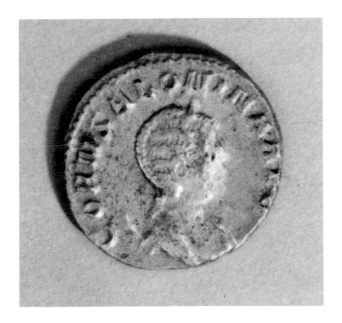
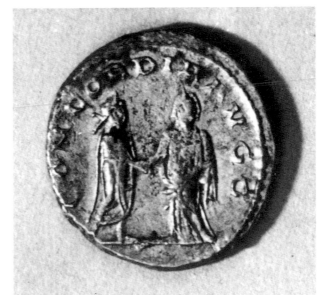

113. Salonina

AE Antoninianus - c. AD 255-258
Obv. CORN SALONINA AVG Head of Salonina, r., draped and diademed, on a crescent.
Rev. CONCORDIA AVGG Salonina and Gallienus standing, clasping hands.
Cm. 1.9 - Gr. 4.5
Brown University, Harkness Collection
Bibliography : RIC V, n° 63.

Cornelia Salonina was the wife of Gallienus ; she was named Augusta in AD 254 when her husband began his joint reign with his father, Valerian. The reverse of this antoninianus portrays Gallienus and Salonina clasping hands ; the legend indicates the harmony between the Emperor and his wife, and by extension, between the Emperor and his kinsmen[1].

At the time this coin was minted, Concordia was purely propagandistic because of Gallienus's tenacious hold over the Empire. At this time he was constantly engaged in, or preparing for war. The situation was particularly acute in Antioch, where this coin was most likely minted[2], as that city was under attack by the Persians in AD 253, 258-59, and 260. Mattingly believes that such instability led the mint at Antioch to continue production elsewhere, perhaps at Cyzicus in Asia Minor[3].

LLA

1. LEVICK, B., *Concordia at Rome*, in *Scripta Nummaria Romana* (R.A.G. Carson and C.M. Kraay, eds.), London, 1978, p. 227.
2. RIC V, p. 23.
3. RIC V, p. 17.

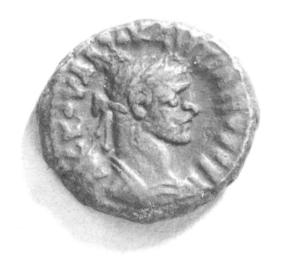

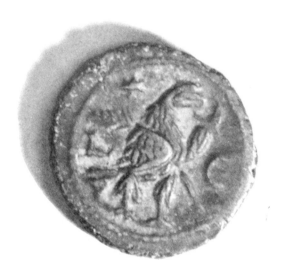

114. Diocletian

Billon tetradrachm - AD 289-290
Obv. ΑΚΓΟΥΑΛΔΙΟΚΛΗΤΙΑΝΟCCEB Bust of Diocletian r., laureate, wearing cloak and cuirass.
Rev. Eagle standing r., palm transversely in background, wreath in beak, to l. above star. In field, L - E
Cm. 1.8 - Gr. 6.5
Brown University
Bibliography : MILNE, n° 4918.

Under Diocletian a great monetary reform took place, which also effected the provincial mints. In AD 293, Diocletian began to issue new Latin-style coinage from Alexandria, which was being produced simultaneously elsewhere. The Greek-style coinage, however, was not terminated by that date, but it was allowed to overlap the new and reformed coinage, being brought to an end, when Diocletian crushed the revolt of Domitius Domitianus and reorganized Egyptian affairs[1].

Between the second and sixth year of Diocletian's reign, four workshops were in use in Alexandria. Two were minting coins of Diocletian and two coins of Maximian. In each pair, one workshop used a star as its distinctive mark[2]. The star that appears on the reverse of this coin, simply indicates a specific workshop and style.

The eagle on the reverse, carrying a wreath in its beak, has a clear military meaning. The eagle was the first zoological type that was taken over from Ptolemaic coinage, and it naturally became popular with the Romans because of its military associations. It is almost the only zoological type used in the Third century AD[3].

EG

1. RIC VI, p. 66.
2. MILNE, J.G., *The Organisation of the Alexandrian Mint in the Reign of Diocletian*, in *JEA*, 3, 1916, p. 207.
3. MILNE, p. xxxiii.

115. Diocletian

AE Follis - c. AD 298-299
Obv. IMP DIOCLETIANVS P F AVG Head of Diocletian, laureate, r.
Rev. SALVIS AVGG ET CAESS FEL KART Carthage standing frontally, whith head to l., holding bunches of fruit.
Cm. 2.6 - Gr. 9.9
Brown University, Harkness Collection
Bibliography : RIC VI, n° 29a.

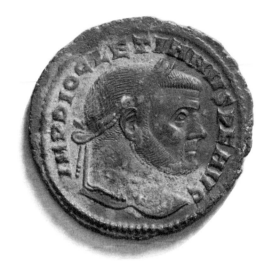

In the last years of the third century, a confederation of Moorish tribes, the Quinquegentiani, invaded the Roman frontiers of Northern Africa. The Tetrarch Maximian was dispatched to the old Roman province of Carthage[1] in order to repel this invasion. Maximian's military operations necessitated the establishment of a mint to pay his expenses, and this coinage belongs to these years of a rapid sequence of aes issues[2]. Until this period, Roman provinces in Africa had been largely dependent upon Italy for their monetary supplies[3]. Since the presence of a mint tended to enhance local commerce[4], the personification of Carthage holding bunches of fruit is a testament to prosperity. The effigy of Diocletian fits in well with coin portraits of long established mints. Stylistically, it is comparable to the geometrical portraits of the late third century. This may in fact be due to molds having been sent to the province from Rome[5].

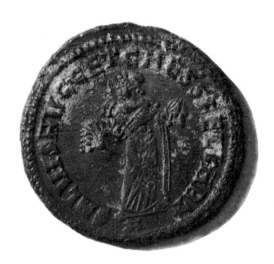

JT

1. An ancient city on the Northeast tip of Africa, destroyed by Rome in the Third Punic War (149-146 BC), and established as a colony by Julius Caesar in 44 BC.
2. RIC, p. 411.
3. MATTINGLY, H., *Roman Coins*, London, 1960, p. 246, noting that the various mints around this time achieved considerable homogeneity as a result of Diocletian's reforms, c. AD 296.
4. *Ibid.*, p. 247.
5. RIC VI (part 2), p. 411. On the iconography of Carthage, see SCATTI, G., in *Enciclopedia dell'Arte Antica : Classica e Orientale*, II, Rome, 1959, p. 377.

116.
Omitted.

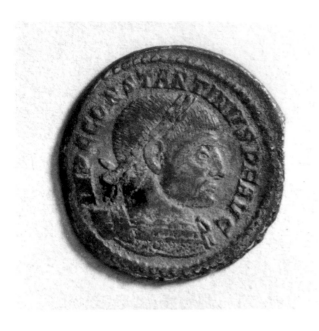

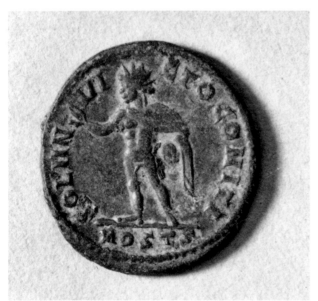

117. Constantine I

AE Follis - Ostie - AD 313
Obv. IMP C CONSTANTINVS PF AVG Constantine, laureate and cuirassed r.
Rev. SOLI IN - VI - CTO COMITI Sol radiate standing l. In exergue, MOSTS.
Cm. 2.2 - Gr. 4.2
Brown University, Harkness Collection
Bibliography : RIC VII, n° 83.

The figure of Sol on the reverse is a reference to the Emperor's patron god. After AD 315, the date of Constantine's first battle with his competitor Licinius, the image of Sol no longer appears on his coins. This coin was minted at Arles.

The transfer of the mint at Ostia to Arles presents us with an infrequent occurrence in the life of Constantine.

The reign of Constantine is characterized by deeds centered on political affairs rather than a life glorified through commemoration of historic deeds and praise of his own personality. Sol on this coin refers back to the years AD 307 when Constantine was given the title *Augustus*. Other coins from the mint of Arles personify that city and Rome, and request that good fortune follows the transfer of *moneta* between the two cities[1].

MRW

1. KENT, p. 51.

118. Constantine I

AE Follis - Constantinople - c. AD 328
Obv. CONSTANTINVS MAX AVG Constantine r. with
rose crown.
Rev. CONSTANTINI - ANA DAFNE Victory seated l.
with wreath, trophy. In field on l., A. In exergue,
CONST.
Cm. 2.1 - Gr. 2.9
Brown University, Harkness Collection
Bibliography : RIC VII, n° 35 ; LRBC, n° 999.

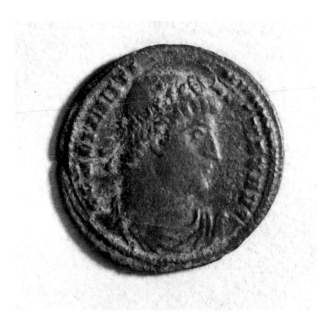

Constantinople was officially dedicated on May
18, AD 330 and celebrations were held in both the
Western capital, Rome, and the new Eastern capital,
Constantinople. Prior the official dedication of
Constantinople a mint had been established and was
producing coins of Constantine as early as AD 326
in what was to become the capital of the Eastern
Empire[1]. This coin with the Emperor on the obverse
and Victory on the reverse was a type central to the
conquest of the area by Constantine. The Empire
won control of Constantinople through a naval
victory. Because of this, virtually all of the coins
minted in Constantinople carried the reminder of
the means by which control of this eastern capital
was gained by the Romans[2].

MRW

1. RIC VII, p. 562.
2. KENT, p. 52.

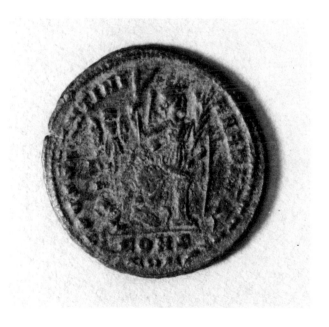

OTHER MEDIA

119. Head of a Man

Coarse Greek Island Marble - c. 40 BC
Cm. 16
Courtesy of the Harvard University Art Museum (Arthur
M. Sackler Museum), Cambridge, Massachusetts
Gift of Stuart Cary Welch, Jr. - Acc. n° 1966-135
Bibliography : Fogg Art Museum, Acquisitions 1966-67,
Cambridge, 1968, p. 76, illus. p. 158.

The middle-aged man represented has a rect-
angular face framed by short wavy hair that runs
in small ringlets across his low forehead. Deep
wrinkles are indicated with incised lines on his

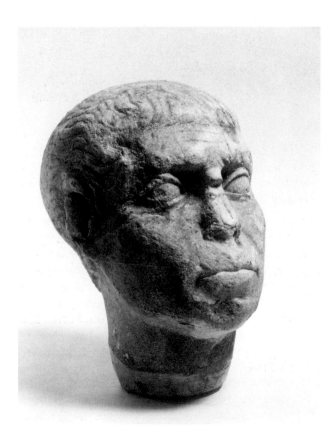

cheeks and forehead. Naturalism as one sees it
here is typical of the late Republican period. This
head is one of a number of works dated to the
time of the Second Triumvirate[1]. It is an example
of a portrait style remarkable for its apparent use
of accuracy as its only guide[2], with every fold and
wrinkle rendered with unflattering honesty. Such a
realistic style reflects the practicality and serious-
ness of the sitters themselves, who tended to be
statesmen and military leaders entrusted with the
care of the Republic[3].

The Harvard *Head of a Man* is comparable to the
Caesar portrait type found in the Camposanto,
Pisa[4]. The hair styles are similar, as are the large,
attentive eyes, tightly closed mouth with lower lip
thrust forward, and high cheekbones accentuated by
a thin, drawn face. Beside the influence of the
Caesar portrait type, the sculptor has managed to
stress the *gravitas* of this particular subject.

JT

1. SCHWEITZER, B., *Die Bildniskunst der römischen Republik*,
 Weimar, 1948, p. 126-127, figs. 192-196 ; cited by VERMEULE,
 C.C., entry on *Head of a Man* in the forthcoming catalogue
 of *Greek, Roman and Etruscan Stone Sculpture in the
 Harvard University Art Museums*. I would like to thank Ms.
 Amy Brauer, Department of Ancient Art, for making a draft
 of this entry available to me.
2. HIESINGER, U.W., *Portraiture in the Roman Republic*, in
 ANRW, I.4, p. 88.
3. The origin of this veristic style is a subject of scholarly
 debate ; see HIESINGER, p. 807-808.
4. See VERMEULE cf. JOHANSEN, F.S., *The Portraits of Gaius
 Julius Caesar : A Review*, in *Ancient Portraits in the J. Paul
 Getty Museum* 1, in *Occasional Papers on Antiquities*, 4,
 Malibu, California, 1987 ; the Camposanto Caesar, JOHAN-
 SEN, figs. 6a-b, and *Head of a Man*, Ny Carlsberg Glypo-
 thek, Copenhagen, n° 565, figs. 14a-b, once erroneously
 considered a Caesar portrait but clearly influenced by them
 like the Harvard work.

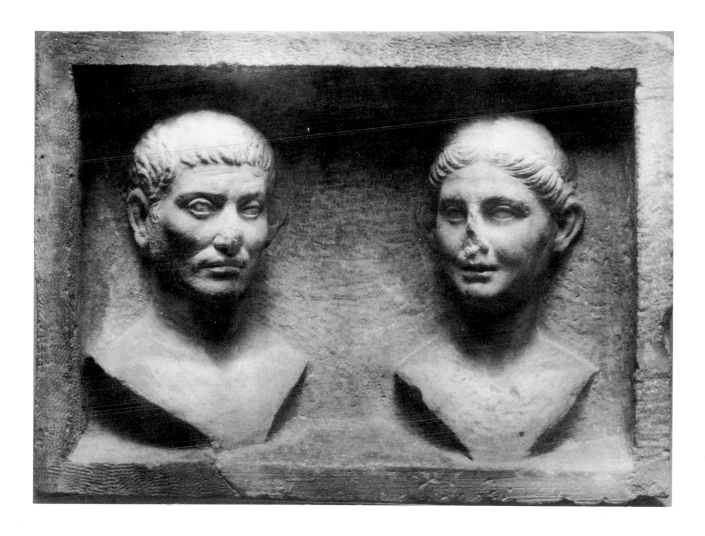

120. Funerary Relief

Marble - c. 13 BC-AD 5 - Cm. 71.7 x 50.8
Courtesy of The Metropolitan Museum of Art, New York. - Rogers Fund, 1909, 09.221.2.
Bibliography :
RICHTER G. M. A., *Roman Portraits*, New York, 1948, n° 6 ; KLEINER D. E., *Roman Group Portraiture*, New York, 1977, p. 208-209, n° 22.

This funerary relief representing two freedmen — a man and his wife or, perhaps, a man and his daughter [1] — probably is influenced by traditional Roman aristocratic funerary practices in which busts and masks of ancestors were made for funeral ceremonies and for display in boxes in ancestral halls and family mausolea.

A popular form of funerary sculpture from the end of the first century BC through the first century AD, these reliefs were often horizontal plaques with unadorned borders. Containing up to nine figures, portrait busts with shoulders just touching were preferred. Such grave reliefs were typically used to decorate the exterior of tombs that would often line the main roads leading to Rome. The rougher portion of the exterior of the frame of this relief indicates that it was set into a structure, possibly serving as one of the building blocks of a wall. Partly on the basis of the inscriptions that were often included on the frames of these funerary reliefs, Diana Kleiners claims that they were commissioned solely by one stratum of Roman society,

1. The figures are identified as husband and wife in CHASE, G.H., *Greek and Roman Sculpture in American Collections*, Cambridge, Mass. 1924, p. 175, and in *The Metropolitan Museum of Art, Bulletin*, V, 1910, p. 236. On the other hand, based on a perceived discrepancy in their ages, MCCLEES, H., identified them as father and daughter in *The Daily Life of the Greeks and Romans*, New York, 1924, p. 131. Contemporary scholars, however, avoid the issue and do not speculate on the relationship between the pair.

the « enfranchised slaves and their freeborn offspring »[2]. Kleiner argues that the freedmen used these to commemorate « their new legitimacy as families [where] the public display of images accompanied by tripartite Roman names was a symbol of their newly won freedom »[3].

Termed « an average example of the journeyman-sculptor's art of the first century AD »[4], the slightly idealized portrayal of the woman and the hairstyles shown support a mid-Augustan dating. The sensitive, somber description of the male head nevertheless recalls the Republican interest in realism. The traces of red paint between the busts are the remains of the original background color. While the flattening of one ear of each of the figures suggests a naivete, the artist has developed an effective, original composition. Abandoning the typical frontal, static format, the sculptor has tilted the entire male bust slightly to the right, while the female's head has been turned to the left in response.

<div align="right">KLB</div>

2. KLEINER, D., *Roman Group Portraiture*, New York, 1977, p. 184.
3. *Ibid.*, p. 188-189.
4. *The Metropolitan Museum of Art, Bulletin*, V, 1910, p. 236.

121. Augustus

Parian marble - 1st or 2nd Century AD
Cm. 24.4 x 20.4
Courtesy of the Museum of Art, Rhode Island School of Design, Providence
Museum Appropriation. - Acc. n° 26.160
Bibliography :
C. M. M., *An Augustan Portrait*, in *BullRISD*, XVII, 4, 1929, p. 38-40.
HAUSMANN, U., *Zur Typologie und Ideologie des Augustusporträts*, in *ANRW*, 1981, p. 35.
POULSEN, V., *Les portraits romains, république et dynastie julienne*, Publications de la Glyptothèque Ny Carlsberg, Copenhagen, 1962, p. 23-24.
RIDGWAY, B., *Catalogue of the Classical Collection*, Providence, 1972, p. 84-85.
VERMEULE, C., *Greek and Roman Portraits*, in *Proceedings of the American Philosophical Society*, 108, 2, 1964, p. 112.
ZANKER, P., *Studien zu den Augustus - Porträts I. Der Actium - Typus*, in *Abhandlungen Göttingen, Phil.-hist.*, 3 F., n° 85, 1973, p. 20, n° 7.

After defeating M. Antony at the Battle of Actium in 31 BC, Octavian was the sole ruler of the Roman world. In 27 BC, he nominally restored the Republic, accepted the Senate's bestowal of the name Augustus, and ruled from an unprecedented position of power. Up to this time, the epithet Augustus had been used only in religious contexts ; its transposition to Octavian indicated a change in the Princeps's political ideals.

According to Suetonius, Augustus was unusually handsome, having bright eyes and curly hair (Suetonius, *Augustus*, 79). During Augustus's reign, his image was pervasive, yet its use was tightly controlled and intentionally employed[1]. Sculpture played a significant part in Augustus's imperial propaganda : he chose a classical and strongly idealized style to best suit his purposes. Augustus was deified after his death in AD 14, and his posthumous portraits take on an even more idealized air as images of apotheosis.

The Providence Augustus does not implicate one specific portrait type. According to Zanker, this piece belongs to the Actium type[2]. Conversely, it could derive from an original which was itself a synthesis of prevailing official portraits. The Prima Porta type, which was created around 27 BC and refers back to the Periclean style[3], and the type known through the Capitoline head, which might have been distributed in the provinces, are considered by some to be the progenitors for the Providence portrait[4]. On both the Capitoline and Providence portraits, the three forelocks are fashioned to the left, visible here even though the strands are missing. On the Prima Porta, however, the locks fork and thereby impart an additional sense of liveliness. The slanted back of the Providence head would have allowed it to be covered by a toga, or to be inserted into a veiled body, as in the Augustus from the Via Labicana[5].

1. WALKER and BURNETT, *The Image of Augustus*, London, 1984.
2. ZANKER, p. 20.
3. *Ibid.*
4. See also POULSEN, V., p. 24.
5. RIDGWAY, B., p. 84.

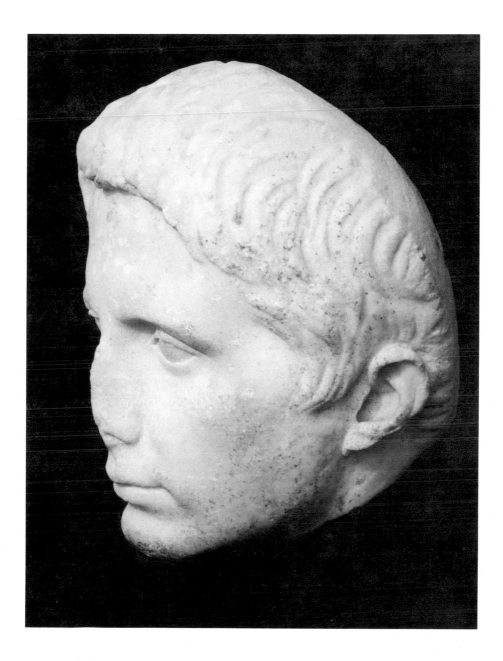

Zanker proposes AD 30-40 as a possible date for this portrait ; another thesis posits that the drilled hair locks are a technical device that date the sculpture to Hadrianic times[6]. The ageless portrait of the Providence Augustus is characterized by a high flat forehead, a compressed space between nose and chin, and an incipient smile. Altogether, this apotheistic portrayal is steeped in a Hellenistic style, and may be more in keeping with Greek workmanship.[7]

Posthumous portraits of Augustus are relatively common since he was continually being remembered as the founder of the Roman Empire. This head may indicate that posthumous portraits of Augustus could be of human proportion, and could imitate a veristic pattern[8].

JS

6. VERMEULE, C., p. 112.
7. *Ibid.*, RIDGWAY, B., p. 85.

8. *Ibid.*

122. Cameo

Dark Brown and White Opaque Glass - Early First
Century AD
Cm. 3 x 1.5
Courtesy of the Corning Museum of Glass, New York
Acc. n° 70.1.16
Bibliography : DE RIDDER A., *Les bijoux et les pierres
gravées*, in *Collections de Clercq*, VII, 1888.

The cameo consists of a bottom layer of translu-
cent dark brown glass with a white opaque layer
fused on top of it. The design was cut from the
upper white layer.

When the piece was first published in the late
nineteenth century in the *Collection de Clercq*, it
was said to be either an Augustan of Julio-
Claudian. Coins of the Emperor Claudius show him
with more angular features than this piece, but with
the same wavy short hair. The features on this
cameo are well-defined and strong, the skin is
smooth and the expression thoughtful and directed.

Richter cites examples of cameos from the
Augustan period that are similar to this piece[1],
for instance the *Augustus and Roma* cameo from
the Kunsthistorisches Museum, Vienna, resembles
the profile and features of this cameo from the
Corning Museum. Also a cameo of Augustus in
the Museo Archeologico Nazionale, Naples, has a
similar profile, hair and prominent ear as this
cameo[2]. Contrasting layers of glass produce a
simple yet striking portrait. This technique enjoyed
much popularity under Augustus. Not only was it
used on small single-figure cameos, but also on
larger vessels and on cameos with multiple figures.

MRW

1. See RICHTER II n° 484.
2. PANNUTI, U., *Tre gemme romane con ritratti imperiali*, in II
*Conferenza Internazionale sul Ritratto Romano, Ritratto
Ufficiale e Ritratto Privato*, Rome, 1988, p. 413-418, fig. 1.

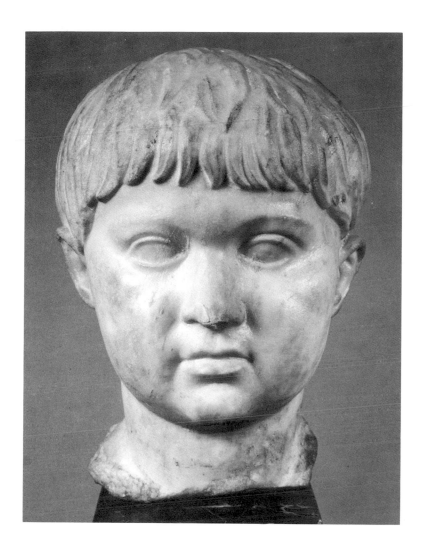

123. Head of a Boy

Marble - Augustan, Early First Century
Cm. 20 x 14.5 x 15.5
Courtesy of The University Museum, The University of Pennsylvania, Philadelphia, Pennsylvania
Gift of Mrs Lucy Wharton Drexel - Acc. n° MS 4030
Bibliography : *Ancient Portraits*, The Ackland Art Center, Chapel Hill, North Carolina, April-May 1970, n° 17.

As a portrait of a child, this head is of great quality and in fine condition, small losses to the tip of the nose and abrasions to the left cheek being negligible. The creamy white marble has been lightly polished as is seen when contrasted with the dry appearance of carving around the nose, mouth and ears. It is a remarkable example of sophisticated transitional modelling, as the temples meld into ridge-like eyebrows, the treatment of the lower face is a sequence of alternately concave and convex dents and ridges which define the mouth, dimples and chin. An unusual feature is the angle at which the back of the head slopes ; when laid horizontally the head lies as naturally as a sleeping child, an aspect poorly explained by any requirement in the vertical (placement in a niches for example) except through subsequent alteration. Comparaisons on the basis of hair style places this juvenile portrait in the early part of the first century, the treatment of which - flamelike stands of hair - is especially notable. A functional explanation for these portraits is difficult to furnish, and although doubtless commemorative there is no reason to suppose that these are all portraits of the recently-dead ; the serious aspect of this child's face being better explained by not smiling than by morbidity.

JWH

124. Portrait of Agrippina the Younger

White Marble - c. AD 40
Cm. 30.5 x 22.2 x 23.5
Courtesy of the Museum of Art, Rhode Island School of
Design, Providence
Gift of Mrs. MURRAY S. Danforth - Acc. n° 56.097
Bibliography :
CLARK, A.M., *An Agrippina*, in *BullRISD, Museum
Notes*, 44, 4 (May 1958), p. 3-5.
RIDGEWAY, B.S., *Catalogue of the Classical Collection*,
Providence, 1972.

Although both genders of the Imperial Family and private citizens exalted themselves through portraiture, R. R. R. Smith believes that, unlike male portraits, the differences between female portraits are often visually insignificant, a fact which signifies that empresses were generally represented as being very similar to their contemporaries[1]. Only context, added attributes and hairstyle details differentiated them from private citizens. In contrast, male imperial types are strongly individualized, thereby setting the emperor apart from his predecessors and contemporaries[2]. As a result, it may be concluded that the recognizability of an emperor was clearly considered very important to Romans, and that of his wife less so[3].

In support of the above two beliefs, much uncertainty exists regarding the identity of female sitters. For example, a large majority of heads ascribed to the fifties are claimed as portraits of Agrippina because of the similarity of coiffures. Scholars, however, often cannot decide which Agrippina is depicted, the mother or the daughter. However, most of these portraits probably depict the daughter, whose power and positiion would insure this[4].

What distinguishes portraits of Agrippina from those of her mother are her harder and more pointed features, her more pronounced nose, and her smaller mouth with thinner lips. Whereas both women had a long eyebrow, the daughter had smaller and closer eyes. These features, as well as the hollow cavities at the corners of her eyes and mouth, are seen also in portraits of Caligula and Germanicus.

While some scholars believe that female imperial portraits purposely evoke the features of a male family member, others believe that these depictions are simply true likenesses of the women. The argument of the former scholars is that by evoking the features of an imperial male in their portraits, and thereby indicating their relationship to him, these imperial women proclaimed their status and importance in society[5].

Although lacking an imperial diadem to distinguish her from her mother, the RISD head has Agrippina's characteristic coiffure-hair parted in the middle, framing the forehead and sides of her face with vertical rows of tightly curled ringlets. The hair is twisted into two rolls behind the ears and is joined in a thick knot over the nape. It is tied with a ribbon and hangs down her neck.

The lack of an imperial diadem places the piece sometime before the date of Agrippina's marriage to Claudius. Ridgway believes the portrait depicts her at the age of twenty-five, shortly after she had given birth to Nero[6].

EDG

1. SMITH, R.R.R., *Roman Portraits : Honours, Empresses, and Late Emperors*, in *JRS*, 75, 1985, p. 214. It should be noted that this thesis may not be universally accepted.
2. *Ibid.*
3. *Ibid.*
4. CLARK, A.M., *An Agrippina*, in *BullRISD, Museum Notes*, 44:4, 1958, p. 4.

5. SMITH, p. 215.
6. RIDGEWAY, p. 86.

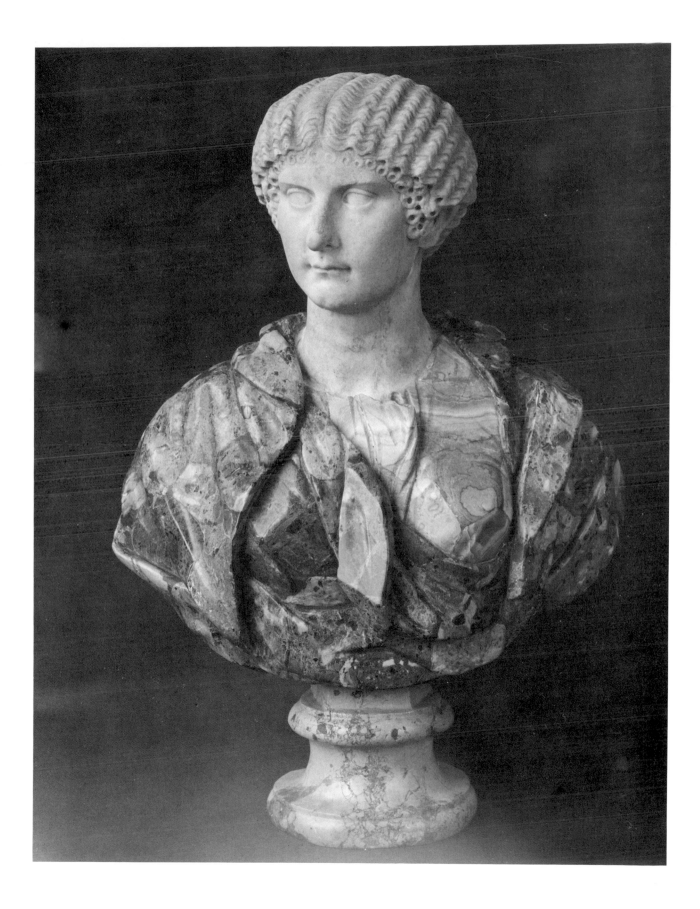

125. Caligula

Bronze - 1st Century AD
H : 14.3 cm.
Courtesy of the Brooklyn Museum - Acc. n° 21.497.12

Bibliography : MITTEN D., *Master Bronzes from the Classical World*, Mainz, 1968, n° 230, p. 238.

Few portraits of Caligula remain. Those that do are often identified by a comparison with his physiognomy as found on coins. Characteristic of his features are a long straight nose, small mouth and jutting chin. After he was murdered by the Praetorian Guards in AD 41, the Senate wanted to order a *damnatio memoriae*. It was formally obstructed by Claudius, who did, however, permit portraits of Caligula to be removed at night, while the Senate allowed his coins to be melted down (Dio Cassius LX.4 and LX.22).

Ancient texts are of little assistance in defining portraits of Caligula, although they do provide us with a glimpse of his personality[1]. It is understandable that there is little of the Suetonian conception in this portrait of the Emperor ; instead, it harkens back to the youthful type of Augustus[2]. This purposeful conflation emphasizes Caligula's dynastic identity, and suggests the peace of the former time. The globe beneath the bust signifies other aspects of the imperium. It implies his sovereignty over the world, realized in a literal sense, since such power is analogous to the Emperor himself[3]. Moreover, since the Emperor is situated above the world, he is endowed with the qualities of a divinity[4]. Although the motif of globe and imperial bust is more common with coins than with sculpture, no coins with globes were produced during Caligula's reign.

In the hairstyle and portrait type, this portrait resembles that of Caligula in the Schloss Fasanerie[5]. It is also similar to a Zürich Caligula dated c. AD 41[6]. The triangular shape of the Brooklyn bust, and the features' close resemblance to those of Caligula on his coins, confirm a first century date.

JS

1. Suetonius writes « so repulsive was the whiteness of his face, which showed many escapades, so haggard were his eyes hidden deep under his forehead, which was like that of an old man, and so large was the repulsiveness fo the baldness of his head, which was only partly covered with hair ». (Suetonius, *Gaius Caligula*, 50.)
2. See BRILLIANT, R., *An Early Imperial Portrait of Caligula*, in *Acta ad Archaeologiam et Artium Historiam Pertinentia*, 1969, p. 13-18. See also GROSS, W.H., *Caligula oder zulässige und unzulässige Interpretationen eines römischen Herrscherbildes*, in *Wissenschaftliche Zeitschrift*, 31, 1982, 2/3, p. 205-207.
3. SYDENHAM, *NC*, 1916, p. 35-36.
4. *Ibid.*
5. VON HEINTZE, H., *Die Antiken Porträts der Landgräflich - Hessischen Sammlungen in Schloss Fasanerie bei Fulda*, Berlin, 1968, p. 30-31, n° 21.
6. MITTEN, p. 238.

126. Head of a Young Man from a Historical Relief

Marble - c. AD 60-65
Cm. 30
Courtesy of The Museum of Fine Arts
Boston, Massachusetts
Gift of Ariel and John Herrmann - Acc. n° 1983.681
Bibliography : VERMEULE C.C., forthcoming catalogue.

The head in three quarter profile was once part of a high relief figure. It is broken on the back in an area from the left rear to below the right ear. The nose is broken, and there is some marble chipped away from above the right eye. The head is somewhat larger-than-life. The hair is formed in two rows of curls along the forehead. The eyes are smooth. The lips are parted slightly and the overall physical expression of the man's personality is demonstrated by his calm, self-assured face.

This piece has been dated to the middle of Nero's reign when he was still a respected Emperor[1]. Following his suicide in AD 68 many of the art works carrying his likeness were destroyed[2]. However, numerous coin issues which carried his portrait continued to circulate throughout the Empire for up to a hundred years after his death. From extant coins and the few remaining pieces of sculpted Neronian art it is possible to make an attribution for this piece. The hair style on this portrait, with the hair combed forward and two rows of curls framing the top of the forehead, was a style worn by the Julio-Claudian princes of whom Nero was the last to become emperor. Heisinger has shown five stages of development of this style in the art of Nero. This piece fits into the last stage which is characterized by two rows of curls on the forehaed along with the corpulent features on the face of the Emperor[3] as is known from Neronian coins[4]. However, the features from this piece from the Museum of Fine Arts, are not corpulent, though they are full. They are either the features of a young Nero, predating the date of attribution and hair style, or they are the features of a follower of Nero. A possible attribution is one of the shortlived successors of Nero, for example his friend Otho, who reigned only for a few months. From coins Otho is known to have worn his hair in this late Neronian style. The *Cancelleria Relief*

1. VERMEULE, C.C., forthcoming catalogue, n° 44.
2. KLEINER, F.S., *The Arch of Nero in Rome*, Rome, 1985, p. 94.
3. For a complete discussion see HEISINGER, *The Portraits of Nero*, in *AJA*, 79, 1975, p. 113-124.
4. BMC I, p. 200-205.

is one of the few surviving depictions of a historical event of the period and it provides a possible example of the setting for which this head may have been carved.

MRW

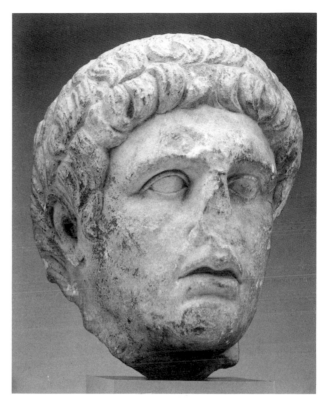

© Courtesy Museum of Fine Arts, Boston.

127. Roman Cameo in Two-layered Chalcedony

White on Pinkish Gray Chalcedony - First Century BC
Cm. 4.1 (width)
Bowdoin College Museum of Art, Brunswick, Maine
Acc. n° 1915.1
Bibliography :
HERBERT K., *Ancient Art at Bowdoin College : A Descriptive Catalogue of the Warren and Other Collections*, Cambridge, 1964, n° 507.
CASSON S., *Descriptive Catalogue of the Warren Classical Collection of Bowdoin College*, 1934, n° 96.

This cameo does not reflect the similarities between cameos and coins. Instead, it stands closer to sculpture. While both images use the device of slightly turned heads, these figures appear more unified due to the fused drapery. Subtle differences between the two figures also need to be noted. The

man on the left stands slightly in front of the woman as is seen by the overlapping shoulder. His head also appears a bit higher and larger than his female counterpart's, perhaps as a result of a larger physique. Overall, the delicate handling of the chalcedony produces fine nuances of relief and shadow.

HBR

128. Intaglio of Hadrian

Blue glass paste - c. AD 123-128
Cm. 2.1 x 1.7 x 0.4
Brown University, Wagner Collection - Acc. n° 417
Bibliography : Unpublished[1].

The intaglio can be dated by relating it to other images of Hadrian. One of the most prominent aspects of his coiffure as seen on this glass paste speciment is its sub-division into distinct, wavy locks that fall over his forehead. This treatment of the hair calls to mind a well-known bust of the Emperor in the Museo delle Terme in Rome and the portrait type is employed in his coinage from AD 123-128, thus providing an approximate date for the intaglio[2].

The intended use of the glass paste portrait is not entirely clear. A possible explanation of its function is that it was part of a signet ring. In Antiquity, engraved gems were frequently used as seals in order to safeguard valuable belongings and to sign documents[3]. Portraits as well as inscriptions and emblematic motifs provided the repertory of images on seals.

According to Aelius, Hadrian used his own portrait as a seal[4]. That the intaglio belonged to the Emperor, however, is highly unlikely because of its material. Glass paste was an inexpensive substitute for semi-precious and precious stones in Roman glyptics[5]. A signet ring in the possession of the Emperor would certainly have been made of a more luxurious material. Quite possibly, the intaglio was a reproduction of an official seal and was used by a functionary acting on behalf of the Imperial administration. This interpretation, although speculative, reconciles the otherwise paradoxical appearance of the Emperor's image on an object composed of a commonplace material.

GW

1. Similar examples found in : VOLLENWEIDER, M.-L., *Catalogue raisonné des sceaux, cylindres, intailles et camées du Musée d'Art et d'Histoire de Genève*, II, Mainz, 1979, p. 224-225, n° 233, pl. 70 ; ZWIERLEIN-DIEHL, E., *Glaspasten im Martin-von-Wagner-Museum der Universität Würzburg*, Munich, 1986, p. 253, n° 761.
2. WEGNER, M., *Das römische Herrscherbild, Hadrian*, Berlin, 1956, p. 13, uses the bust to illustrate one of the Emperor's portrait types. FELLETTI-MAJ, B., *Museo Nazionale Romano. I Ritratti*, Rome, 1953, p. 99-100, n° 189, dates the bust to AD 123-128 and compares it with Hadrian's portrait on coins of this period. Examples of these coins are illustrated in BMC III, n°s 333-470.
3. RICHTER, G.M.A., *Engraved Gems of the Romans*, London, 1971, p. 1 ; MARSHALL, F., *Catalogue of the Finger Rings, Greek, Etruscan and Roman in the British Museum*, London, repr. 1968, p. xv-xviii.
4. MARSHALL, p. xviii.
5. *Ibid.*, p. xxxv-xxxvi.

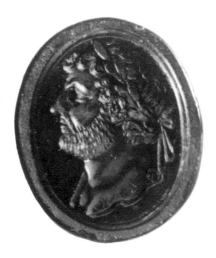

129. Large Fragment of a Blue-Shell Roman Cameo

Cm. 2.8 - AD Late Second Century
Bowdoin College Museum of Art, Brunswick, Maine
Acc. n° 1915.89

Bibliography :

CASSON S., *Descriptive Catalogue of the Warren Classical Collection of Bowdoin College*, 1934, n° 85.
HERBERT K., *Ancient Art at Bowdoin College : A Descriptive Catalogue of the Warren and Other Collection*, Cambridge, 1964, n° 511.
JUCKER H., *Ein Kameo-Porträt des Commodus*, in *Schweizer Münzblätter*, 16, 1966, p. 162-166.

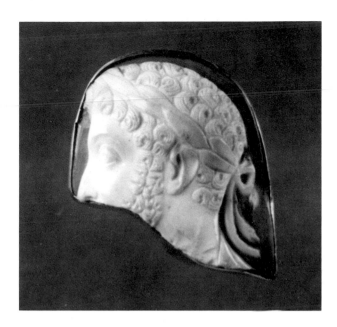

This fragment displays the close artistic relationship between coins and the glyptic art of cameos because of their minute size and similar use of circular or oval fields[1]. Cameos were enjoyed by a small group of people since the precious and semi-precious stones and glass used in cameo production was quite expensive and sometimes rare[2]. These connections between coins and the Roman people in general versus cameos that were predominantly used by the upper class explain how each serve : coins for the state and cameos and gems for individuals[3].

The artist, taking advantage of the natural fusion of two colored shells, carved the white shell to produce the portrait and revealed the darker shell as the background. The outer layer was cut away using various drills which is evidenced in the portrait's of curled locks of hair[4]. Drills also allowed the artist to incise deep strong lines like those differentiating the individual hairs or separating parts of the laurel wreath.

The finer transitions of the portrait such as the movement from cheek to nose or the curve of the neck are achieved by rubbing powder with fine abrasives such as diamond dust on the surface. This also polishes the surface giving the object a finished sheen[5].

The figure, in relief, then stands in contrast to the darker layer below whose exposure defines the figure's negative space. Subtle nuances in the relief also allow various amounts of the darker layer to show through obtaining delicate shadow-effects as seen in the bows tying the wreath.

The elaborate use of the drill in comparison with sculpture, place the piece in the second century during the Antonine period. Casson postulated the identification as Marcus Aurelius which is readily seen when comparing the cameo to a coin with Marcus Aurelius[6] where both heads heavenward gaze as is frequent in imperial iconography. M. Hirmer proposes Commodus as the Emperor[7]. The treatment of Commodus's nose in the coin is much closer to the Bowdoin cameo.

Additionally, the portraits of Commodus on three other intaglios in Leningrad, Naples, and Paris, display many affinities to the Bowdoin cameo[8].

HBR

1. RICHTER, G.M.A., *Catalogue of the Engraved Gems Greek, Etruscan, and Roman*, Rome, I, 1968, p. 23.
2. HARDEN, D.B., *Glass of the Caesars*, Cologne, 1987, p. 3.
3. RICHTER, p. 23.
4. A sculptural parallel of this may be seen in a portrait perhaps of Julia Titi in Rome Museo Capitolino.
5. For a more detailed discussion of cameo production, see the Introduction.
6. See KENT, n° 334, for example.
7. See KENT, n° 361, for example.
8. VOLLENWEIDER, M.-L., *Le développement du portrait glyptique à l'époque des Antonins et des Sévères*, in *II Conferenza Internazionale sul Ritratto Romano. Ritratto Ufficiale e Ritratto Privato*, Rome, 1988, p. 87-104, fig. 11, 12, 13.

130. Fragment of a Historical Relief Head

Marble - End of the Second Century AD
Cm. 19
Courtesy of Mr. and Mrs. Artemis Joukowsky
Bibliography : *Love for Antiquity*, Exhibition at Brown
University, Providence, October 12 - November 8, 1985.
Eds T. HACKENS and R. WINKES, n° 80, p. 107.

The Joukowsky piece could have come from one of the many battle sarcophagi of the Late Antonine period but, it seems more likely that it belonged to a historical relief[1]. However, there is not enough information to place this head to any specific monument.

The relief conveys no traces of a distinct personality. In the way it follows a set type of form with generic features, it is clearly not meant to be a portrait of an individual. It was probably one of the background relief figures that were usually either soldiers or barbarians. Evidence in support of the above is that the head was intended to be seen in a profile view, which was the favored position for background figures. It also shows a flat, shallow and crude carving with the evident use of the running drill[2].

Stylistically, it is closest to the reliefs of the Column of M. Aurelius, a monument completed c. AD 193[3]. It successfully represents most of the artistic changes and conventions of its time. This was the period when the first traces of the Late Roman style began to appear. The plasticity, the foundation of Greek art, now slowly deteriorates giving way to a more spiritual outlook. Especially in the treatment of the facial features, hair and beard there is a shift away from naturalism toward a dissolution of organic form by optical and expressive means[4]. This pictorial quality is based on the strong play between light and shade especially evident ont he relief heads of this period. It is also reminiscent of the optical illusions that painting was trying to achieve by means of a blocking-out, quasi-impressionistic technique[5].

The Joukowsky fragment exhibits this strong shadowing effect with its cork-screw shaped locks of hair done entirely with a drill. It stands as one of the many artistic examples bearing testimony to the changing attitudes of the Roman world. The Late Antonine period was characterized by a religious anguish, apparent in M. Aurelius's *Meditations* and an intense anxiety[6]. This irrational reliance on metaphysical solutions for the world's problems resulted in a search for an inner expression and a complete loss of individuality, both characteristic traits of the Joukowsky relief.

EG

1. HOLLOWAY, R.R., *Love for Antiquity*, p. 107.
2. BONNANO, A., *Roman Relief Portraiture to Septimius Severus (British Archaeological Reports, Supplementary Series* 6), 1976, p. 141-142.
3. HOLLOWAY, p. 107.
4. *Ancient Portraits. A Show of Greek, Etruscan and Roman Sculptured Portraits.* Ackland Art Center, Chapel Hill, North Carolina, 1970, n° 22, p. 3.
5. BIANCHI, B.R., *Rome : The Center of Power*, Eds. A. MALRAUX and A. PARROT, p. 316.
6. *Ibid.*, p. 310-314.

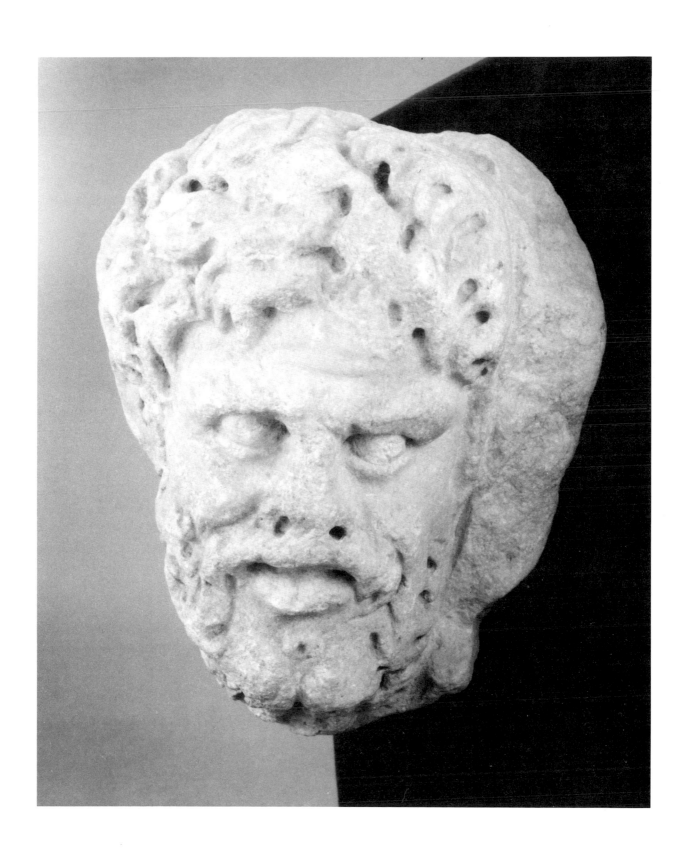

131. Female Portrait with Removable Wig

White Marble with Removable Wig in Dark Marble - Late Second, Early Third Century

Cm. 24 x 18

Courtesy of The Detroit Institute of Arts

Gift of P.F. Nesi - Acc. n° 38.41

Bibliography : RATHBONE P.T., *Three Roman Portrait Heads*, in *Bulletin of the Detroit Institute of Arts*, 17, May 1938, p. 69.

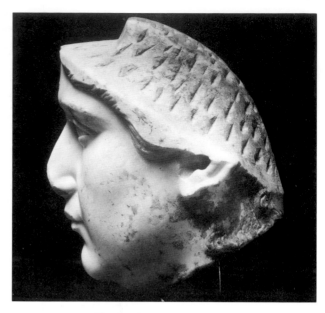

A simple contour and broad facial planes with horizontal brow are relieved by heavy-lidded eyes, full lips, and fleshy chin in this portrait of an anonymous woman. The eyes are treated in an almost abstract manner : the irises are described by an incised line and the pupils by two drill holes. A single drill hole, evident at the inner corners of the eyes, is also found at the outer corners of the mouth. The sense of abstraction is heightened by the striking division between the white marble of the face and the black of the wig. At the junction between the two pieces of stone, the sculptor has summarily described locks of hair that continue onto the white marble. The wig, unfinished at the back, is parted at the center and waved down over the ears to the nape of the neck where the hair is gathered into a chignon.

The Detroit woman is fascinating not only for the simple, abstract treatment of the face, but especially for the removable hairpiece. It is by no means an anomaly in Roman portraiture ; approximately twenty-five later Antonine and Severan portraits have detachable hairpieces, five of which are in colored stone[1]. Scholars generally agree that separate hairpieces were simply a result of fashion consciousness. Hairstyles changed rapidly, as can be seen on coins as well as in sculpted portraits, and the portrait could be kept abreast of the latest style by merely ordering a new hairpiece to replace the outdated one. This trend in sculpture seems to date primarily to the late second and early third centuries, particularly following the fashion of the Empress Julia Domna[2].

In the Detroit piece, the wig was attached by a rectangular tenon on the head which fits into a corresponding mortise in the underside of the hairpiece. The connecting surfaces were roughened, perhaps to give a good grip for adhesive[3].

Gazda has suggested that originally the head was completed entirely in white marble during the late Antonine period, then it was cut down and fitted with a wig in the Severan period. Evidence for such a theory lies in the fact that the white stone was cut too far down above the left eye. Also, the locks of hair visible on the white portion are not carefully continued on the black hairpiece. Gazda relates the style of the face to portraits of the Antonine period, particularly similar to one in the Metropolitan Museum[4]. Both pieces are characterized by geometric planes and contours, subtle, fleshy modelling of the face, and waves of the hair at the hairline[5]. The style of the wig, however, is closer to that of the Severan period, similar to styles worn by Julia Domna[6].

The head is an excellent example of the vanity displayed by the Roman upper classes, particularly around the turn of the third century. It is also illustrative of the manner in which styles and trends touted by the Imperial family were emulated by their subjects.

LLA

1. GAZDA, E., *Roman Portraiture : Ancient and Modern Revivals*, Ann Arbor, 1977, p. 26.
2. RATHBONE, P.T., *Three Roman Portrait Heads*, in *Bulletin of the Detroit Institute of Arts*, 7, May 1938, p. 69.
3. GAZDA, p. 26.
4. This head is illustrated in RICHTER, G.M.A., *Roman Portraits*, New York, 1948, fig. 85.
5. GAZDA, p. 26.
6. RATHBONE, p. 69.

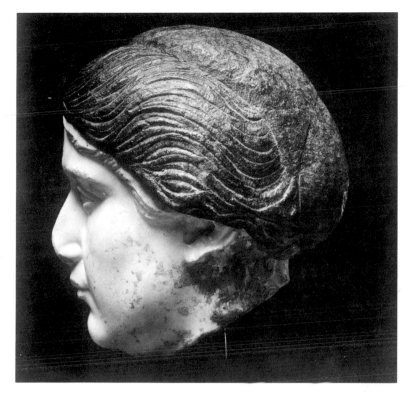

© The Detroit Institute of Arts, 1988.

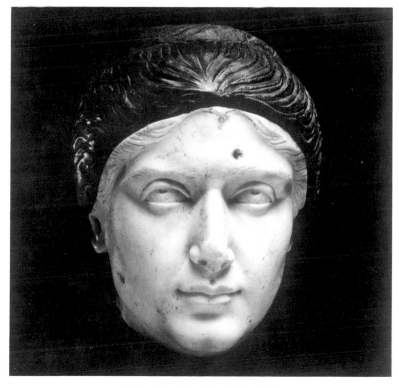

© The Detroit Institute of Arts, 1988.

132. Head of a Young Boy

Marble - c. AD 250-260
Cm. 11.5
Courtesy of The Harvard University Art Museums (The Arthur M. Sackler Museum)
Gift of Mr. and Mrs. Charles D. Kelekian in Honor of G.M.A. Hanfmann - Acc. n° 1979.414
Bibliography: *Fogg Museum of Art Annual Report, 1978-1980*, Cambridge, 1982, p. 42, 72 (illus.), and 173.

Simple, closed contours, minimal detail of the features, and treatment of the hair as a cap-like mass characterize this head and place it within the third century. Deep drill holes at the inner corners of the eyes are also indicative of this time period[1]. The pupils are indicated only by a lightly incised circle, and were probably painted on the stone[2].

The generalized treatment of the Harvard head and the lack of incised pupils indicate that this portrait was most likely intended for a funerary monument; the drill holes at the inner corners, representing tear ducts, are characteristic of third century portraits[3]. Its small size might also mean that it was made for a memorial in a household shrine[4]. A portrait of a man in The Museum of Fine Arts, Boston, made at about the same time, was perhaps intended for a similar purpose[5]. The piece is close to the Harvard head in the closed contours, the treatment of the hair, and the drill holes at the inner corners of the eyes. Another related head is Severus Alexander at Schloss Fasanerie[6]. Again, the treatment of the hair resembles a close-fitting cap; the locks are vaguely indicated by lightly gouged incisions, as in the Harvard boy.

In the third century, a significant distinction existed between portraiture of children and that of adults. Youthful images became mor generalized and childlike. The trend toward abstraction, evident in all types of portraiture at this time, was particularly well suited to the representations of children; the wrinkles and sharp features of mature patrons required more expressive handling[7].

Portraits of young boys produced in the simple, more geometrized style of the post-Severan third century take on an almost timeless quality[8]. If, as has been suggested, the Harvard head was intended for a funerary or memorial purpose, this quality would have been well-suited.

LLA

1. COMSTOCK, M., and VERMEULE, C.C., *Sculpture in Stone*, Boston, 1976, p. 240.
2. VERMEULE, C.C., *Greek, Roman and Etruscan Stone Sculpture in the Harvard University Museums*, forthcoming.
3. COMSTOCK and VERMEULE, p. 240.
4. VERMEULE, forthcoming.
5. COMSTOCK and VERMEULE, p. 240, n° 376.
6. VON HEINTZE, H., *Die Antiken Portäts in Schloss Fasanerie bei Fulda*, Mainz, 1968, n° 46.
7. WOOD, S., *Child Emperors and Heirs to Power in Third-Century Portraiture*, in *Ancient Portraits in the J. Paul Getty Museum*, Malibu, 1987, p. 125.
8. VERMEULE, forthcoming.

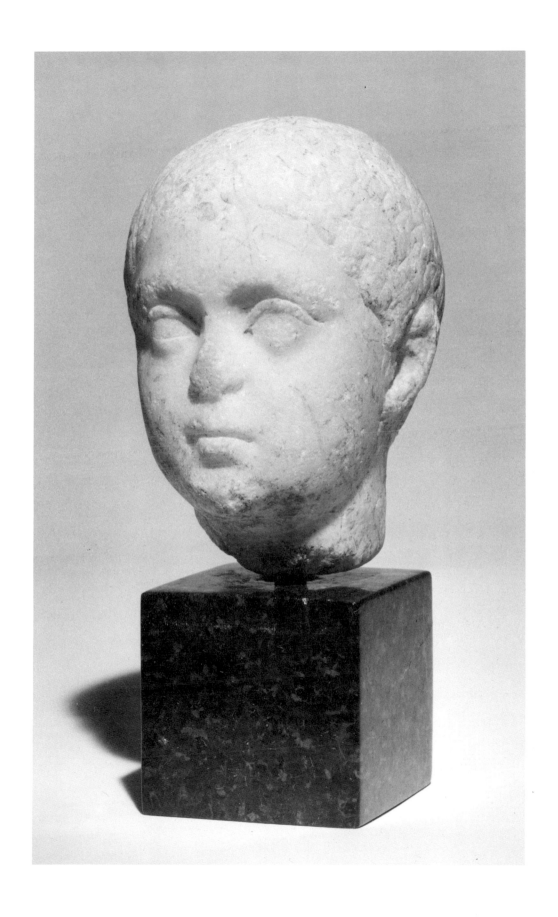

133. Head of Portrait the Emperor Diocletian

Black Basalt - AD 302-305
Cm. 20.3
Courtesy of The Worcester Art Museum
Alexander H. Bullock Fund - Acc. n° 1974.297
Bibliography :
TEITZ R., *Portrait of the Emperor Diocletian*, in *Worcester Art Museum Bulletin*, 44, 1975, p. 15-16.
WEITZMANN K., *Age of Spirituality*, Metropolitan Museum of Art, 3, 1978-79, p. 10-11.

The frontal, fixed gaze of this head attracts immediate attention to the eyes and their crystalline reflection of an inner abstract life. Set in a frame of intense curves, these eyes dominate the entire expression[1]. The portrait shows Diocletian as an older man with sagging cheeks and a downward-twisted mouth. The short-cut hair is rendered by chisel-strokes in a pointillistic hatching and stippling technique, and it is left unfinished on the forehead thus emphasizing the blocklike, geometric form in this portrait.

The image has been identified as the Emperor Diocletian based on a comparison with other accepted portraits in the round and representations of the Emperor on coins[2]. Apart from intending to give the objective physiognomy of Diocletian, it also aims at revealing his psyche. By laying stress on the assymetrical constellations of the folds and wrinkles, which are especially striking in the muscles of the forehead and around the mouth, it reveals the Tetrarch with an uncanny psychological intensity[3]. Diocletian's image conveys a brutal strength in this struggle for self assertion in a period of turmoil and insecurity. His powerful personality, responsible for all the political, economical and social reforms of the Roman Empire, is successfully reflected.

By the middle of the Third Century, a totally new world had come into existence. The Empire had been transformed, and not just politically and geographically but above all spiritually. This is the time of Plotinus and Neoplatonism, a philosophy emphasizing that the physical image could never be the true representation of a person[4]. Art reflects this crisis by shifting from the natural to the abstract, from the sculptural to the two-dimensional, and from the descriptive to the symbolic[5]. Seldom in the history of art has the relationship between society and formal language been so close[6]. It is exemplified by the Worcester head portraying an image of unsurpassed power that at the same time is shown tormented by the anguish of facing the problems of a declining Empire.

EG

1. L'ORANGE, H.P., *Art Forms and Civic Life in the Late Roman Empire*, Princeton, 1965, p. 121.
2. McCANN, A.M., *Head of Diocletian*, in *Age of Spirituality*, p. 10-11. See also TEITZ'S, R., entry on Diocletian published in the *Worcester Art Museum Bulletin*, 44, 1975, p. 15-16.
3. L'ORANGE, p. 107.
4. BRECKENRIDGE, J.D., *Imperial Portraiture : Augustus to Gallienus*, in *ANRW*, II, 12.2, p. 508-509. Also for general information on the art of the Tetrarchy and the Late Empire see : VON SYDOW, W., *Zur Kunstgeschichte des Spätäntiken Porträts*, Bonn, 1969.
5. McCANN, A.M., *Beyond the Classical in Third Century Portraiture*, in *ANRW*, II, 12.2, p. 623.
6. BIANCHI, R.B., *Rome : The Late Empire*, London, 1971, p. 19.

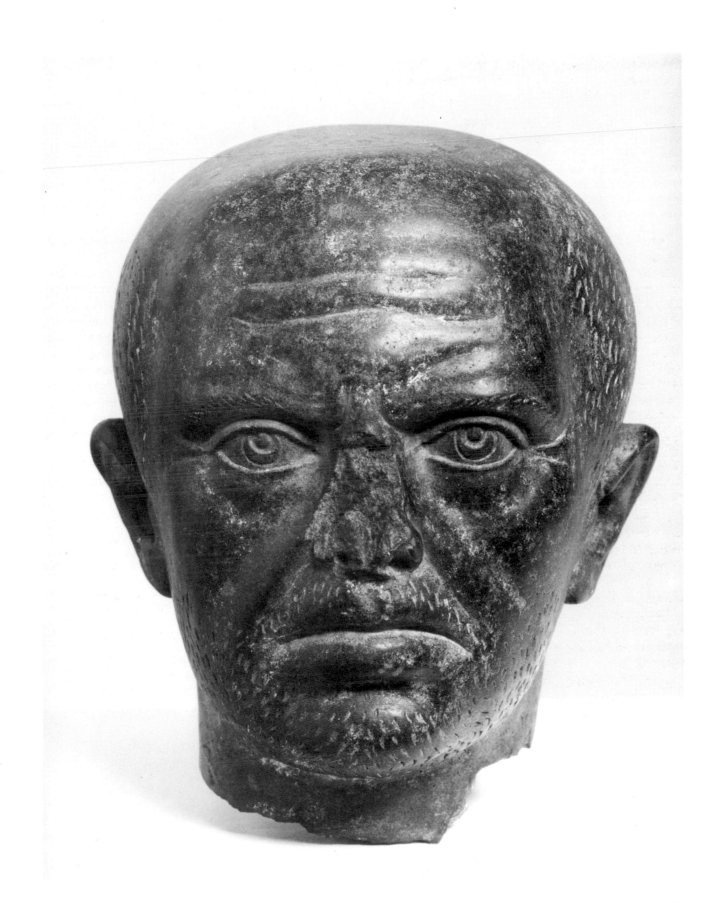

134. Portrait of a Man

Tempera on wood - c. AD 253-268
Cm. 32.3 x 18.4
Mary B. Jackson Fund
Courtesy of the Rhode Island School of Design Museum,
Providence - Acc. n° 39.026

Bibliography :

WINKES R., *Catalogue of the Classical Collection, Roman Paintings and Mosaics, Museum of Art, Rhode Island School of Design*, Providence, 1982, p. 67.
LOEFFLER E. P., *The Museum's Classical Collection*, in *BullRISD*, May 1965, p. 12-13.
PARLASCA K., *Mumienporträts*, Wiesbaden, 1966.

Mummy paintings, often called Fayum portraits after the famous area in which many examples were found, probably represented Romans living in Egypt. Mummy portraits are generally dated in relation to the styles and fashions shown in sculpted portraits. This painting disproves a common assumption that later works are less skillful and more generalizing than earlier paintings. The youthful man's large, round eyes, outlined in black, are characteristic of later portraits. The hair is depicted with curling lines of black paint and a more broadly applied dark greyish tone. Brown curls surround the face. The pale green leaves of a laurel wreath appear in the hair. The fillet showing on either side of the neck forms a zig-zag pattern. Subtle hatching marks the plane below the left cheekbone. The skin is rendered with a careful mixture of light creamy tan and darker ruddy brown colors. Grey lines mark the creases in the cream colored drapery that travels over the figure's left shoulder, and in his white tunic[1].

This portrait was once in the collection of Theodor Graf of Vienna, who acquired mummy paintings said to have been stolen from a grave site at Er Rubayat[2]. The exhibition of Graf's collection in 1899 stirred archaeological interest. Mummy portraits probably would have been displayed during the subject's lifetime. After death, panel paintings such as this would have been cut down and set into the mummy wrappings over the head[3]. The RISD painting shows the irregular shape of a reduced panel : Recent work has shown that, while some mummy portraits present a likeness of the person beneath, others were not even the same sex as that of the mummy[4]. The poor condition of many of the mummies found suggests that they would have been exposed to the elements, most likely on display in the courtyard of the house for a period of time before burial. This practice would have agreed with the Roman custom of retaining *imagines maiorum* in the atrium[5].

DCS

1. WINKES, R., p. 67.
2. REINACH, S., *Les Portraits Gréco-Égyptiens*, in *Revue Archéologique*, 1914, ii, p. 36-37.
3. PETRIE, W.M.F., *Roman Portraits and Memphis*, London, 1911, p. 7.
4. THOMPSON, D.L., *The Artists of the Mummy Portraits*, Malibu, 1976, p. 12.
5. *Ibid.*, p. 2-7 ; BERGER, J.E., et CREUX, R., *L'œil et l'éternité Portraits Romain d'Égypte, Paudex, 1977, p. 89-106.*

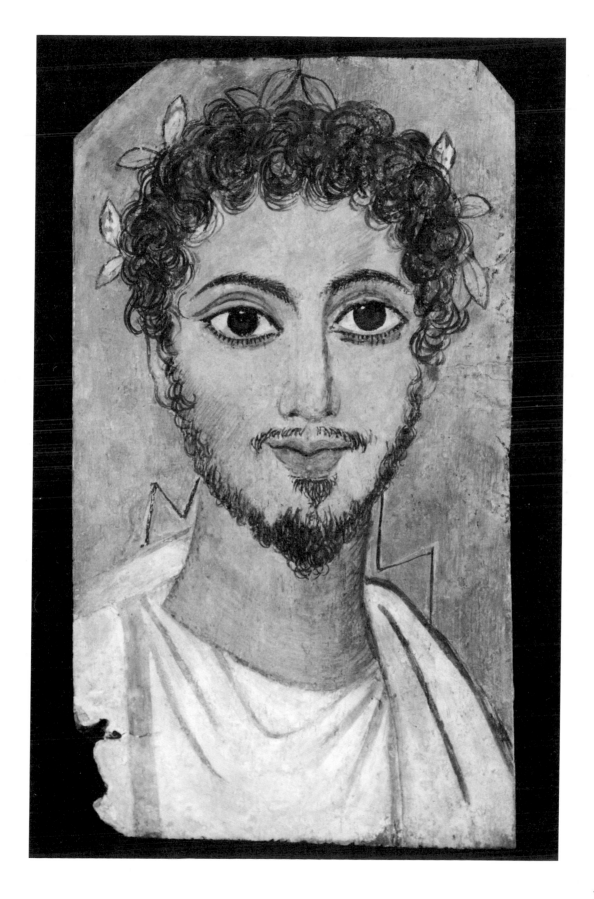

135. Head of a Man

Marble - Undated
Cm. 10.5
Courtesy of the Brooklyn Museum, New York
Charles Edwin Wilbour Collection - Acc. n° 16.239
Bibliography: Brooklyn Museum, *Late Egyptian and Coptic Art*, Brooklyn, 1943, p. 17, n° 10.

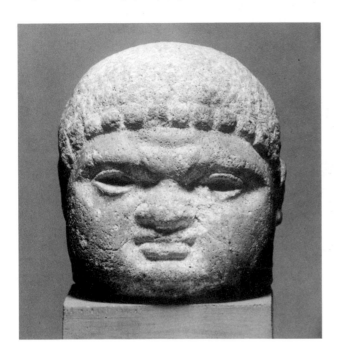

This unusual miniature head raises questions about the nature and boundaries of portraiture. Because of its small size and exaggerated physiognomy, seen for instance in the squatness of the features and the extreme width of the head, the sculpture is unlike more conventional portrait heads from Graeco-Roman Egypt[1]. The head's dimensions and bulbous features as well as its rough modeling ally it with the so-called grotesque statuettes that were produced in large numbers in the Fayum and Alexandria during the Ptolemaic and Roman periods[2].

These terra-cotta figures represent various comic types and use distorted facial features as the basis for their humor. The function of these objects was twofold : to contain the malevolent powers of the Evil Eye and more commonly to be a source of amusement[3]. Many of these heads are crude ethnic caricatures of the peoples of Abyssinia and Numidia. The marble piece has in fact been compared with a bronze example of this genre of caricature art and can be related to numerous other examples in terra-cotta[4].

A striking difference between the head and these other images, however, is its expression. While most of these figures are represented in states of contorted laughter or blithe insouciance, the marble head appears reserved and dignified. Probably the work is not a portrait in the usual sense of the word, but its sober expression suggests that its maker sought to create an imaginary individual's likeness within a normally comic genre rather than a stock impersonal type[5].

GW

1. Compare with examples illustrated in DRERUP, H., *Ägyptische Bildnisköpfe griechischer und römischer Zeit*, Münster, 1950.
2. See for examples : Musée National du Louvre, *Catalogue raisonné des figurines et reliefs en terre-cuite grecs, étrusques et romains*, III, Paris, 1972, p. 145-152 ; KAUFMANN, C.M., *Ägyptische Terrakotten der griechisch-römischen und koptischen Epoche*, Cairo, 1913.
3. CÈBE, J.P., *La caricature et la parodie dans le monde romain antique des origines à Juvénal*, Paris, 1966, p. 354.
4. The 1943 Brooklyn catalogue compares the head to a bronze piece illustrated in VON BISSING, W., *Die griechisch-römischen Altertümer im Museum zu Kairo*, in *Archäologischer Anzeiger*, 1902, p. 149, fig. 4*l* ; EDGAR, C.C., *Catalogue général des Antiquités égyptiennes du Musée du Caire. Bronzes grecs*, Cairo, 1904, pl. V, n° 27,711. Compare with terra-cotta specimens in Société Royale d'Archéologie d'Alexandrie, *Monuments de l'Égypte gréco-romaine*, Bergamo, II, 1934, p. 51, pl. c.
5. The head could be considered an example of what Richter has called near portraits. RICHTER, G.M.A., *Greek Portraits*, III, Brussels, 1960, p. 24-25. She applies this concept to images which are physically similar to the Brooklyn head and states that despite their ostensible parody many of these heads are highly individualistic and assume a portrait-like aspect (p. 28).

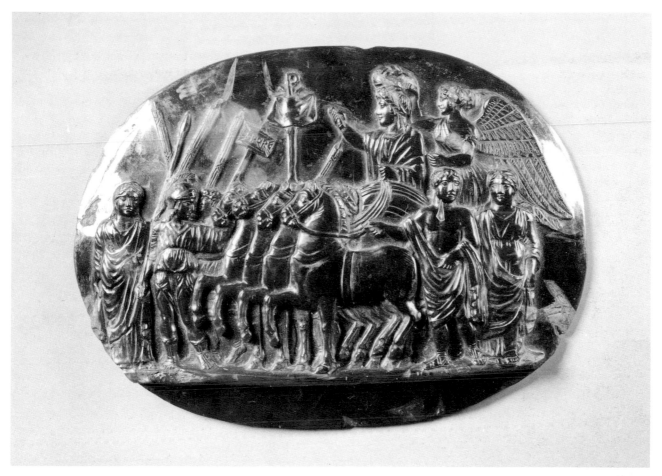

136. Emperor in a Quadriga

Sardonyx (Horizontally-cut Agate) - Fourth Century
Cm. 11 x 15
Courtesy of The University Museum, The University of
Pennsylvania, Philadelphia
Sommerville Collection - Acc. n° 29-128-3
Bibliography : BIEBER, M., *Honos and Virtus*, in *AJA*,
49, 1945, p. 25-34.
Archaeology, 10, 1957, p. 61.

The Somerville cameo shows an Emperor in a
quadriga drawn by four horses and with an assort-
ment of other figures on the ground. This is an
excellent example of the continuing skill of cameo
and intaglio engravers in the later Empire, manipu-
lating the variations inherent in the material for
decorative effect. Particularly fine is the treatment
of Victory's wings and the recession in space of the
four horses pulling the *quadriga*, all the more
remarkable since the depth of relief never exceeds
five millimetres. The figures depicted all show the
increasingly abstract qualities of later Roman art,
decreasing verism combined with iconographic hie-
rarchy. The Emperor appears on a scale far greater
than those flanking him, and in profile although
identification is hard to ascertain merely on the
basis of this simplified representation[1]. The portrait
would seem to be more an image of emperor-like
pursuits and attributes. Identities for the subsidiary
figures are harder to supply. Bieber suggest the
scantily-clad woman leading the horses in a short
tunic and crested helmet to be Virtus, and the semi-
nude man to the right many represent Genius Populi
Romani. The outermost figures are so similar as
almost to be mirror images. The scroll that the
Emperor holds in his hand probably records the
successes occasioning the granting of the Triumph.
In the background are visible the *fasces* borne by the
lictors and a military standard, the emblem of which
is covered by drapery.

JWH

1. Bieber suggest Constantine the Great.

137. Gold-glass Vessel Fragment

c. Early Fourth Century

Cm. 10.2

Courtesy of The Corning Museum of Glass, Corning, New York

Acc. n° 62.1.20

Bibliography :

Accessions of American and Canadian Museums, October - December 1962, in *Art Quarterly*, 26, 1 (Spring 1963), p. 80, repr. p. 87.

Recent Important Acquisitions made by Public and Private Collection in the U.S. and Abroad, in *Journal of Glass Studies*, V, 1963, p. 143, n° 14.

Glass from the Corning Museum of Glass : A Guide to the Collections, 3rd ed., Corning, 1965, p. 23, n° 22.

Gold-leaf laminated between two layers of glass. Profile busts of Saints Peter and Paul respectively. Between them stands Christ holding a wreath in each of his extended hands over the heads of the saints.

Glass-making is thought to have been invented in Mesopotamia about the turn of the 3rd to the 2nd millennium BC[1]. Evidence of the first core-made glass vessels, does not appear in Mesopotamia and Egypt until c. 1500 BC ; most of the earliest vessels were small bottles and flasks core-forming, casting, cold-cutting and grinding, and the decorative techniques employed included trailing, relief and intaglio cutting, and casting of mosaic designs. Although the glass-making process was technically advanced, inflation of glass, or glass-blowing, was not understood until the second half of the first century BC. Since glass-making was laborious and slow, the obvious consequence was that it was rare and costly. Only the wealthy could afford it, and its impact failed to reach the common citizen[2].

The earliest gold-glass vessels date to the early Hellenistic period, but the dates cannot be narrowed further ; its production probably lasted for about a century and a half, from c. 300-250 until 150-100 BC[3]. After this time the quality of gold-glass declined and was not revived with notable merit until the Third and Fourth centuries AD when two major outposts developed, one in the Rhineland and the other in Rome[4].

1. VON SALDERN, A., *Glass 500 BC to AD 1900 : The Hans Cohn Collection, Los Angeles/CAL*, Mainz, 1980, p. 14-15.
2. HARDEN, D.B., *Glass of the Caesars*, Milan, 1987, p. 3 and 89.
3. *Ibid.*, p. 262.
4. *Ibid.*, p. 263.

There has not been extensive research devoted to the manufacture of gold-glass, and so a number of theories exist which attempt to account for its production. According to David Whitehouse, the process most logically occurred as follows[5] : as most gold-glass consists of a patterned gold-leaf decoration, sandwiched between two pieces of glass for protection, the craftsman must blow the lower piece[6] to the full size and form that he desires the finished object to take. He lets this piece cool, and only when it has cooled and is rigid does he apply the gold foil and execute the cut-out work, also applying colored paint on occasion. The gold design is then worked until it, too, attains its desired appearance, and then this piece in its entirety — both gold and glass — is carefully reheated[7]. In the meantime, the glassmaker blows out another gob on the blowpipe, inflating it like a balloon. As it expands it is blown against the other, now warmed, piece of decorated glass, so that it flattens over the gold surface. When the balloon shape is stuck to the decoration it is then cut off the blowpipe and its edges are reheated and worked into the desired finished shape.

Portraits on gold-glass appear to have been made primarily in two different contexts. The most common remnants are fragments, as is the case of our Corning example, which originally served as the base of a vessel probably intended for display and not for daily use[8]. It is likely that such objects would have been gifts for weddings or anniversaries. The other form gold-glass took was that of the medallion. Often these medallions were affixed with lime mortar to the walls of a tomb where they served to identify the occupant ; many surviving examples were found in the catacombs in Rome[9].

On the Corning fragment, Saints Peter and Paul are shown in bust length profiles : between them stands a little figure of Christ holding a small

5. I would like to thank Dr. Whitehouse, Chief Curator at The Corning Museum of Glass, Corning, New York, for providing me with this information and other insights.
6. The craftsman may also blow the upper piece of glass, depending upon which piece he intends for the application of the gold.
7. It is necessary to reheat this piece for the following process because if hot glass is applied to cool glass shattering is inevitable.
8. HARDEN, p. 268.
9. NEUBURG, F., *Ancient Glass*, Trans. Michael Bullock and Alisa Jaffa, London, 1962, p. 69.

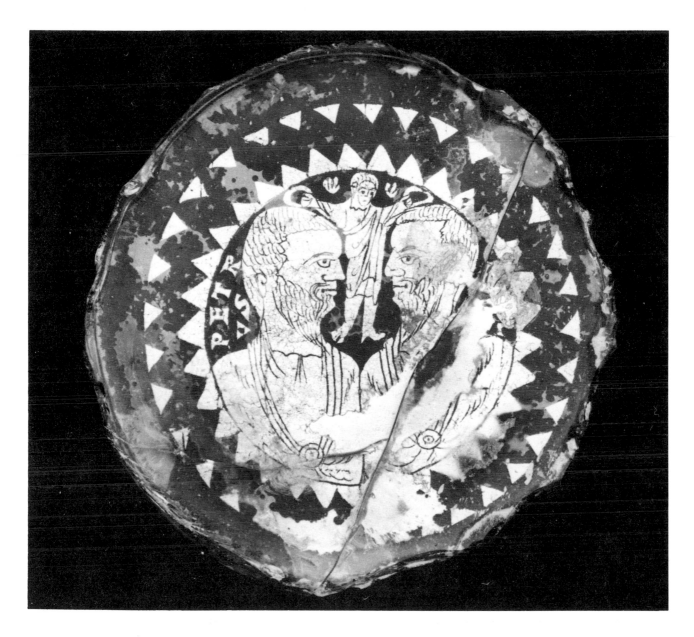

wreath over each of their heads[10]. This motif is also popular on glass depicting married couples. The resemblance between the two images indicates that the Corning fragment, like those pieces created in honor of weddings or anniversaries, was intended for the celebration of the festival of the two Saints. Such Christian ceremonies were as worthy of celebration as the secular and pagan ones at this time[11].

The origin of this wreath-bestowing central figure may be traced to pagan triumphal images often found on coins and medallions, in which a Nike, Hercules, or Cupid is shown crowning the victor[12]. It is interesting to note that on gold-glass the wreath-bestowing figural motifs, though originally inspired by pagan imagery, actually appeared first in scenes that depicted saints with the Christ figure ;

only after such forms had set the precedent is the same motif found commemorating weddings and anniversaries[13]. Thus, at least in the gold-glass tradition, the crowning motif was found first on glass devoted to Christian themes not to secular or pagan ones.

ACW

10. The figure's identity is not expressed in a legend here, but his identity has been established through several examples of medallions with the same motif on which the name *Christus* appears above the figure. ENGEMANN, J., *Bemerkungen zu Spätrömischen Gläsern mit Goldfoliendekor*, in *Jahrbuch für Antike und Christentum*, 11/12, 1968-1969, p. 23.
11. HARDEN, p. 268.
12. *Ibid.*, p. 23, notes 105 and 106.
13. ENGEMANN, p. 24.

138. Young Augustus

Marble - American, probably 19th Century
55 cm. high ; 30 cm. wide ; 26 cm. deep.
Brown University, John Hay Library
Bibliography : Unpublished.

An adolescent Augustus (31 BC - AD 14) is represented in this finely-chiselled bust with the soft features of youth. His brows converge in a manner typical for the ruler and known from adult portrait types of Augustus expressing the *cura imperatoris*. This particular juxtaposition is not found in any ancient portraits of Augustus[1]. This bust is one of several copies of a late eighteenth or early nineteenth-century conception of *Young Augustus*. These were inspired by a marble bust in the Vatican that was believed to be ancient and found in Ostia. Busts of *Young Augustus* were sought by nineteenth-century collectors as faithful renditions of an ancient portrait[2]. Now, however, the Vatican piece has been convincingly attributed to the workshop or following of the neoclassical sculptor Antonio Canova[3]. Therefore all nineteenth-century copies are derived from a modern work.

The Providence bust is similar to versions made by American sculptors active in Italy in the nineteenth century[4]. This modern rendition combines the softened features of Octavian with a hairstyle familiar from ancient portraits of the Emperor. This is the so-called pincer formation of locks of hair on the forhead. A well-known ancient example of this si the Primaporta statue of Augustus in the Vatican, Rome, dated after 20 BC[5]. This work is representative of the real Augustan classical style, and provided the basis for the Canovian original. The Providence bust is an embodiment of the nineteenth-century's conception of classical form. Every surface is treated with a pristine carefulness that conforms to the learned, almost codified repertory of neoclassical features : straight noses, finely-chiselled waves of hair, and smooth transitions. The difference between this classicism, and that of the Primaporta Augustus, is thus a lesson in the progression of style and the history of taste. In the Primaporta portrait head, the generalized classical forms are carved in a naturalistic manner approximating fifth century Greek art, evolving the Neo-Attic style. *Young Augustus* exhibits a well-defined, canonical adherence to these forms in a way that is typical of modern neoclassical sculpture.

JT

1. BRINNON, J.W., in *Roman Portraits : Ancient and Modern Revivals*, The Kelsey Museum of Archaeology. The University of Michigan, Ann Arbor, 1977, p. 36, describes a similar bust of *Young Augustus* in the Detroit Institute of Arts, attributed to an anonymous American nineteenth century sculptor.
2. *Ibid.*, p. 37. Other copies are in Detroit (see n° 1 above) ; Museum of Fine Arts, Boston (by H. Greenough, c. 1836) ; and the Newark Museum (by W.W. Storey, date unknown). It is not clear whether the Providence bust could be by one of these artists ; the possibility remains that it could be a commercial manufacture, since *Young Augustus* busts were available in marble or plaster, through catalogue mail-order, in the nineteenth century.
3. MINGAZZINI, P., *La datazione del ritratto di Augusto Giovinetto al Vaticano*, in *Bolletino della Commissione Archeologica, Comunale di Roma*, 73, 1949/50, p. 255-259.
4. Including the American sculptors cited in n° 2 above.
5. FELLETI MAJ, B.M., in *Enciclopedia dell'Arte Antica : Classica e Orientale*, I, Rome, 1959, p. 922, fig. 1158.